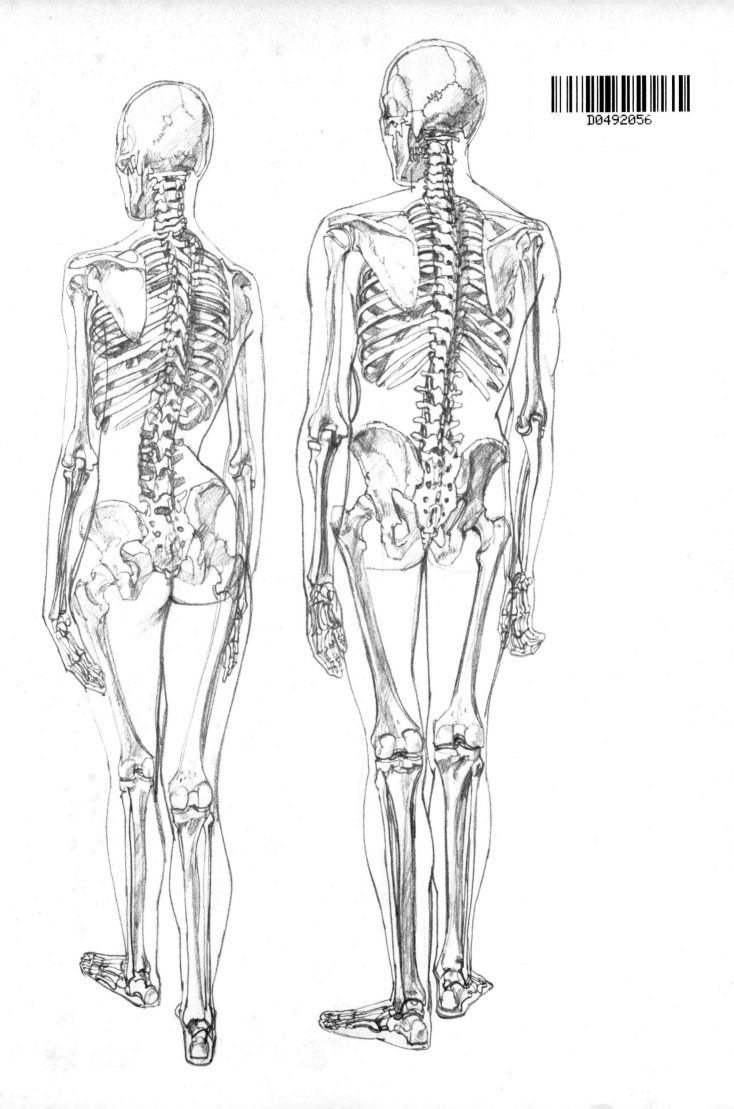

Human Anatomy for the Artist

Book Club Associates

London

Human Anatomy for the Artist

John Raynes

This edition published 1979 by
Book Club Associates
By arrangement with The Hamlyn Publishing Group Limited
London · New York · Sydney · Toronto
Astronaut House, Hounslow Road
Feltham, Middlesex, England

Phototypeset by Tradespools Ltd., Frome, Somerset.
Printed and bound in Great Britain by
Cox & Wyman Ltd.,
London, Fakenham and Reading

The drawings in this book are the work of the author, with the
exception of those dot drawings on pages 20, 27, 28, 35, 37, 41–43,
51, 56, 57, 59 and 135, which are the work of Polly Raynes.

Contents

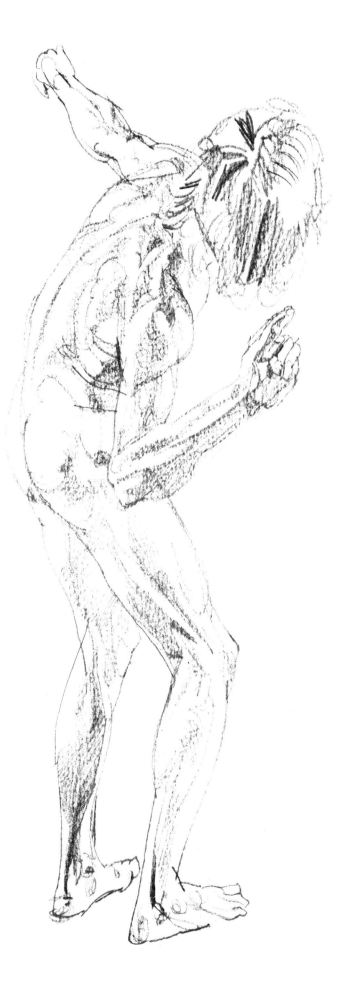

Introduction

Before embarking on a study of human anatomy for the artist, it may be helpful to establish the main stages in the history of western man's observation and depiction of his own shape.

We tend to perceive the world in such a way that all information which does not seem useful is treated as though it is not seen. The eye, as far as we know, passes on every detail of the objects on which it is focussed, but the brain selects which of the vast number of pieces of information are to be recorded and acted upon. As far as it can be ascertained, this selection is generally an automatic process and we are not conscious that it is taking place. All we are aware of doing is scanning the view, combining information from our other senses, reacting with interest, boredom, fear, delight or whatever, and acting accordingly.

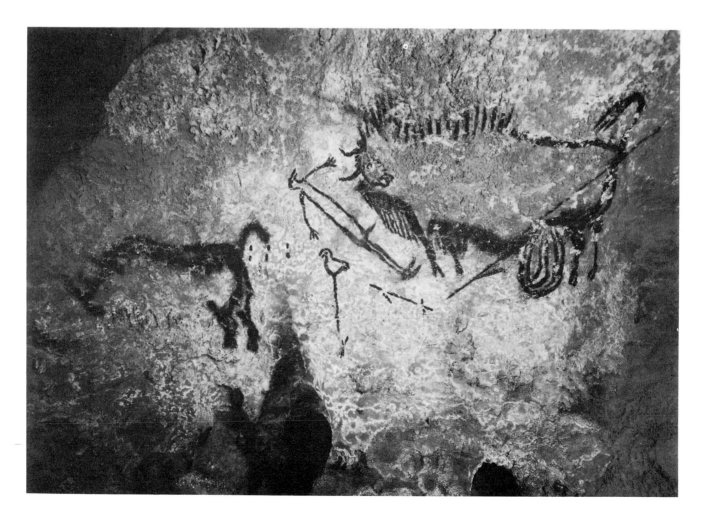

In order to act correctly, or perhaps even to act at all, the data from our eyes must be monitored according to our experience and circumstance, and transformed into useful information. If a potential enemy is approaching with a weapon, it is obviously of primary interest to observe the expression on his face and the position of the weapon, rather than to ponder the colour of his clothing or the pleasant pattern of light falling on the figure. In other circumstances perhaps these latter items of information would be the ones noted. In a similar situation but in a culture where attackers have learned not to reveal their intentions by facial expression, the experienced observer might look for shifts of balance or bodily attitude as warning of a possible attack. In other words, his culture would have taught him to select different pieces of information as relevant; in a sense it would have taught him to see differently.

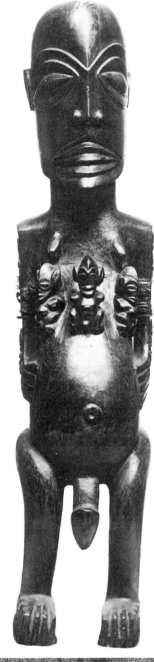

It is possible that, even if presented with essentially the same objective reality, modern and early man would see quite different things. This would presumably even apply to their perception of the human figure. A Stone Age hunter making drawings on his cave walls seems only to have seen stick figures in his fellow men, although the strikingly beautiful and accurate outlines of animals show that he was capable of observing shape with considerable clarity. We can assume that recognition of the prey was of primary importance to him; men were drawn only to depict the action, and did not need to be identified, so no detailed perception of their physical form was necessary.

The earliest civilizations found it necessary to externalize their ideas of gods and spirits, and drew them in the human idiom, but the relative importance given to bodily features would be governed by the 'idea' of their particular power and function, rather than by objective fact. A primitive god might be terrifying of face with a minimal body, his all-seeingness symbolized by huge eyes; a god of fertility, on the other hand, might be all genitals, a goddess of the harvest just breasts and fruitful belly. An intended sacrificial victim might be drawn with the heart clearly visible to stress the fact that he was shortly to loose that vital organ. In general heads, hands, feet and sexual organs were the principal foci of attention; scant observation was made of the rest of the body. Such use of symbols implies 'subjective' ways of seeing.

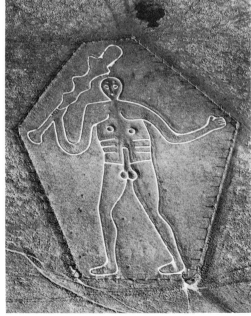

For a very long time man's vision of human form seems to have been exclusively subjective. The ability to see and depict the 'objective' external shape did not begin until a mature culture developed in the ancient Middle East. The change to objective vision was a gradual process, and its steps can be traced through many cultures.

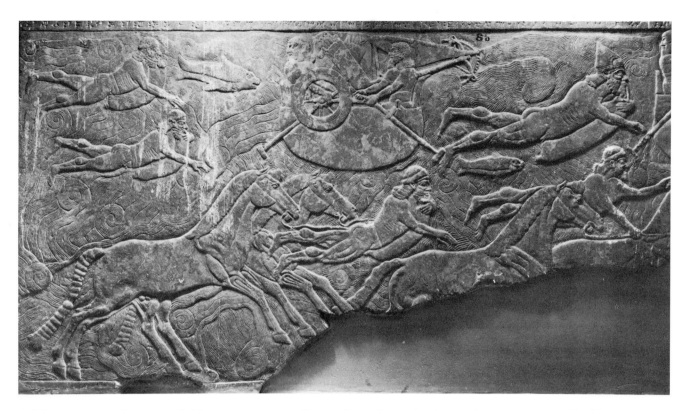

Soldiers crossing a river; bas relief from
Nimrud. 883-859 BC. British Museum, London.

In ancient Assyria the artist was compelled by
tradition to represent royalty in formal and courtly
attitudes; although figures of lower rank were depicted
in a more lively manner, there seems to have been a
pattern of acceptable poses, an overwhelming interest
in clothing and a total refusal to see the human head in
any view but profile. Only when drawing or modelling
animals was the Assyrian artist apparently freed from
his straight-jacket of formality and able to observe
naturally. Fragments of a relief from a royal palace at
Nimrud, now in the British Museum, belie this to some
extent: the human figures do show some knowledge of
anatomy, but even here the horses seem to have been
fashioned with more conviction.

Early Egyptian painting and reliefs also show an
interest in rank, depicted in the head-dresses and other
insignia. Hands, heads in profile and formal facial
features are the next foci of attention, and the rest of
the body was very stylized and formal. In the relief
illustrated from the pavilion of Sesostris I (c.1940 BC),
it is interesting to see the difficulty experienced by the
artist in making the transition from the frontal view of
the shoulders to the profile of the lower body. There is
no problem with the head, which can turn to profile
without affecting the set of the shoulders too much, but
having to show the dress with due symmetry makes the
transition to profile around the waist-hip area difficult
to achieve comfortably.

The artist has solved the problem quite well in the
right hand figure of the king – placing the navel off-
centre and making the skirt-like garment asymmetrical
has helped the transition to a side view of the legs and

feet. But the figure of the god Amon, on the left, is rather less successful anatomically. His waist-hip area shows no sign of a gradual turn and can be seen as profile or, alternatively, full face; the ambiguity is so great that it is possible to see the erect phallus as protruding from his hip!

Relief from the temple of Sesostris, Karnak, showing the king and Amon. c.1940 BC.

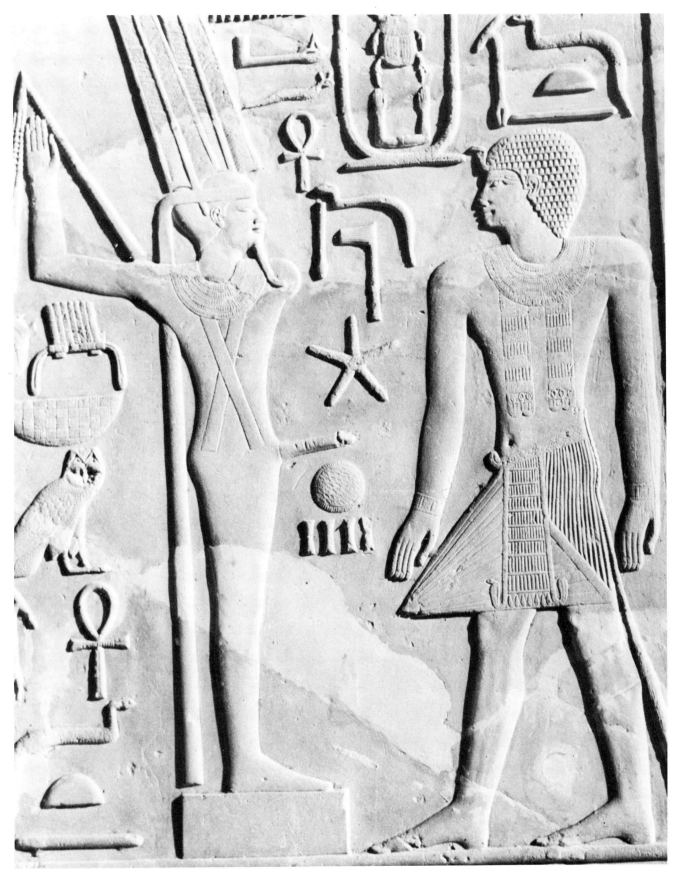

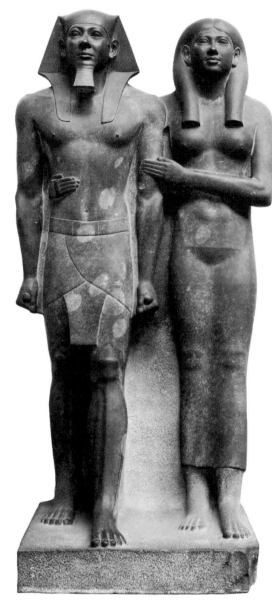

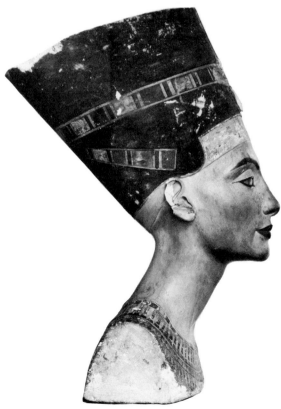

Curiously, sculpture in the round, even of a much earlier date, was more consistent anatomically. The sculpture of *King Mycerinus and Queen Chamerernebti* was carved in about 2510 BC and the anatomical structure, although idealized, shows great subtlety and cohesion. It is noticeable that throughout the history of art, at least until the 20th century, the human form is generally depicted with greater anatomical accuracy in sculpture than in painting. This may be so because sculpture required less translation and less compromise. Painters had to suggest three dimensions on a two-dimensional surface; inconsistencies where frontal forms turned away out of sight, which sculptors were forced to resolve, could safely be ignored. The need for structural coherence, the very fact of building up the structure, especially in modelling, as well as the necessity for all views to work, accentuate the need for anatomical accuracy in sculpture.

Later Egyptian sculpture shows great accuracy of anatomical observation, as the beautiful and famous head of *Nefertiti* demonstrates. Note the subtly modelled jaw and neck and the slight swell of the skull immediately behind the ear. The growing anatomical truth may have been connected with the increasingly sophisticated techniques of embalming which required a degree of skill in dissection.

Early Greek sculpture showed something of the rigidity of Egyptian art, but during the second half of the 6th century BC the much sought-after naturalism began to be achieved. The old decorative sense combined with new anatomical knowledge to produce figures like the *Kouros* illustrated here. The form of the abdominal muscles and their relation to the chest began to be understood better and items of detail, such as the greater height of the inner ankle point relative to the outer, indicate growing anatomical sophistication. It is interesting that these early sculptors were almost exclusively interested in the male nude. Female figures, where they existed at all in sculpture, were always draped; only later, in the full classical age, did the Greek sculptor discover the female nude.

By the early 5th century BC, sculpture began to appear more lifelike, as pelvic movement was achieved by placing the weight of the body mainly on one leg. Frontality and symmetry was being abandoned, probably for the first time in thousands of years. Thereafter development was rapid. The famous *Diskobolos* is dated 460–450 BC and the *Doryphoros* by Polykleitos illustrated here perhaps ten years later. By this time the sculptor knew his anatomy—head form, pelvic swing, counter-swing of vertebral column, muscles shortened or lengthened, tense or slack; all combined in superbly balanced poses.

Ancient Greece held perfection of human physical form in very high esteem and its sculptors Polykleitos and Praxiteles clearly knew a great deal about human anatomy. Head, hands, feet and genitals took a less dominant role; torso and limbs acquired new importance. The harmonious relationship of all the parts of the human body to each other, their combining into a coherent and convincing whole, reached new heights in this golden age of sculpture. Idealized the forms undoubtedly were, but the idealism must have been based on acute observation of real people to exhibit such understanding of the human form. Whether the Greek artists' understanding was based only on careful study of the surface form, or whether anatomical knowledge was gained by dissection, is not known for certain. The authority with which bone, muscle and fat were modelled, however, certainly suggests an intimate knowledge of the underlying structures of the body, just as the stance and the suggestion of movement indicate familiarity with its dynamics.

My enthusiasm for the Greeks' anatomical knowledge does not necessarily imply a preference for their art forms over the simpler and more subjective forms of earlier cultures. The early Egyptians, for instance, may well have known a great deal about the fine detail of the human structure but chose not to use it in the interests of greater simplicity, to clarify the story contained in the work of art. For the true primitive painter, even of today, anatomical knowledge is probably a positive disadvantage. It can stand in the way of a totally direct, childlike and innocent gaze. To all but the most naive painters and draughtsmen of the human figure, however, some knowledge of anatomy is obviously valuable. The artist must take what he needs, even if only to know what to throw away. As will be clear at the end of this book, many great figure painters used their knowledge of anatomical structure simply as a starting point, as a peg on which to hang their fantasies.

In the Hellenistic period (c.330–100 BC), an interest in realism overtook idealization and led to representations of old age, childhood and emotions shown in pose and expression. By the 1st century BC Greek sculptors met the demands of the Romans for copies of earlier famous sculptures for the adornment of their public places. Soon anatomical interest, or perhaps capability, was to decline. Whatever the reason, by the 2nd century AD anatomical knowledge comparable to that of the Greeks of the classical and Hellenistic periods had disappeared.

It was to be over a thousand years before real intensity of vision was brought to bear on the human form again. In the intervening period religious scruples limited artists to relative stylization of the human body,

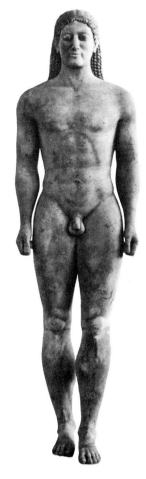

above Statue of a *kouros* from Anavysos, Greece. 540-515 BC. National Museum, Athens.

opposite top King Mycerinus and Queen Chamerernebti. c.2510 BC. Museum of Fine Arts, Boston

below Doryphoros, sculpture by Polykleitos. Roman copy of the 5th-century Greek original. Naples Museum.

opposite bottom Head of Nefertiti; painted limestone and plaster. c.1350 BC. Egyptian Museum, Charlottenburg, Berlin.

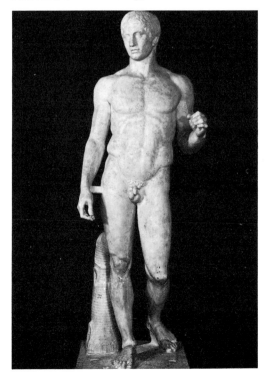

and anatomical studies were frowned upon. A return to a 'scientific' vision of anatomy only began when the artists of the Italian Renaissance attempted to revive the canon of antique nudity. The artist who, above all others, personified the return to objective and intense investigation of human anatomy was Leonardo da Vinci (1452–1519). A number of great Italian artists, such as Masaccio, Pollaiuolo and Botticelli studied the nude figure carefully before Leonardo, but the hundreds of surviving anatomical drawings by him show that Leonardo delved much deeper than any of his

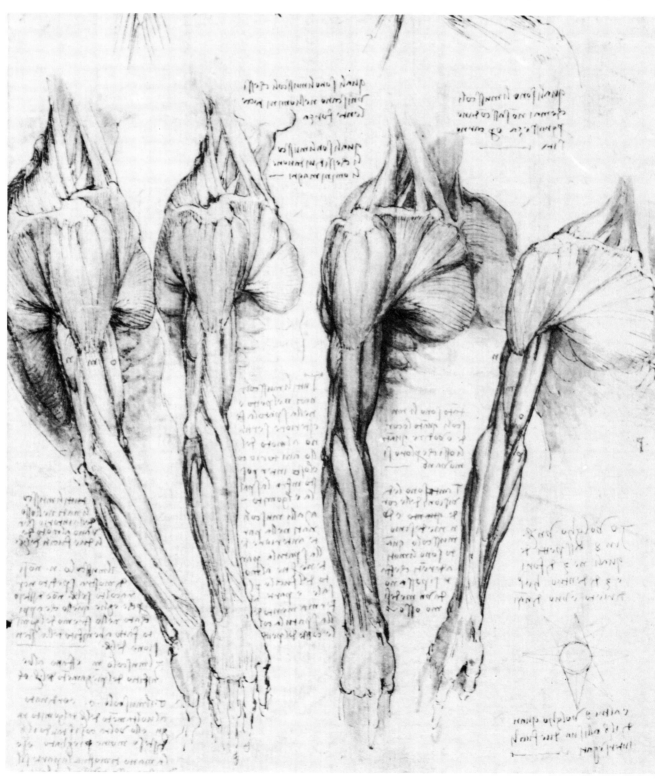

Study of the arm and shoulder muscles. Leonardo da Vinci. Royal Library, Windsor Castle.

predecessors. At the same time Albrecht Dürer was
pursuing his own anatomical studies in Germany, but
the inspiration to do so only came from his visits to
Italy where he saw the work of the new masters of the
human idiom.

In order to acquire any real knowledge of the human
structure, objectivity is essential. We must look without
preconceptions. For the moment we must subdue the
subjective observation which, by unconscious selectivity,
enables us to make quick decisions about other people
and our environment. We must look at the human body
as though we were visitors from outer space who had
never seen a shape like ours before. We must consider
this strange structure literally from the ground up; we
must ask how this collection of props and pulleys,
fluid and tissue manages to stand upright when gravity
is continually trying to pull it over. More miraculous
still, how does it manage to move and co-ordinate?

For Leonardo it was not enough to observe and draw
the model. To answer these questions he had to know
how the mechanism worked. At Windsor Castle there is
a large collection of Leonardo's anatomical drawings,
essentially notes made while dissecting cadavers. Every-
thing was of interest to him; his all-pervading curiosity
led him to research into many diverse directions. He
brought his amazing powers of observation, analysis
and invention to aeronautics, optics, hydro-dynamics,
mechanics, heavy engineering and architecture.

Anatomical study and drawing from the naked form
soon became an accepted and indispensable part of all
Italian Renaissance artists' training. The Florentines'
interest in anatomy, to quote Lord Clark, 'was related
to the idea of energy, by making our awareness of bodily
movement more vivid and precise. But in addition to
this quality of life-enhancement there is no doubt that
the Florentines valued a demonstration of anatomical
knowledge simply because it *was* knowledge and as such
of a higher order than ordinary perception.'

Whereas human anatomy was only one of Leonardo's
wide range of interests, there was another Florentine
artist 25 years his junior passionately consumed by
the study of the human figure almost to the exclusion of
all else. His name was Michelangelo Buonarroti.

Michelangelo, like Leonardo, was a man of many
parts – sculptor, painter, poet and architect – but he
made the human body his primary vehicle of expression.
He believed in the god-like character of the male nude
and contrived to express emotions, ideas, and even
spiritual concepts through limbs and torsos flowing
with vitality and sensuality. There is no doubt that he
understood anatomy as well as Leonardo did; he drew
from the nude model and there is a little evidence that
he, too, dissected cadavers.

Pen and ink studies of sections of a skull.
Leonardo da Vinci. Royal Library, Windsor
Castle.

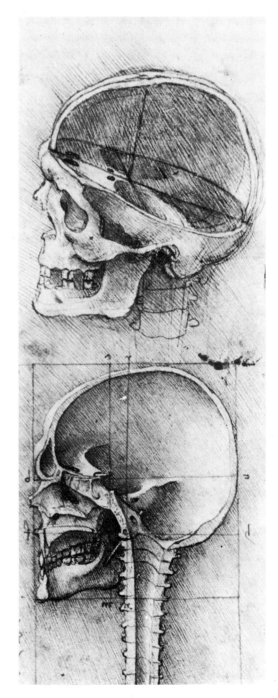

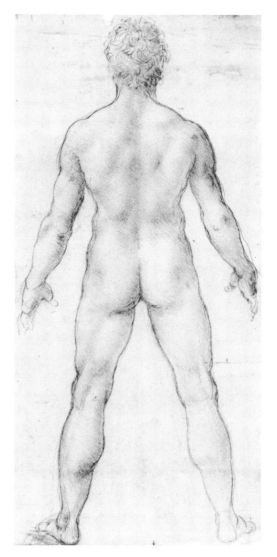

above Figure of a man. Leonardo da Vinci. Royal Library, Windsor Castle.

opposite Tomb of Giuliano de' Medici, with the figure of Night on the left. 1522-34. Medici Chapel, Florence.

For Michelangelo the objective reality of the skeletal and muscular form of man was just a starting point. He used his mastery of anatomy to produce larger-than-life figures, with huge limbs and torsos resembling landscapes. His figures have their own anatomy, based on reality, but transformed into a new, heroically grand and gigantic reality; although they sometimes involve anatomical impossibilities, they have a structural completeness which convinces and makes the impossible believable. For example, the figure of *Night* from the tomb of Giuliano de' Medici reproduced here is anatomically extraordinary. The torso is impossibly long and the length and shape of her calf relative to her thigh seems highly questionable. Michelangelo's female figures were always adaptations of the male model, (for he considered the female body inferior to that of the male), so it is not surprising that this figure is so noticeably unfeminine in its muscularity and absence of smooth areas of fat. It is nevertheless hard to understand why he has reduced the breasts, in Lord Clark's words, 'to humiliating appendages'. However, the companion figure, *Day*, is so powerful and majestic that *Night* seems feminine by comparison, and the whole group has a unity and rightness which is entirely convincing.

The masculinity of Michelangelo's male figures has been attributed to his hatred of womankind and to his erotic love of young men, but strangely many of his male figures seem hermaphroditic. Nearly all the figures in the Sistine Chapel frescoes are male, but many are endowed with facial features and poses more typical of a female than a male. Perhaps the whole point is that he was not drawing real people with individual personalities; Michelangelo's forms were on a grander scale, representing the universal life and death struggle of both man *and* womankind.

In this potted history of art and anatomy, a glaring omission of any art outside the western tradition may be felt. Partly because the Indians, for instance, were more concerned with religious and erotic symbolism than in anatomical accuracy, and because it never occurred to the Chinese or Japanese to be interested in the human form for its own sake, no other culture developed an interest in art and anatomy equal to that of the Greeks or the Renaissance painters. By Michelangelo's day objectivity had discovered all that could be known of the shape of the human figure; and this information provided the data on which subjectivity could take flight. The new subjectivity was to take many diverse forms, some of which are illustrated and discussed in the last part of this book; but let us first try to catch up with Leonardo and discover the objective reality of human anatomy.

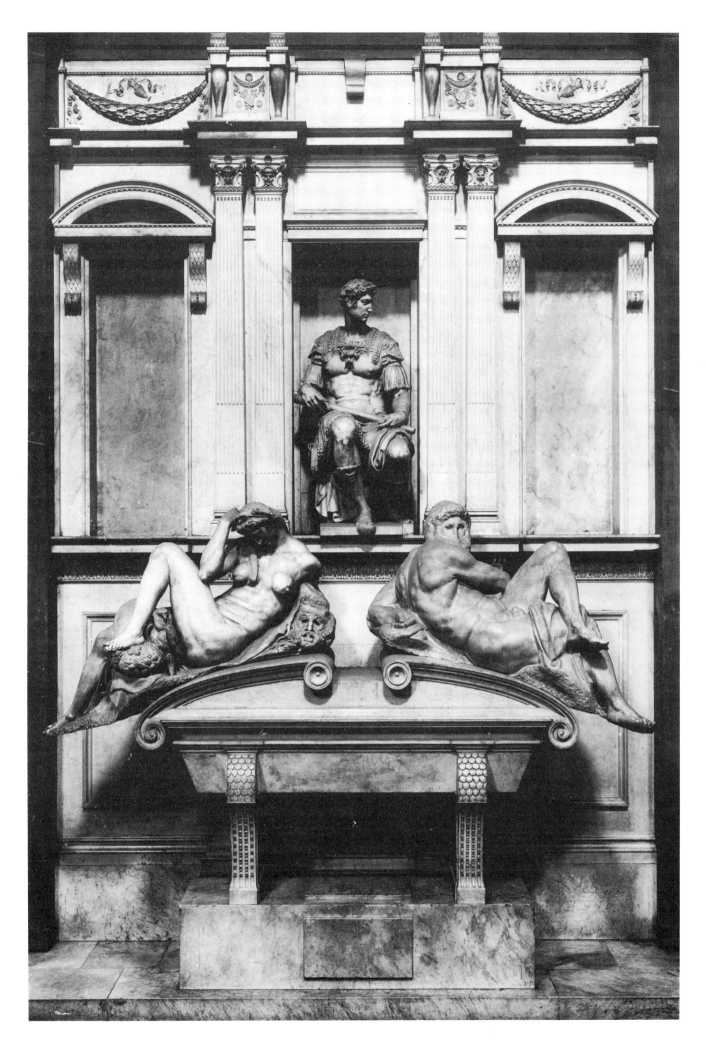

The Skeleton

An understanding of human anatomy must begin with the skeleton. The whole structure comprises 179 main bones, all splendidly specialized for their purpose and combining together to form a very strong but light framework.

All drawings of the skeleton are, in a sense, an invention. The vertebrate skeleton falls apart when robbed of muscle, tendon and cartilage. The skeletal drawings here are therefore from real skeletons or plastic replicas threaded together with copper wire, bolts and wing nuts and variously contrived hinges. Great ingenuity in this assembly has simulated most of the freedom and restriction of actual human movement, but, perforce, articulation cannot be fully or precisely represented.

The drawings on this page show frontal views of complete male and female adult skeletons.

The most important support structure in the body is the spine or *vertebral column*, the lower end of which is virtually one piece with the pelvis or hip bone. In fact three separate bones make up the pelvis, but they are bound together so securely that, although some movement is possible, for practical drawing purposes they can be considered as a single rigid structure. A complicated and strong system of musculature rather like the rigging of a ship, maintains the curved but basically upright stance of the vertebral column, and the strong links between this flexible mast and the stable deck of the pelvis support the rest of the structure so fundamentally that they nearly always provide the key to analyzing the essence of any pose.

The *femurs* or thigh bones, very strong bones with extensive surfaces to which the large buttock and thigh muscles are attached, are located by their domed upper ends into hemispherical sockets in the pelvis. Two long bones make up the lower leg, the *tibia* or shin bone and the *fibula*; their upper ends combine with the *patella* or kneecap to form a compound joint with essential movement in only one plane. Their lower ends are recognizable as the protuberances normally known as the ankle, and they form a joint with the true ankle bones of the foot, the *tarsal* bones, the longest of which is the heel bone or *calcaneus*. Together with the long foot bones, or *metatarsus*, they form a strong arch capable of supporting great weight. The toe bones are named collectively the *phalanges*.

Attached to the vertebral column and supported by its upper sections, there is a cage composed of thin curved bones – the ribs. This system actually does perform the function of a protective cage around vital organs such as the heart, but it is primarily a kind of bellows alternately compressing and expanding the lungs for inhalation and exhalation. A third function of the rib cage is to support the shoulder girdle and arms.

1 *Cranium*
2 *Mandible*
3 *Clavicle*
4 *Sternum*
5 *Humerus*
6 *Rib cage*
7 *Vertebral column (24 bones)*
8 *Pelvis*
9 *Radius*
10 *Ulna*
11 *Carpus (8 bones)*
12 *Metacarpus (5 bones)*
13 *Phalanges–hand (14 bones)*
14 *Femur*
15 *Patella*
16 *Tibia*
17 *Fibula*
18 *Tarsus (7 bones)*
19 *Metatarsus (5 bones)*
20 *Phalanges–foot (14 bones)*

Frontal view

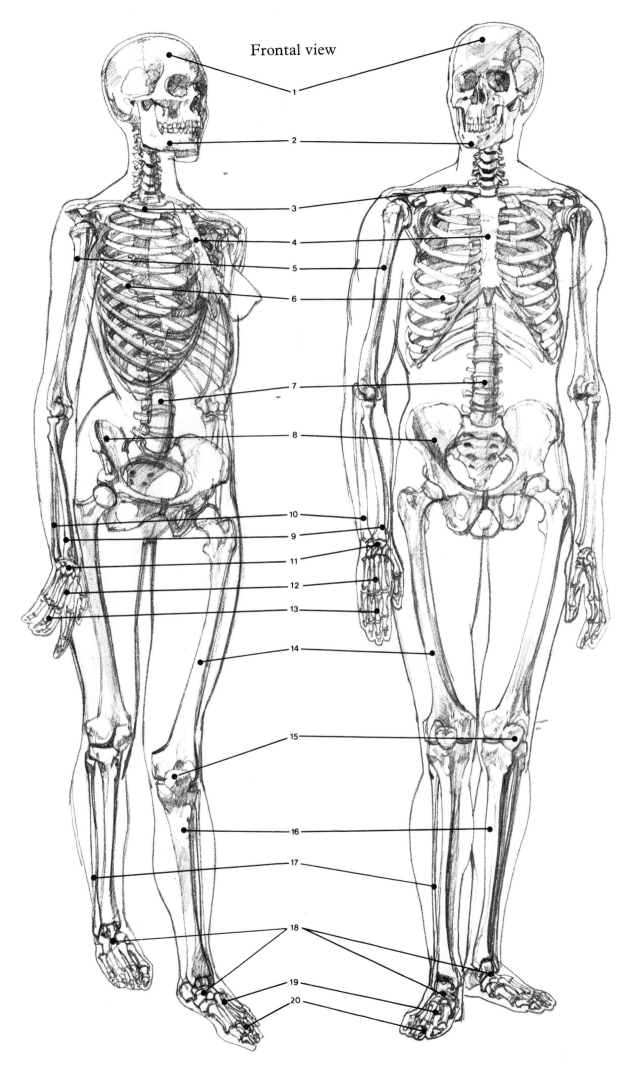

1
2
3
4
5
6
7
8
10
9
11
12
13
14
15
16
17
18
19
20

A complex system of mainly flat muscles interlace the rib cage or *thorax* and complete the frontal links with the pelvis to make a strong flexible whole, the trunk. The relative positions of the pelvis and thorax, the consequent variation in shape of the thorax and the linking curve of the vertebral column, together constitute a vital relationship which the artist must analyze with precision.

Resting on the upper back of the thorax and on either side of the vertebral column are two flattish triangular bones: the shoulder blades or *scapulae*. Approximately in line with the tops of the scapulae but on the front of the rib cage are the collar bones or *clavicles* which join the breast bone (*sternum*) to extensions of the outer corners of the scapulae; this system makes up the shoulder girdles. The domed end of the upper arm bone or humerus is inserted into the loosely formed cavity under this girdle to form a joint similar to the ball-and-socket of the hip but even more mobile. The elbow joint between the lower end of the humerus and the two bones of the lower arm (the *ulna* and the *radius*) resembles the knee joint. Eight small, irregularly shaped bones called the *carpals* form the wrist, the five hand bones are known as the *metacarpals* and the finger and thumb bones, the *phalanges*.

At the top end of the vertebral column are two very complicated and specialized vertebrae, the *axis* and the *atlas*. Their special function is to provide movement and support for the skull. A skull is for the most part an ovoid boney protection for the brain. At the front there are eye sockets, a nasal opening and the upper jaw containing teeth. The lower jaw or *mandible* is a separate bone, in which the lower teeth are set. It hinges on processes at the side of the skull, or *cranium*, to open and close the mouth.

This is a very simple description of the human skeleton and may seem to contain some self-evident statements. However, it is useful to establish an impression of the basic functions of the complete system. It is all too easy to see the skeleton as a slightly ghoulish collection of indeterminately shaped remains – only a slight change of approach is needed to reveal the beauty of the highly efficient supports, levers, bearings and enclosures, all perfectly shaped for their individual functions and combining together with marvellous precision.

In order to speak of the skeleton in more detail, it is necessary to define some terms normally used in anatomical description. *Anterior* means near to the front of the body, *posterior* near to the back. Bones which fit together at a joint are said to *articulate* with each other at that point and the parts of the bones which meet in the joint are called their *articular surfaces* or *facets*.

1 *Cranium*
2 *Mandible*
3 *Clavicle*
5 *Humerus*
6 *Rib cage*
7 *Vertebral column (24 bones)*
8 *Pelvis*
9 *Radius*
10 *Ulna*
11 *Carpus (8 bones)*
12 *Metacarpus (5 bones)*
13 *Phalanges–hand (14 bones)*
14 *Femur*
16 *Tibia*
17 *Fibula*
18 *Tarsus (7 bones)*
19 *Metatarsus (5 bones)*
20 *Phalanges–foot (14 bones)*
21 *Scapula*

Rear view

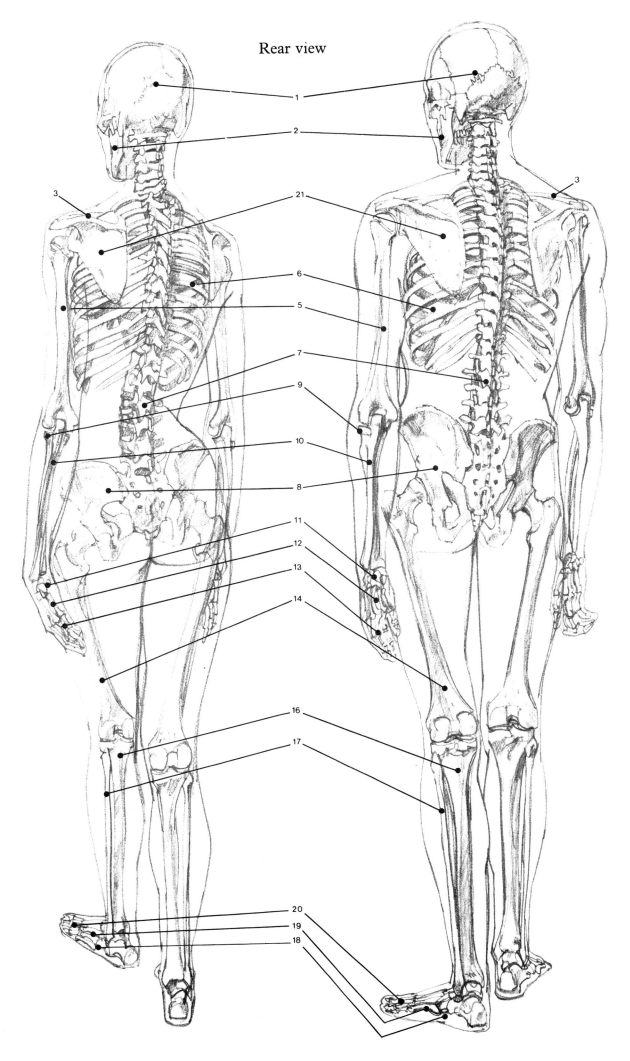

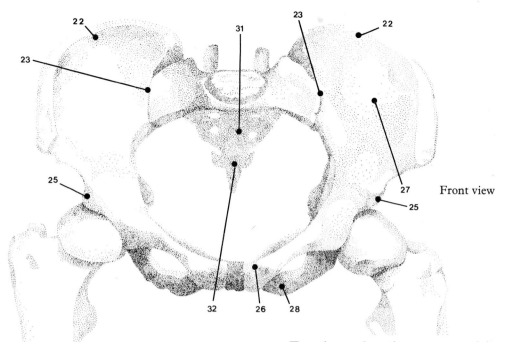

Front view

22 *Iliac crest*
23 *Sacro-iliac joint*
24 *Anterior superior iliac spine*
25 *Anterior inferior iliac spine*
26 *Pubic arch*
27 *Ilium*
28 *Ramus of ischium*
29 *Ischium*
30 *Posterior superior iliac spine*
31 *Sacrum*
32 *Coccyx*
33 *5th lumbar vertebra*
56 *Acetabulum*

For the artist, the exact position of the pelvis relative to the rest of the skeleton and to the ground plane is almost always the key to the correct analysis of a pose.

In both sexes the pelvis is a strong, rigid support structure made up of the two hip bones, called the *innominate bones*, and the *sacrum*. Each innominate bone is a combination of three bones joined by cartilage in the young, but fused together in the adult. The upper part is called the *ilium*, the upper edge of which is the *iliac crest*, the most obvious and easily identified feature of the pelvis in the live figure.

The pubis forms the anterior part of each innominate bone. These are joined together by cartilage at the pubic symphysis, to form the pubic crest. The crest and its lateral extensions, to which the muscles and fascia of the abdominal wall are attached along the upper edge, form the lower boundary of the trunk, which is clearly visible in life. The *ischium* is the lower, posterior part of the innominate bone and forms most of the inverted arch created by the combined rami of the ischium and

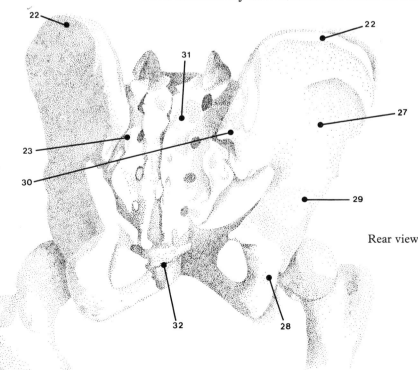

Rear view

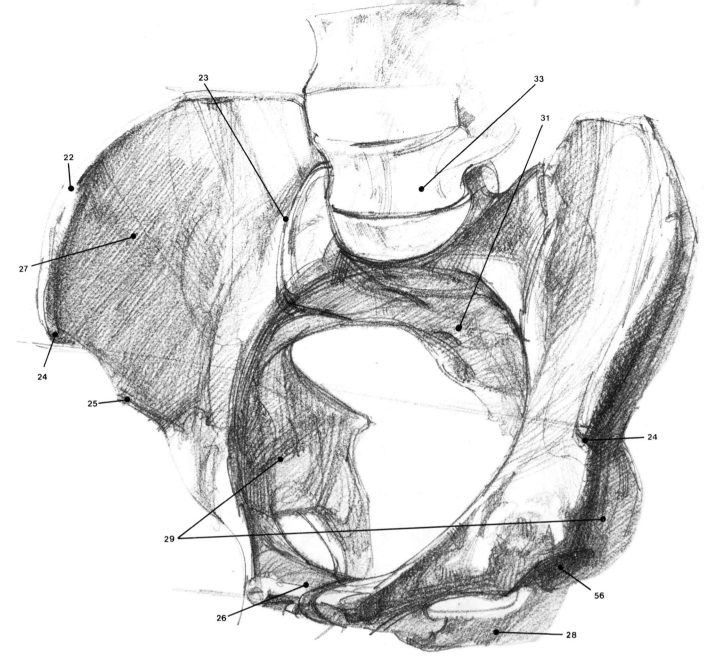

pubis. The ischium is never near to the surface in life, but it provides attachment for a number of the powerful muscles of the thigh, and the two ischial tuberosities also provide a firm base for the sitting figure.

All three parts of the hip bone come together at a triple junction which, on the lateral (external) side forms the socket, the *acetabulum*, for the head of the femur. The triangular wedge of the sacrum joins the two innominate bones posteriorly. Its shape is visible in life chiefly by reference to the prominences of the posterior superior iliac spines. The sacrum is described more fully on page 40.

Most of the obvious differences in male and female skeletons are to be found in the pelvis. In view of the heavier weight and musculature in the male, the male pelvis is generally more massive and rugged than the female. To facilitate childbirth the female pelvis is wider, more open and less deep, and it normally adopts a more forward-tilted attitude so that the upper surface of the sacrum is more nearly horizontal.

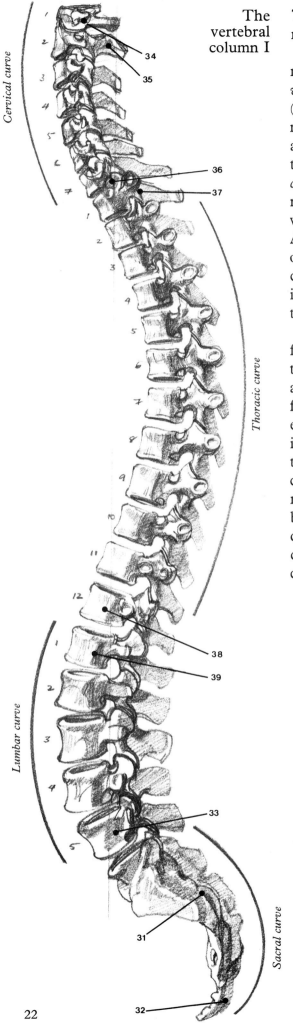

Cervical curve

Thoracic curve

Lumbar curve

Sacral curve

34
35
36
37
38
39
33
31
32

The
vertebral
column I

The pelvis is rigid in itself, but it acquires considerable mobility from the movement of the spine.

The spine or vertebral column is the key to human mobility. It is composed of 24 individual bones, the *vertebrae*, linked together into a column about 60–70 cm (24–28 in) long. Each vertebra is separated from the next by a fibro-cartilage disc, which cushions shocks and allows tilting and torsion between adjoining vertebral bodies. At the top, or neck end, there are seven *cervical vertebrae*; the next twelve vertebrae support the ribs and are called *thoracic vertebrae*, and the last five, which link to the pelvis, are the *lumbar vertebrae*. Although the sacrum has been considered here as part of the pelvis, it is really a continuation of the vertebral column, in that it is five vertebrae fused together and includes another four or five small fused vertebrae in the *coccyx*, the residual tail.

In normal upright posture, the vertebral column has four curves: the cervical curve is convex forwards, the thoracic concave, the lumbar convex forwards again and the sacro-coccygeal concave downwards and forwards. These curves help to cushion shocks and enable the column to bear vertical pressure better. The intervertebral discs are elastic and compressible, and therefore augment the cushioning action of the vertebral curves in taking up and neutralizing the shocks of muscle pull and weight thrust, which may be imparted by violent activity such as running and jumping. The degrees of curvature vary from race to race and individual to individual, and change with age; they must be carefully observed as the spine posture is fundamental

to the analysis of a standing figure.

The cervical curvature begins at the atlas, continues until the second thoracic vertebra and then begins to change into the contrary curve of the thoracic. It is the least extreme of the four curves and when the head is bent forwards it may become a concave forwards curve. The forward concave curvature of the thoracic is most extreme at the sixth thoracic vertebra and merges into the lumbar curve at the twelfth. Its curvature is caused by the fact that each vertebral body is slightly wedge-shaped – the posterior parts of the vertebral bodies are deeper than the anterior. The lumbar curve, on the other hand, is mainly caused by the slight wedge-shape of the discs rather than of the vertebral bodies. Lumbar curvature is more pronounced in the female than the male, but lessens with age in both sexes.

The amount of movement between one vertebra and the next is in fact rather small, but when added together throughout the column the degree of flexibility is considerable, allowing *flexion* (forward bending), *extension* (backward bending), bending to one or other side and rotation or twisting. Most of the flexion and extension movement occurs in the cervical and lumbar regions, least in the thoracic; sideways bending can take place in any part of the column but also is most free in the cervical and lumbar areas. Rotation too is slight between individual vertebrae, but over the whole column the degree of twist is considerable, although it is least in the lumbar region. In any one action of the body the vertebral column may exhibit combinations of all these movements.

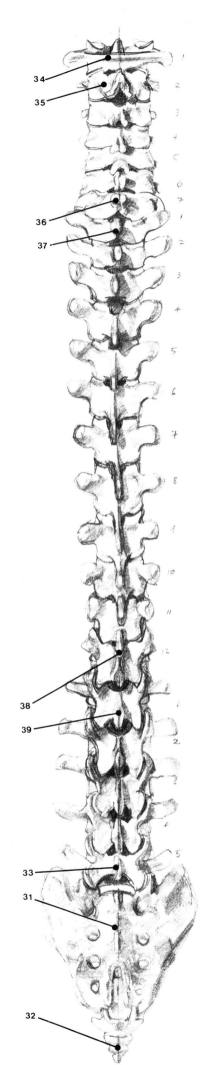

31 *Sacrum*
32 *Coccyx*
33 *5th lumbar vertebra*
34 *Atlas*
35 *Axis*
36 *7th cervical vertebra*
37 *1st thoracic vertebra*
38 *12th thoracic vertebra*
39 *1st lumbar vertebra*
Note: slight lateral curvature in the thoracic region; directed towards left in left-handed people, to the opposite side in the right-handed.

Each of the separate vertebrae is in itself quite a complex and precise structure. In most vertebrae there is a more or less cylindrical part called the *body* of the vertebra, the flat surfaces of which are joined to the next by the intervertebral discs. Most of the weight supported by the vertebral column in the normal upright posture is transmitted through the bodies of the vertebrae. However, the articular processes of the vertebrae are also in contact and contribute to the weight-taking and the general strength of the complete column, especially in flexion and extension. These surfaces are lever-like processes which extend from an arch on the posterior or dorsal side of the body. The arch encloses a space known as the *vertebral foramen*, and protects the spinal cord which occupies it.

Lumbar vertebra

Sacral curve

Lumbar curve

There are seven processes projecting from the vertebral arch, four of which articulate with the neighbouring vertebra, two with the one above and two below. The others are one spinous and two transverse processes, which function as levers, since muscles for extension and rotation of the vertebral column are attached to them.

Thoracic curve

Cervical curve

34

35

21

Typically, the seven cervical vertebrae have comparatively small broad bodies and large foramens. The articular processes combine together on each side to form articular pillars; the spinal process is sometimes double-ended, and the transverse processes are perforated by foramina. As a group, these cervical vertebrae constitute the neck of the human skeleton; they interlock closely to form a relatively smooth and neat profile.

Only the top cervical vertebra, the *atlas*, noticeably stands out from its fellows, not least because it lacks a body. It supports the head (hence its name) and is able to pivot freely on a vertical projection from the front of the *axis*, or second cervical vertebra. The transverse processes are larger than those of the other cervicals and there is virtually no spinous process, just a posterior tubercle which gives the atlas a rather ring-like form. Movement, especially rotation of the skull, is facilitated by long and slightly convex articular facets, which slide on the corresponding facets of the axis beneath.

As mentioned above, the axis has, jutting vertically from its body, a strong peg-like process on which the atlas and the head rotate. Otherwise, for the purposes of this study it appears essentially as a typical neck vertebra.

 2 *Mandible*
 3 *Clavicle*
14 *Femur*
16 *Tibia*
21 *Scapula*
22 *Iliac crest*
31 *Sacrum*
40 *Spinous process*
41 *Lamina*
42 *Transverse process*
43 *Pedicle*
45 *Superior articular process*
46 *Inferior articular process*
47 *Body of vertebra*
48 *Foramen transversarium*
49 *Dens*
50 *Groove for vertebral artery*
51 *Anterior arch*
52 *Facet for dens*

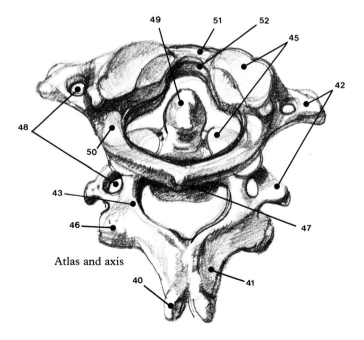

Atlas and axis

21

36

37

2

3

21

31

22

15

14

16

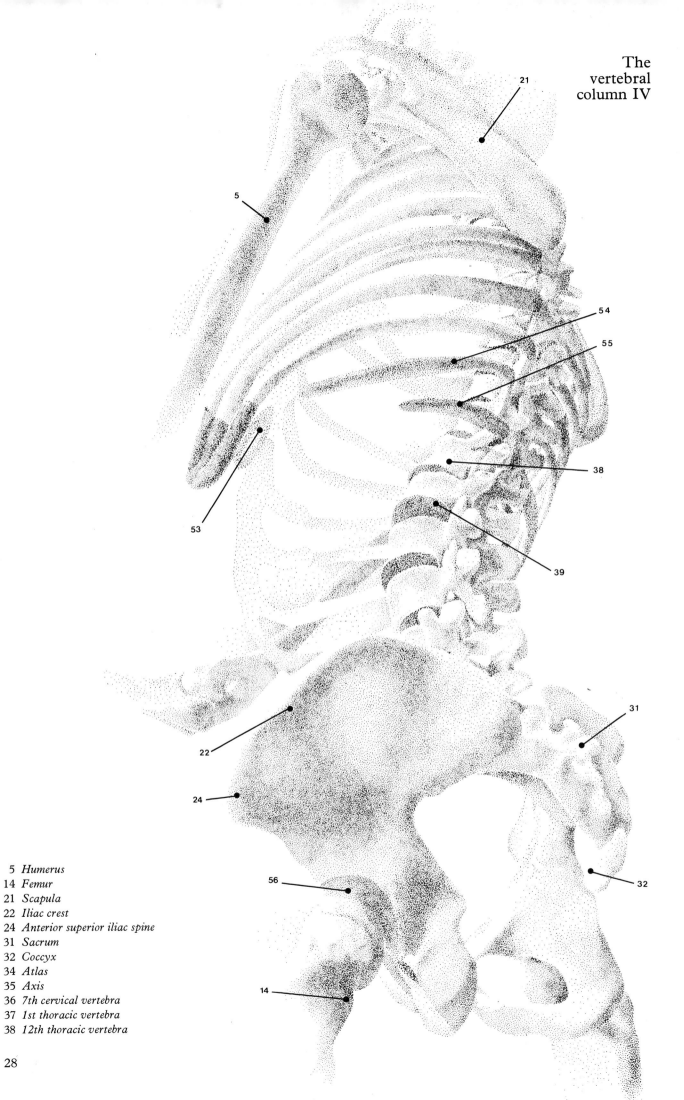

The
vertebral
column IV

5

21

54

55

38

39

53

31

22

24

32

56

14

5 *Humerus*
14 *Femur*
21 *Scapula*
22 *Iliac crest*
24 *Anterior superior iliac spine*
31 *Sacrum*
32 *Coccyx*
34 *Atlas*
35 *Axis*
36 *7th cervical vertebra*
37 *1st thoracic vertebra*
38 *12th thoracic vertebra*

Only at the seventh cervical vertebra is there any further deviation from the relatively smooth column; this vertebra has a much longer spinous process. This is especially important as it is nearly always visible through the skin in the living subject; for this reason the seventh cervical is sometimes called the *vertebra prominens*. A number of important muscles are attached near the tip of this spine, including those responsible for extension of the neck and head, and the deep muscles of the upper back.

Thoracic vertebrae have costal facets on the sides of their bodies and, but for the last two or three vertebrae, on the transverse processes. These provide for articulation with the tubercles and heads of each pair of ribs, in a manner that will be described later. A general increase in size is apparent down the column, especially in the thoracic vertebrae, the last or twelfth of which is almost of the lumbar type in its solidity and bulk. All the thoracic vertebrae have closely interlocking articular spines, very prominent transverse processes and even more prominent and downward-slanting spinal processes.

Lumbar vertebrae, five in number and the last of the separate vertebrae, are very large and strong. They play a vital role as support structures for the whole upper skeleton. The body of a lumbar vertebra is wider from side to side than back to front, and a little deeper in the front than the back. The spinous process is almost horizontal, square-ended and thicker at its edges, which are roughened for muscle attachment. All but the fifth have relatively thin, long transverse processes, the fifth's being much more massive and emanating partially from the vertebral body itself rather than from the vertebral arch.

39 *1st lumbar vertebra*
40 *Spinous process*
42 *Transverse process*
45 *Superior articular process*
46 *Inferior articular process*
47 *Body of vertebra*
48 *Foramen transversarium*
49 *Dens*
53 *Xiphoid process*
54 *11th rib*
55 *12th rib*
56 *Acetabulum*
57 *1st rib*
58 *2nd rib*
59 *Vertebral foramen*

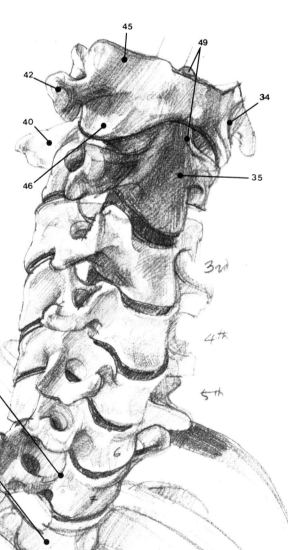

2nd cervical vertebra

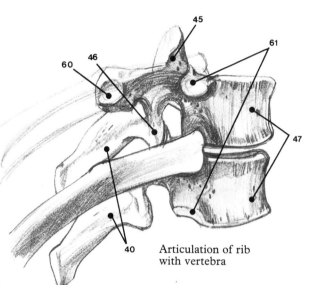

Articulation of rib
with vertebra

Suspended from the thoracic vertebrae are twelve pairs of elastic arches of bone forming the greater part of the *thorax* or rib cage. The first seven pairs are connected by lengths of cartilage (shown darker in the skeletal drawings) to the *sternum*. Of the remaining five pairs of ribs, three – the eighth, ninth and tenth – are joined to the cartilage of the rib immediately above, and the last two pairs are free at the anterior ends. These three types of ribs are described as true, false and floating ribs respectively.

From the vertebral column, each rib curves backwards before swinging round and downwards to the front (anterior) surface where it meets the sternum. Consequently a cross-section of the thorax is kidney-shaped, and the back (posterior) surface has two wide and deep grooves running alongside the spinous processes of the thoracic vertebrae. Occasionally an extra pair of ribs may develop on the seventh cervical or the first lumbar vertebra, or there may be only eleven ribs, owing to the absence of the lower pair of floating ribs.

Each rib has a shaft, a posterior and an anterior end. The shaft is flat, curved and slightly twisted in such a way as to follow the curves of the complete thorax and make up a smoothly contoured surface. The posterior end, which articulates with the thoracic vertebrae, has a head, a neck and a tubercle. The head has two facets, the lower, larger one for articulation with the appropriate thoracic vertebral body and the upper, smaller one for the body of the vertebra above. Between the two facets is a ridge, called the *crest*, which attaches to the disc between the two vertebrae. The tubercle has a facet which articulates with the transverse process of the numerically corresponding vertebra. In total, for a typical rib, there are thus four points of contact with the vertebral column. Only the last three ribs are exceptions, in that the tenth has only one articular head facet, and the floating ribs only one facet and no tubercle.

The small upper opening of the thorax, known as the *inlet*, slopes downwards and forwards; the lower opening or *outlet* is bounded at the sides by the twelfth ribs and in front by the cartilages of the tenth, ninth, eighth and seventh ribs. As these ribs ascend from each side to the lower end of the sternum they form an angle, called the *infrasternal angle*. There is great variety of size and shape of thorax depending on sex, race, age and individual build. Thin people usually have a long narrow thorax, whereas stocky figures have a broad, short one. In females the thorax is generally smaller, actually and proportionately to the rest of the body, and the slope of the inlet is greater.

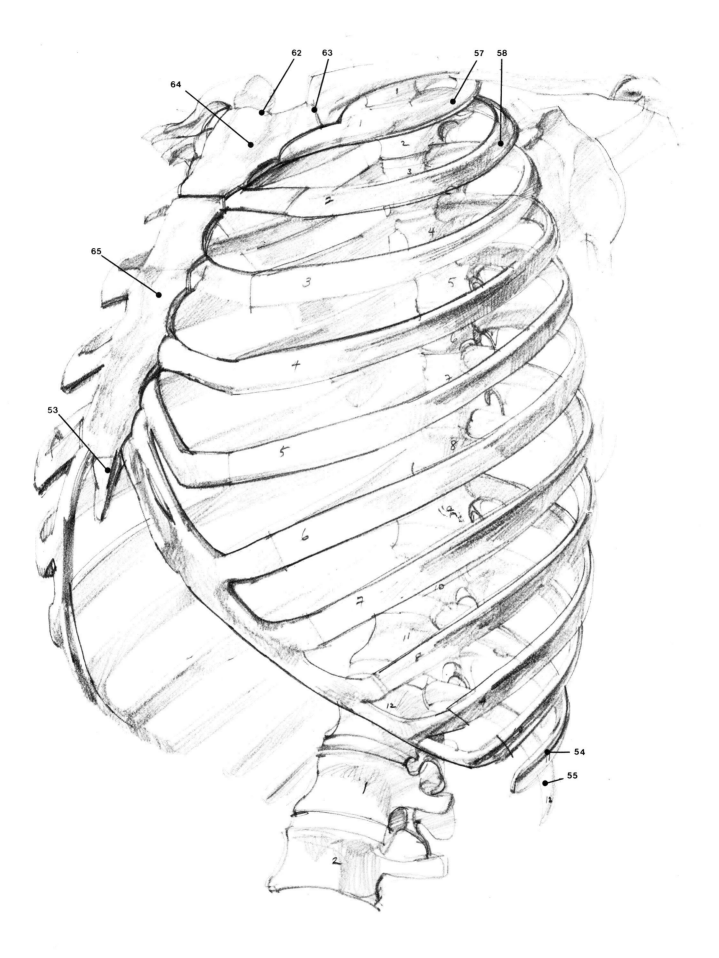

For the figure artist the capabilities and limitations of movement in the spinal column are of paramount importance. Skeletons for demonstration, whether real or manufactured, are always made up so that the shoulder, elbow, wrist, hip, knee and ankle joints approach as nearly as possible the articulation they enjoy in life, but the vertebral column is normally threaded on to a rigid rod, curved to simulate the upright, symmetrical posture.

In life such a position is rarely maintained; weight transferences from leg to leg are continual in walking and running. Even when standing, most people take their weight more on one leg than the other, shift from one foot to the other and transfer weight from the heel to the ball of the foot as the muscles involved begin to tire. Every action of the head, arms or legs affects the curvature of the spine to a lesser or greater degree.

For this reason the restraining rod was removed from the vertebral column of the skeleton used as reference for the illustrations on pages 33–41, and was replaced with a flexible cable, in order to simulate the movements possible in life. There is a risk of inaccuracy in such a procedure, for the absence of the restraining ligaments means that the only restriction to movement is the natural shape of the bodies of the vertebrae and their articular processes, and, in the thoracic region, the limitations of thorax flexibility.

The ligaments that hold the vertebrae securely together possess a varying but relatively small degree of elasticity, greater in the young than in the old. The intervertebral discs, too, can only be deformed to a limited extent, although the thickest ones, in the lumbar and cervical areas, can be squashed rather more than the thinner thoracic discs. When the vertebral column is bent back in extension, the anterior longitudinal ligament is stretched and the vertebrae tend to pivot over their articular processes. The possible movement, which is greatest in the lumbar and cervical regions, is limited by the tension of the anterior longitudinal ligament and the proximity of the spinous processes. In the lumbar region of the young the movement can be extreme and the spine very supple.

Flexion or forward bending is not as free as extension, since the posterior longitudinal ligament, the *ligamenta flava*, interspinous and supraspinous ligaments all limit the amount of movement. As in extension, the thoracic area has least flexibility, so that interference with breathing is kept to a minimum. Flexion is freest in the cervical vertebrae, although Gray's *Anatomy* insists that 'Flexion is arrested just beyond the point where the cervical convexity is straightened: the movement is checked by the apposition of the projecting lower lips of the bodies of the subjacent vertebrae.' Maybe the

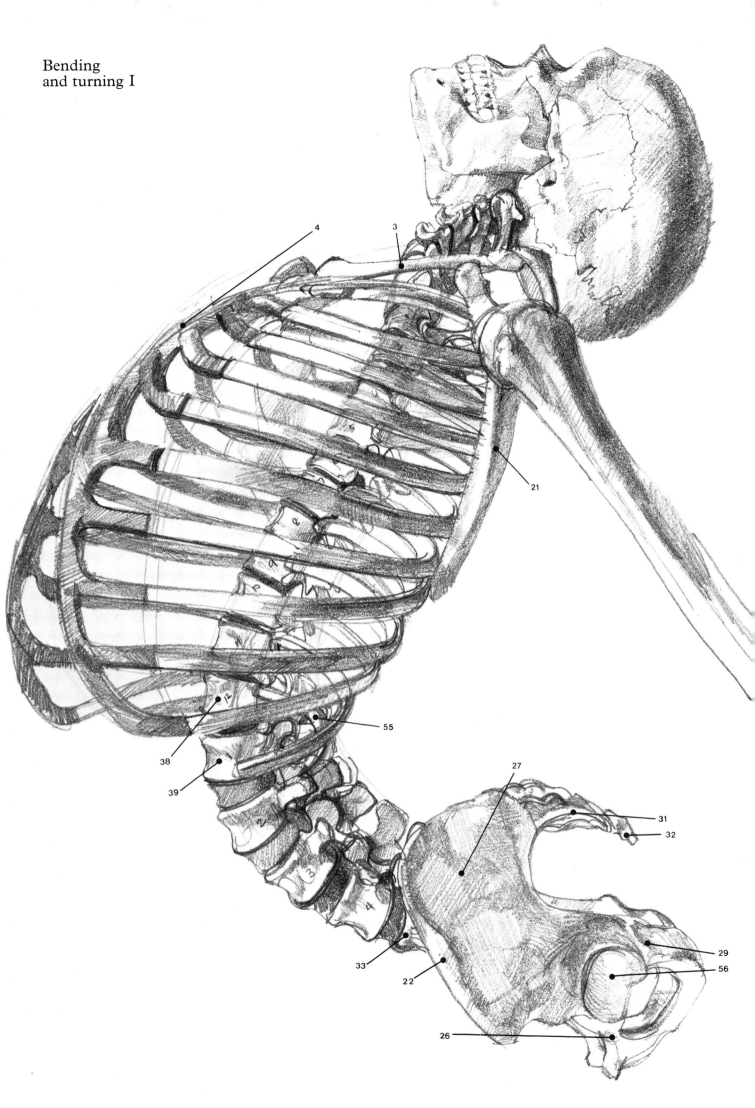

degree of flexion shown in these drawings then is a little excessive, but great individual variation does exist; the lumbar region of a trained acrobat, for instance, can be extremely extended.

Lateral flexion, bending to one side or the other, is accompanied by some rotation of the vertebrae on each other, especially in the neck. This is caused by the relative angles of the articular processes. In life this may not be obvious, for the head can be counter-rotated on the axis to compensate exactly, but if the head is allowed to fall freely to the side from the upright, face-forward position, it will tend to turn towards that side too.

In the thoracic area lateral flexion crowds the ribs together on one side and spreads them on the other, thus limiting movement. Nevertheless, this plane of movement is the freest in the thoracic area, since the vertical disposition of the articular processes hinders forward and backward bending. Again, the lumbar region has a considerable range of lateral bend, widely variable according to age and flexibility. Rotation has been mentioned in the context of lateral flexion in the neck; but rotation unaccompanied by extension or forward or lateral flexion is possible between all vertebrae only to a very slight degree. It is only when these slight movements are added together along the whole column that any appreciable degree of twist is achieved. In the living human figure most actions, other than

14 *Femur*
21 *Scapula*
27 *Ilium*
28 *Ramus of ischium*
36 *7th cervical vertebra*
37 *1st thoracic vertebra*
39 *1st lumbar vertebra*
56 *Acetabulum*
66 *Interspinous ligament*
67 *Supraspinous ligament*
68 *Ligamentum flavum*
69 *Posterior longitudinal ligament*
70 *Anterior longitudinal ligament*
71 *4th lumbar vertebra*

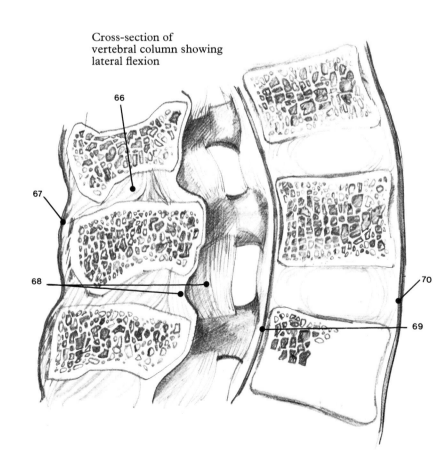

Cross-section of vertebral column showing lateral flexion

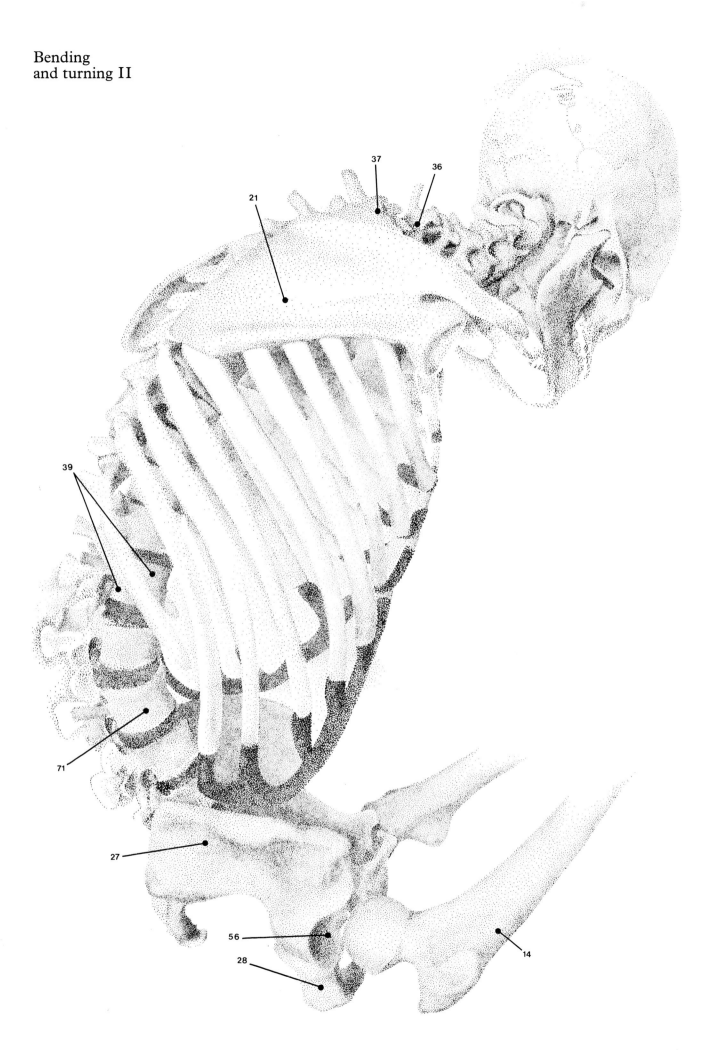

formal exercises, involve the vertebral column in a combination of two or more of the movements discussed.

In the pose on the opposite page, the whole column is showing rotation; from the lower lumbar to the top of the thoracic, rotation appears clockwise from this angle and is accompanied by some lateral flexion in the lumbar area. The cervical region rotates in the other direction and also involves passive lateral flexion. The degree of twist or rotary movement between pelvis and thorax shown here is about as much as most people could normally manage comfortably, although the relaxation of musculature and the relief of pressure on the inter-vertebral discs brought about by the lying position would increase the degree of flexibility in the vertebral column.

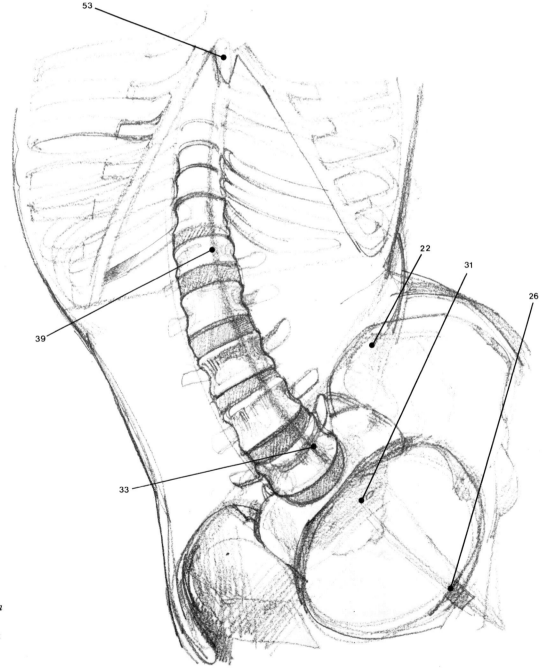

2 *Mandible*
3 *Clavicle*
4 *Sternum*
22 *Iliac crest*
26 *Pubis*
31 *Sacrum*
33 *5th lumbar vertebra*
34 *Atlas*
39 *1st lumbar vertebra*
53 *Xiphoid process*
74 *Greater trochanter*

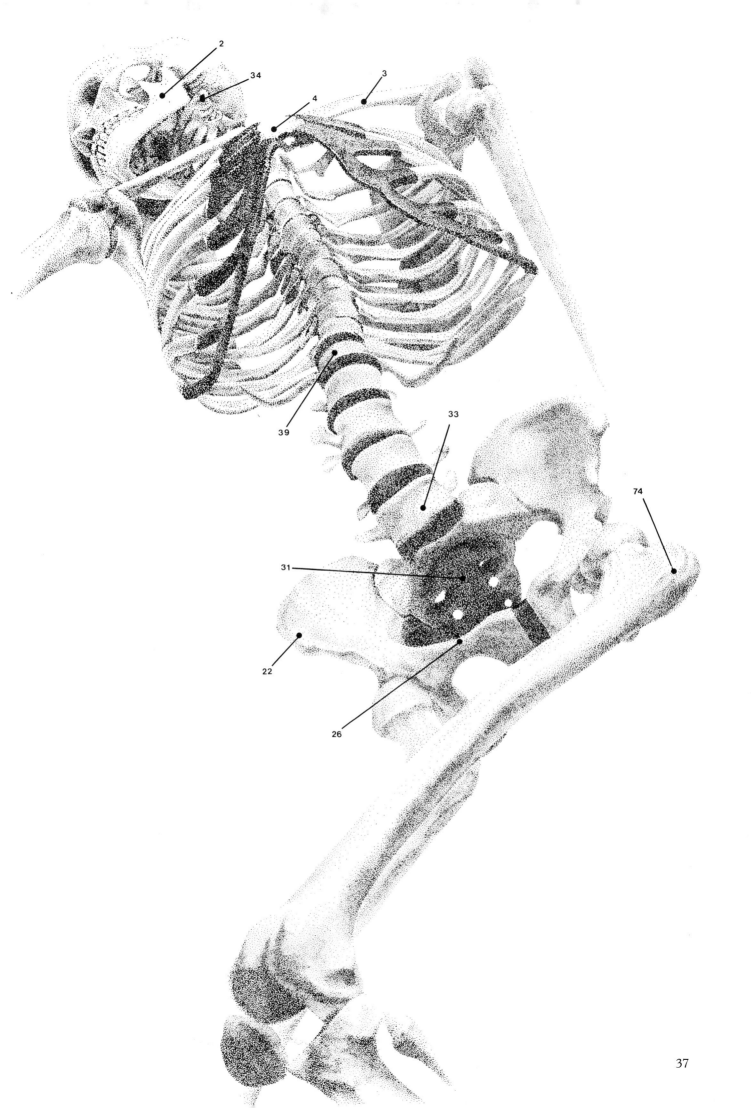

The drawings on this page show the disparity between theoretical range of movement and that possible or reasonable in real life. To achieve the amount of twist in the lumbar region of the skeleton, the model would have to align her left hip bone almost with the centre of the thorax outlet; an extraordinary degree of distortion would have to be accommodated by relaxing the abdominal and lower back musculature and ligaments.

In short, it would be impossible. The limited rotation between each vertebra and the next has been increased and concentrated to an unrealistic degree.

It is worth mentioning that it is possible to bend laterally sufficiently to cause a confluence of the lower edge of the thorax and the iliac crest, and it is more likely that the lower ribs would tuck slightly into the pelvic cavity than the other way round.

3 *Clavicle*
15 *Patella*
22 *Iliac crest*
26 *Pubis*
53 *Xiphoid process*
72 *Greater trochanter*

On the opposite page the vertebral column shows, in an exaggerated form, all the possible directions of movement combining together into a sinuous curve. The lumbar area is extended, laterally flexed and rotated, the thoracic is forward and laterally flexed with slight rotation and the cervical area is forward and laterally flexed and rotated.

In nearly every case of spinal bending and torsion some small movement occurs between the sacrum and the innominate bones at the sacro-iliac joint. Although for the purposes of an anatomy for artists, the sacrum is usually considered to be a firmly fixed part of the rigid structure of the pelvis, this small degree of movement does occur, and greatest change derives from the movement from lying to standing posture. Sacro-iliac movement is small, but the angle of the sacrum relative to the lumbar curve has a great effect on the appearance of the whole pelvic area and indeed on the whole stance of the body, by virtue of the counter-balancing adjustments of the rest of the vertebral column. A brief description of this part of the pelvis as a separate entity is thus appropriate at this stage. In life, however, the pelvic girdle should be observed in its entirety.

The sacrum is a large triangular bone formed by the fusion of five vertebrae, and a cross-section reveals the remains of intervertebral discs and tubercles and residual spinous processes on the upper surface.

The region known as the base of the sacrum is rather confusingly at the top when the pelvis is in the upright position; it makes more sense when one thinks of it as the base of the spine, articulating with and supporting the fifth lumbar vertebra. The articular surface consists of the body, which is larger and wider than those of other vertebrae, and two articular processes. In the erect position the sacrum projects backwards to form an angle with the fifth lumbar vertebra, called the *sacro-vertebral angle*. Its dorsal (back) surface is convex and

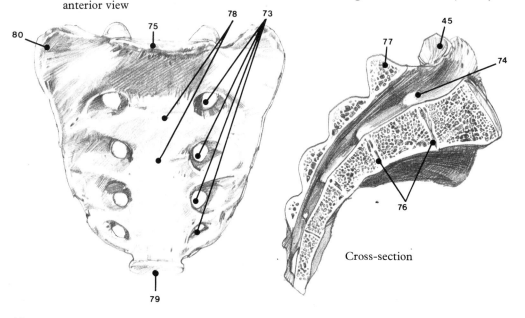

The sacrum—
anterior view

Cross-section

The sacrum

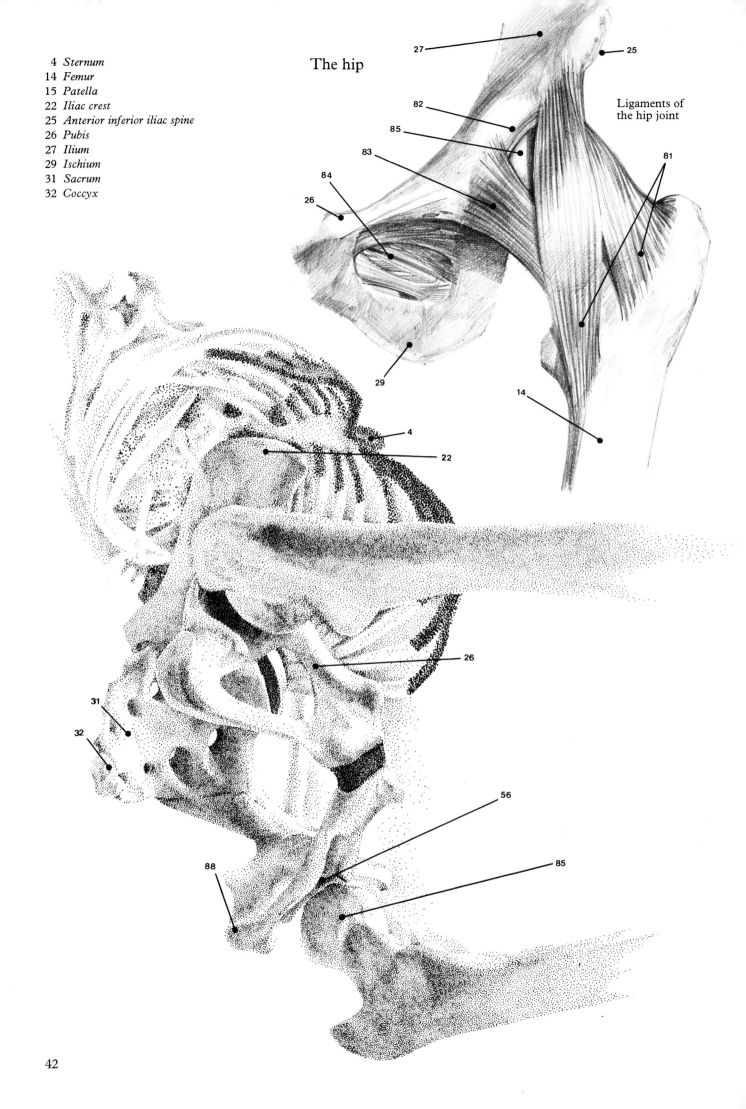

The hip

4 *Sternum*
14 *Femur*
15 *Patella*
22 *Iliac crest*
25 *Anterior inferior iliac spine*
26 *Pubis*
27 *Ilium*
29 *Ischium*
31 *Sacrum*
32 *Coccyx*

Ligaments of
the hip joint

very uneven with spinous and transverse tubercles providing large attachment areas for the strong spinal muscles. The *apex* is at the lower, inferior edge, and articulates with the coccyx, and the whole is held in position like a wedge between the hip bones by a strong web of ligaments (see pages 20 and 90).

Although well covered by ligament and muscular attachments, the triangular area is outlined on the surface of the figure by the two posterior superior iliac spines and the coccyx, and is a useful landmark.

We now come to the connection of the skeleton of the torso with the legs – the hip joint.

This joint is of the ball-and-socket type; the slightly more than hemispherical head of the femur articulates in the cup shape of the *acetabulum*. From a small roughened pit a little below and behind the centre of the head, a ligament connects the head to the interior of the acetabulum, but the strongest connections are secured by a number of ligaments which completely cover the head and most of the neck of the femur. Within this binding of ligaments the femur has a vast range of movement, allowing the thigh to swing forward (flexion of the hip joint), backward (extension), outward (abduction), and inward (adduction). It can also rotate so that the leg faces outward (lateral rotation) and to point knees inward (medial rotation). The first three movements can be of a large degree in the young or very flexible, as is evident when a dancer or a gymnast rotates the trunk through 180° while the legs remain in the 'splits' position. It is also very securely constructed; when a footballer takes a swinging kick at the ball, his whole body rotates about the hip joint of the leg in contact with the ground.

56 *Acetabulum*
72 *Greater trochanter*
81 *Ilio-femoral ligament*
82 *Labrum acetabulare*
83 *Pubo-femoral ligament*
84 *Obturator membrane*
85 *Head of femur*
86 *Lesser trochanter*
87 *Pubic tubercle*
88 *Ischial tuberosity*

The leg I

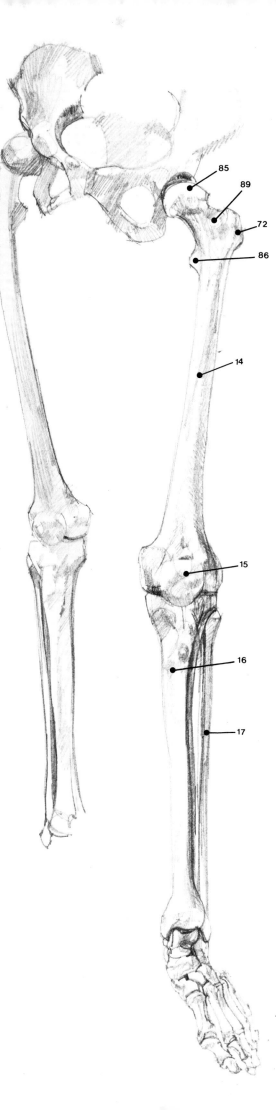

14 *Femur*
15 *Patella*
16 *Tibia*
17 *Fibula*
72 *Greater trochanter*
85 *Head of femur*
86 *Lesser trochanter*
89 *Neck of femur*
90 *Adductor tubercle*
91 *Medial condyle*
92 *Lateral condyle*
93 *Patellar surface*

The *femur* is the longest and heaviest bone in the body, and is a quarter or even a third the length of the total body. The head, which has been described, is separated from the main shaft by about 5 cm (2 in) of neck which is angled at around 125° to the main shaft. At the outside of the shaft, where it joins the neck, there is a large prominence, named the *greater trochanter*; this lies close to the surface and is identifiable in life either as a lump at the widest part of the hips or at least as the point where the plane of the flank changes to that of the thigh. Most of the shaft, covered with tuberosities, grooves and ridges, affords attachment to or is covered by muscles. Although it is deep in the leg, its direction is evident at the surface by the tubular form of the thigh, with its familiar, slightly diagonal appearance from hip to knee, as seen from the front.

The lower end is made up of two large condyles separated posteriorly by a deep division called the *intercondylar notch*. At the anterior (front) side the condyles are joined together and form an articular surface for the *patella* or kneecap. The lower surfaces articulate with the upper end of the tibia. Much of the lower end of the femur and most of the upper end of the tibia is close to the surface in life, and together with the patella gives shape to the outer form of the knee.

The knee is the largest joint in the body and is structurally complicated. Basically it is a hinge, with the convex condyles of the lower end of the femur sliding in the loosely matched hollows of the upper condyles of the tibia. In the fully straightened (extended) position the knee joint 'screws' itself into tight contact, ligaments and muscles reach the limit of their travel and the knee locks securely. This description of the locking mechanism of the knee is over-simplified and rather unenlightening, but the medical descriptions of the action are extremely complicated and the precise role of all factors is still a matter of dispute. From the point of view of the artist complete understanding of the dynamics is not really vital, but there is one modification of the simple hinge concept which is worth taking into account.

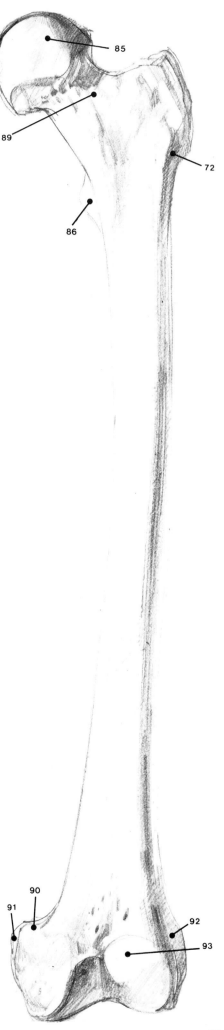

The leg II As the knee joint nears locking point in full extension, the femur has to rotate a little inward (medially) in order to make close contact with the unequally sized 'receiving hollows' of the tibia. Consequently the inner condyle of the femur acquires more prominence from the front view when the knee is locked, and is rather more noticeable from the medial side when the knee is bent back.

An instantly recognizable part of the external form of the knee, especially in the male, is the thinly covered tuberosity of the tibia. The sharp front edge of the triangular section shaft of the tibia is also close to the

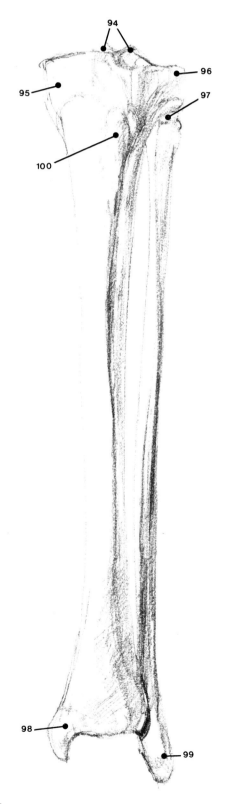

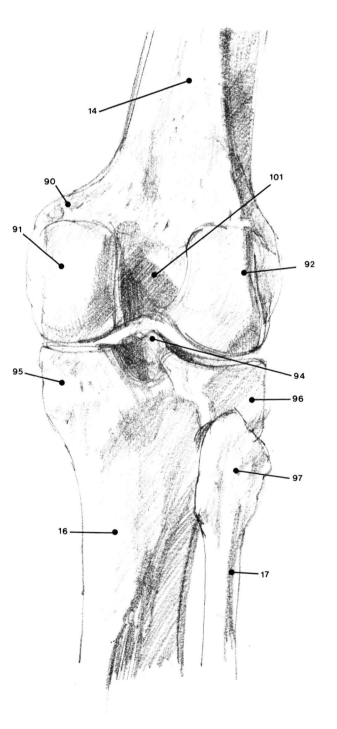

skin in life, and the whole of the medial face of its shaft is free of muscular attachments, and therefore presents another useful fixed line of reference for the artist.

Alongside the tibia on the outside (lateral side) of the leg is the slim bone named the *fibula*. It does not have to share support of the body weight, but functions as a bracing rod for the ankle articulation and also provides attachments for many muscles of extension and flexion. The head of the fibula is enlarged and articulates with the under-side of the lateral condyle of the tibia by means of a small circular facet. It is superficial in life and contributes to the outer form of the knee.

14 *Femur*
15 *Patella*
16 *Tibia*
17 *Fibula*
90 *Adductor tubercle*
91 *Medial condyle – femur*
92 *Lateral condyle – femur*
94 *Intercondylar eminences – tibia*
95 *Medial condyle – tibia*
96 *Lateral condyle – tibia*
97 *Head of fibula*
98 *Medial malleolus*
99 *Lateral malleolus*
100 *Tibial tuberosity*
101 *Intercondylar fossa*
102 *Calcaneus*
103 *Talus*
104 *Navicular*

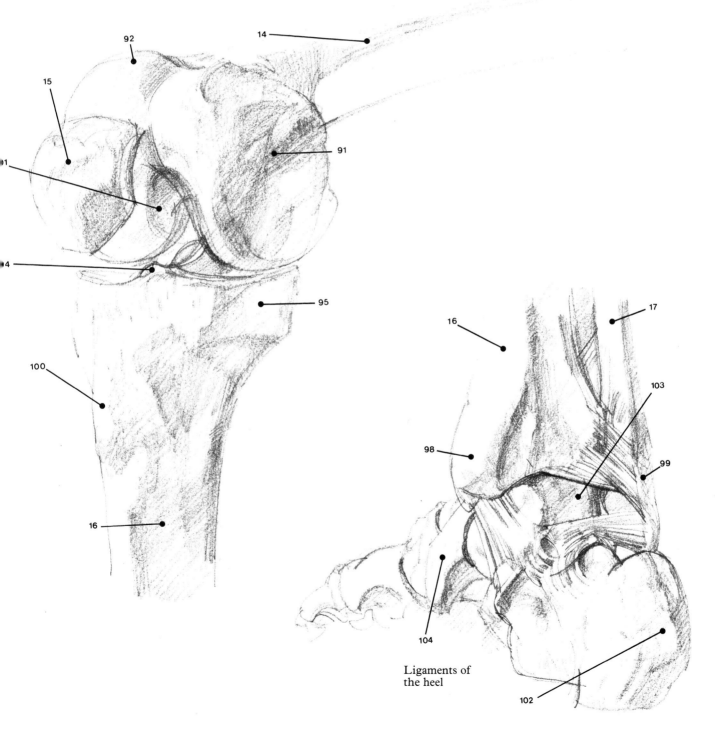

Ligaments of the heel

47

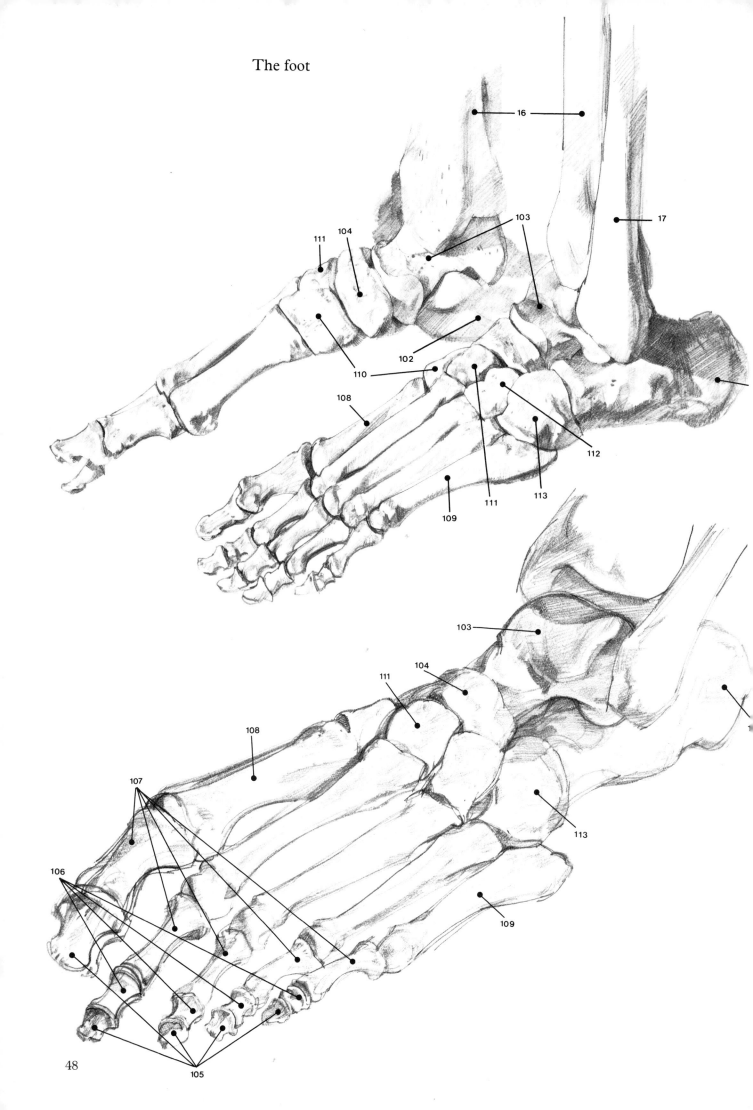

At the ankle end of the lower leg the medial edge of the tibia projects down and outwards to form the *medial malleolus*, while the fibula extends even further down on the lateral side, becoming the *lateral malleolus*. These are important prominences in life in all but the very fat, and are responsible for the familiar ankle form, in which the inner 'ankle' is always higher than, and forms a constant angle with, the outer one.

The *talus* has a complex shape, consisting mainly of articular surfaces, but consideration of its shape and detailed function relative to the adjacent bones of the foot would be beyond the needs of a study of anatomy for artists. Its articulation with the lower leg, however, is comparatively simple and important, allowing flexion and extension by a rocking motion in line with the foot.

To avoid confusion with the terms describing toe movements, flexion or drawing the foot upwards is called *dorsiflexion*, and extension or pointing the foot is called *plantarflexion*.

In dorsiflexion the broadest part of the articulating surface of the talus is wedged into the space between the malleoli, forcing them apart slightly and holding the foot very securely. Plantarflexion reduces the tension; although the malleoli spring back to retain their grasp on the sides of the talus, there is a small amount of side-to-side motion possible when the toe is fully pointed (in full plantarflexion).

By their muscular and cartilaginous connections the bones of the foot form a series of springy arches which act as a strong platform for the support of the body. It is astonishing that such a small structure is capable of absorbing the enormous loads to which it is subjected, but the complex of small bones and ligaments in the foot is beautifully contrived to do just this and it deserves careful observation. The form of the whole structure is easily seen through the skin in life. There are three arches – one transverse arch across the foot at about the line of the joints between metatarsus and tarsus, and one longitudinally on each side of the foot. Both longitudinal arches have the posterior part of the *calcaneus* or heel bone as the posterior pillar. From here the *lateral arch*, which is very low, continues through the body of the calcaneus (which joints with the *cuboid bone*), on into the lateral two metatarsal bones. Body weight or pressure is transmitted to this arch through the joint between the talus and the posterior facet on the upper surface of the calcaneus.

Much higher and more important is the *medial arch* comprising calcaneus, talus, navicular, the cuneiforms and the three metatarsal bones. The weight of the body is imposed directly on to the talus. This arch is the most pliable and resilient and probably the most active in absorbing imposed forces.

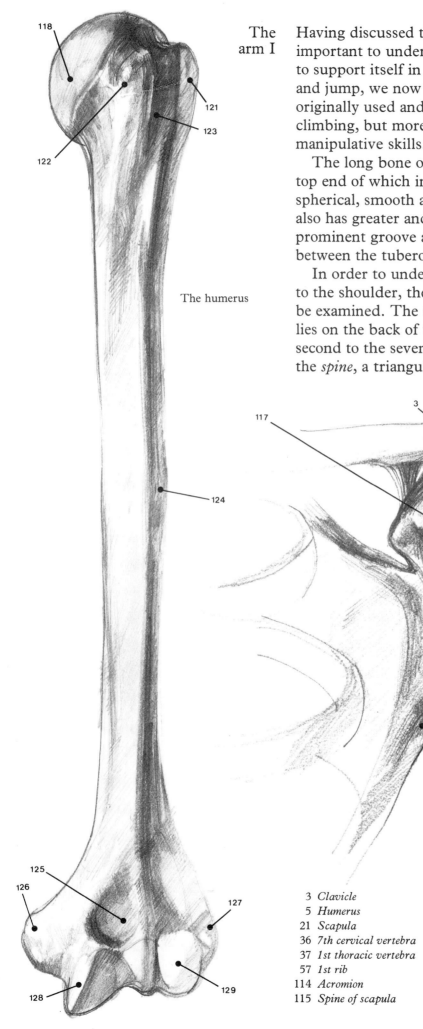

The
arm I

Having discussed the support structures that are so important to understanding the human biped's ability to support itself in the upright stance and to walk, run and jump, we now turn to the upper limbs. They were originally used and are still useful for swinging and climbing, but more normally involved in lifting and manipulative skills.

The long bone of the upper arm is the *humerus*, the top end of which includes a convex, nearly hemispherical, smooth articulating surface called the *head*. It also has greater and lesser tuberosities and shows a prominent groove at the opposite side to the head and between the tuberosities.

In order to understand the connection of the humerus to the shoulder, the *scapula* or shoulder blade must first be examined. The scapula is a flat triangular bone which lies on the back of the thorax, overlapping parts of the second to the seventh ribs. Its most prominent feature is the *spine*, a triangular plate-like process which projects

The humerus

3 *Clavicle*
5 *Humerus*
21 *Scapula*
36 *7th cervical vertebra*
37 *1st thoracic vertebra*
57 *1st rib*
114 *Acromion*
115 *Spine of scapula*

from the dorsal surface of the scapula, extending outward and curving forward to form the bony upper edge of the shoulder known as the *acromion*. Nearly the whole of the crest of this spine, as well as the acromion, is just under the skin in life, and is clearly visible either as a prominence or a depression, depending on individual musculature.

On the upper border of the scapula the *coracoid process* projects forward and slightly laterally. Between the coracoid and the acromion, on the top outer corner (its *lateral angle*), lies the *glenoid cavity* which, although small and shallow, functions as the socket for articulation with the head of the humerus. When the *clavicle* is in position the shoulder girdle is formed, with the bony ridge of the scapula spine continuing over the shoulder at the acromion and across the front via the clavicle. A space is defined by the underside of the shoulder girdle, the glenoid cavity, and by the coracoid process, which dictates the freedom of movement of the humerus.

116 *Glenoid cavity*
117 *Coracoid process*
118 *Head of humerus*
119 *Capsular ligament*
120 *Groove for long tendon of biceps*
121 *Greater tubercle*
122 *Lesser tubercle*
123 *Intertubercular sulcus*
124 *Deltoid tuberosity*
125 *Coronoid fossa*
126 *Medial epicondyle*
127 *Lateral epicondyle*
128 *Trochlea*
129 *Capitulum*

The arm II

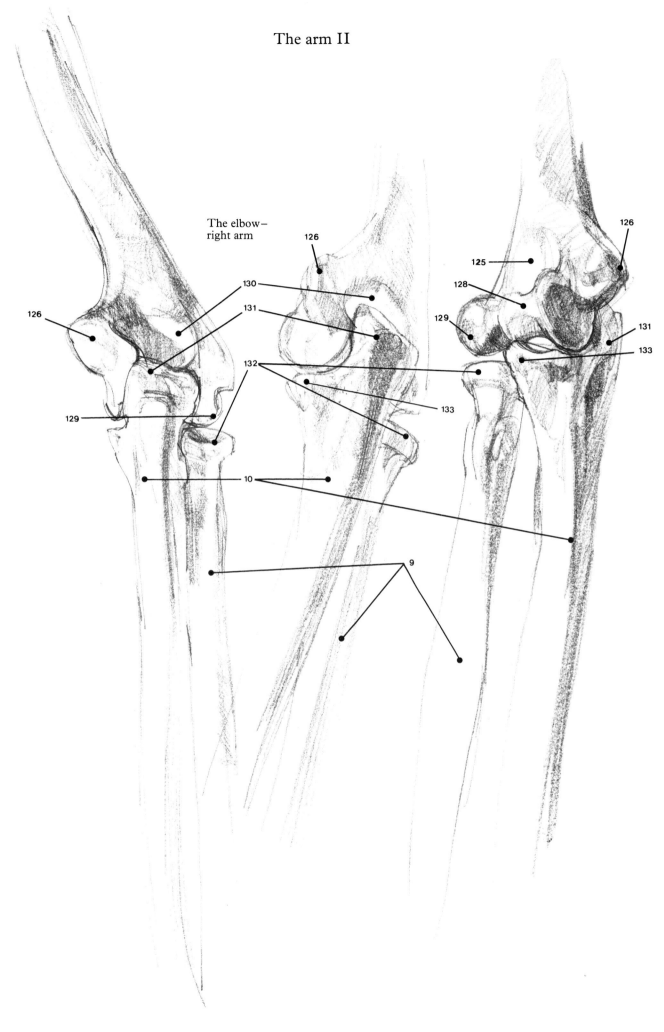

The elbow—
right arm

The shaft of the humerus is fairly long, about one-fifth the length of the total body. It is almost cylindrical in its upper half but flattens and widens in the lower half to culminate in a condyle or knuckle-shaped articular surface. From the front view the articular surface can clearly be seen to consist of a smooth, concave, pulley-like surface, the *trochlea*, and a hemispherical convex one, the *capitulum*. The medial epicondyle is also prominent and is seen in life as the inner point of the elbow joint.

Articulating on the capitulum is the cupped upper surface of the upper end of the *radius*, the shorter of the two forearm bones. The upper end of the other forearm bone, the *ulna*, has a notch, called the *trochlear notch*, which fits neatly round the trochlea at the bottom end of the humerus and articulates with it, enabling the joint to execute flexion and extension movements. There is a large projection forming the upper end of the ulna, called the *olecranon*; this inserts into a fossa (depression) on the humerus at full extension, preventing further movement and locking the arm. When the arm is *supinated* (with the palm of the hand uppermost or forward), the forearm bones are side by side, but when it is *pronated*, the hand and wrist turn inward and carry the radius across the ulna obliquely to the medial side, so that the two forearm bones cross and the lower ends rotate into reverse positions.

The lower ends of the radius and ulna form the beginning of the wrist, the end of the ulna being smaller than that of the radius. Both have styloid processes which can be seen on the surface, with that of the ulna normally more prominent. Their combined articular surfaces embrace the articular surfaces of the *triquetral*, *lunate* and *scaphoid* carpal bones of the wrist.

Pronation and
supination – right arm

5 Humerus
9 Radius
10 Ulna
125 Coronoid fossa
126 Medial epicondyle
127 Lateral epicondyle
128 Trochlea
129 Capitulum
130 Olecranon fossa
131 Olecranon
132 Head of radius
133 Coronoid process

53

The hand

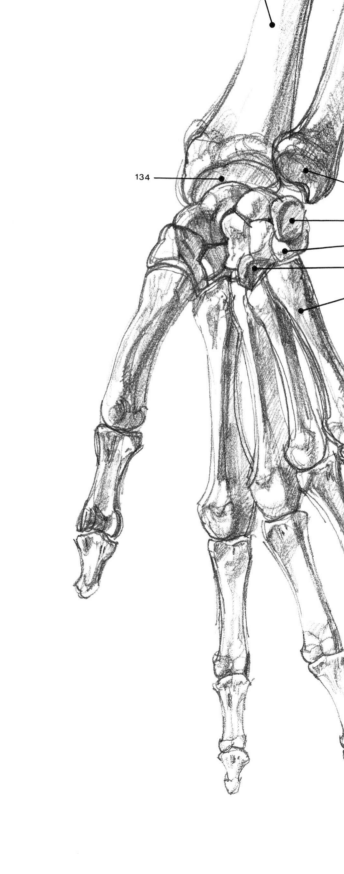

The wrist is a mobile joint that allows free movement in virtually all planes. Rotational movement within the wrist itself is limited, but since the whole wrist can be rotated this is scarcely too restricting.

Other than the triquetral, lunate and scaphoid bones, the remaining five carpals articulate on each other but in fact move very little. Their motions are mostly small sliding or rocking ones to accommodate to or extend the larger wrist movements.

Four of the *metacarpal* bones of the hand proper articulate with the distal (nearest to the free end of the limb) row of carpal bones and with each other, while the fifth metacarpal or thumb bone articulates with the *trapezium* and the first metacarpal in the familiar disposition of opposition to the hand. At their distal ends or heads, the metacarpal bones are rounded.

The fingers of the hand are made up of three *phalanges*, the thumb only two. Each phalanx, like the metacarpal bones, is a 'miniature' long bone, with a proximal end (nearest the wrist), called the base, a shaft and distal end called the *head*. The proximal phalanx of a digit is the largest, and has a concave base to articulate with the appropriate metacarpal and a pulley-shaped head. The middle phalanx is smaller and has the reverse-shaped base to articulate with the pulley shape of the first, and a similar but smaller pulley-shaped head, on which articulates the third or distal phalanx. This phalanx is distinguished by a rough horseshoe-shaped tuberosity to which the soft tissues of the finger tip attach. The two phalanges of the thumb resemble the proximal and distal phalanges of the fingers without the middle one.

55

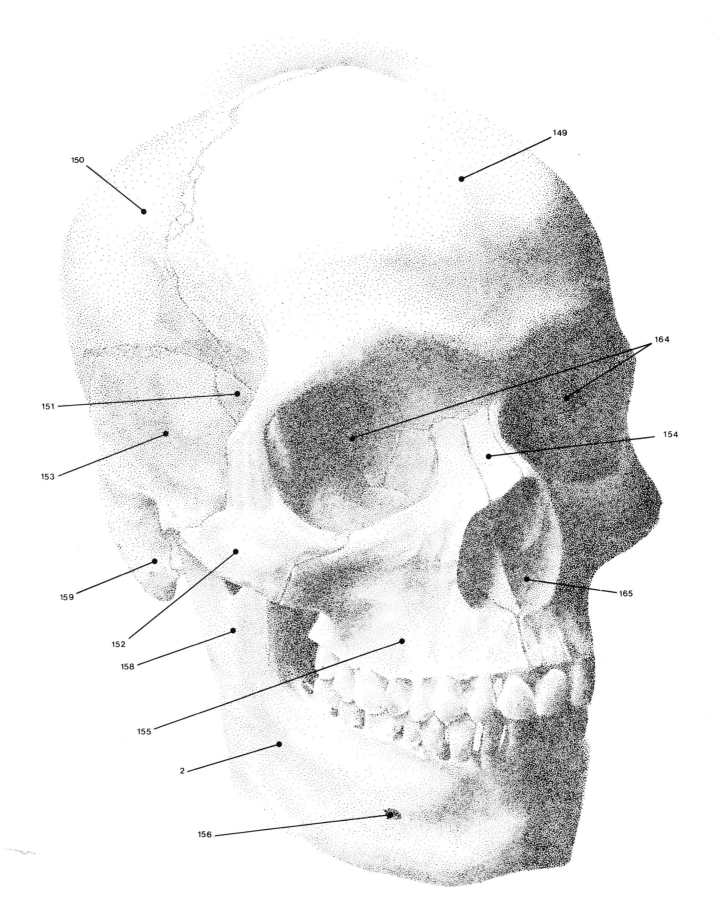

In terms of separate moving parts, the skull consists of only two bones: the *mandible* or jaw bone and the rest, which constitutes the *cranium*. In fact the cranium is made up of a total of 21 bones which operate as a single joined unit, but can be separated from each other. In an infant's skull the bones are only loosely joined with some gaps, but during the second year of life they knit together firmly and throughout life the joints gradually disappear and neighbouring bones fuse together. For the most part the cranium forms a box to enclose the brain. The rest of the skull is called the facial skeleton.

The forehead area is composed of a large bone called the *frontal*, which also forms the eyebrow ridges and the upper parts of the eye sockets. While it clearly forms part of what is normally considered to be the face, it is also the front part of the brain box. Next to the frontal are the two large *parietal bones*, joined together at the top centre of the cranium and forming the greater part of the sides and back. Between the parietals at the back is the *occipital bone*, leaf-shaped and bent to form the back and base of the cranium. It has a very rough surface for attachment of the powerful extensor muscles of the neck and spine.

The *temporal bones* are found at the sides of the skull beneath the parietals and extend a little into the base of the skull. The temporal bone includes the external *acoustic meatus*, or ear hole, the area immediately behind which is known as the *mastoid temporal*.

2	*Mandible*
149	*Frontal bone*
150	*Parietal bone*
151	*Greater wing of sphenoid bone*
152	*Zygomatic bone*
153	*Temporal bone*
154	*Nasal bone*
155	*Maxilla*
156	*Mental foramen*
157	*Occipital bone*
158	*Ramus of mandible*
159	*Mastoid process*
164	*Orbit*
165	*Nasal cavity*

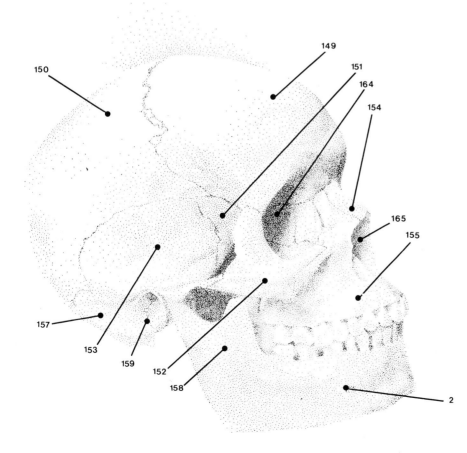

The skull II There are two other subdivisions of the temporal.
The *zygomatic process* of the temporal is a projection
from the *squamous part*, or large area above the ear
passage. A small plate of bone, called the *tympanic
plate*, forms the front and rear wall of the ear passage
and the *styloid process* projects downward from it. The
remainder of the temporal is called the *petrous part*. It
is situated deep in the base of the skull and as such is of
little importance to the artist.

The *sphenoid bones* complete the enclosure of the
cranium and form more of the eye sockets. Contributing
to the generally conical space and squarish outlets of
the eye sockets (*orbits*) are the *ethnoid* and the *lacrymal*
bones. These largely determine how far apart the eyes
are set. The bridge of the nose is formed by the two
nasal bones. There are a number of thin plates of bone
within the nasal cavity which again have no effect on
surface form and are of little interest to the artist-
anatomist.

The *maxillae* and the *zygomatics* are very prominent
in the surface form of the face. The two maxillae form
the upper jaw and extend at their upper edges into the
orbits, and also join with the nasal bones to form the
bony shape of the sides of the nose. Parts of the maxillae
extend into the interior of the nasal cavity (the rear-
facing area under the zygomatic) and also form the bony
palate. The lower part of the anterior wall, known as the
alveolar process, includes the teeth sockets and provides
the basic form of the upper lip area.

The zygomatic bones are the cheek bones and form
part of the outer lower rims of the eye sockets. Together
with the zygomatic processes of the maxillae and the
zygomae of the temporal bones, they form the zygomatic
arches.

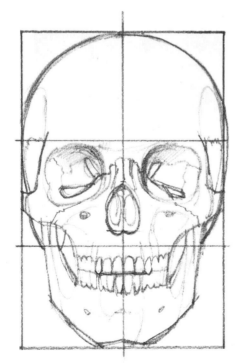
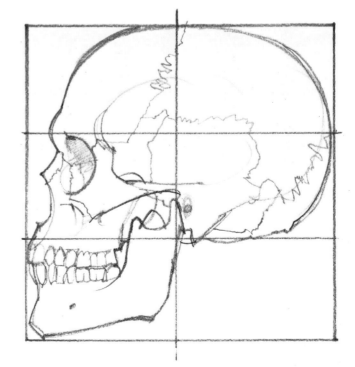

The lower teeth are situated in the lower jaw, or mandible, which has a rounded V-shaped body and two flat broad rami that project upward from the posterior ends. Each ramus has two upward-projecting processes; the anterior non-articulating one is the *coronoid process* and the posterior one, called the *condyloid process*, articulates with the temporal bone to form the *mandibular joint*.

Relative sizes, shapes and distances between the mandible, maxillae, nasal bones, zygomatics, eye orbits and frontal bones are infinitely varied and subtle and make possible the uniqueness of each and every face. Musculature and surface tissue of course fill out the basic forms, but although the superficial features change throughout life, the underlying bone structure is so fundamental to appearance that recognition of the individual throughout maturation and aging is almost always easy. Even the lengthening of the maxillae, which principally takes place between the ages of six and twelve years and alters the childish roundness into a more adult length, does not completely change the individuality of the face beyond recognition.

Viewed from above, the skull can be seen to have

 2 *Mandible*
149 *Frontal bone*
150 *Parietal bone*
152 *Zygomatic bone*
153 *Temporal bone*
154 *Nasal bone*
155 *Maxilla*
160 *Bregma*
161 *Superciliary arch*
162 *Sagittal suture*
163 *Coronal suture*
164 *Orbit*
165 *Nasal cavity*

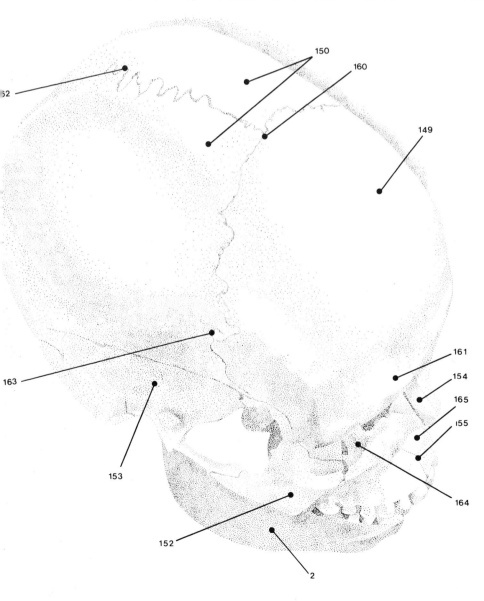

The skull III

convex contours; although there is great ethnic variation, European skulls are normally ovoid from this view, with a flattened narrow end forming the facial surface. The skull is widest across the cranium, nearer the occipital than the frontal region. From the front the outline is again somewhat ovoid, sometimes widest at the zygomatic and sometimes across the cranium a little higher up. The great variation in shape and size of the mandible has an important influence on the general shape from this view. The side view of the skull and mandible can be seen as fitting into a square, so that the cranium occupies the upper two-thirds and the mandible occupies half the remaining third.

At the base of the skull, on the occipital bone, there are two condyles, one each side of the foramen magnum,

for articulation with the atlas vertebra. This makes up the *atlanto-occipital* joint. The movements possible at this joint are flexion and extension (nodding the head) and a little tilting from side to side.

Most of the mobility of the head depends on the movement between the atlas and the axis, and the combinations of movement in the other cervical vertebrae. The articulation between atlas and axis takes place in two ways: as well as the normal sliding, rocking contact between their opposed articular processes, there is also a special one involving rotation of the anterior arch of the atlas around the upward-projecting odontoid process of the axis. Rotation, flexion, extension and lateral tilting can be combined to produce great mobility for the head and neck.

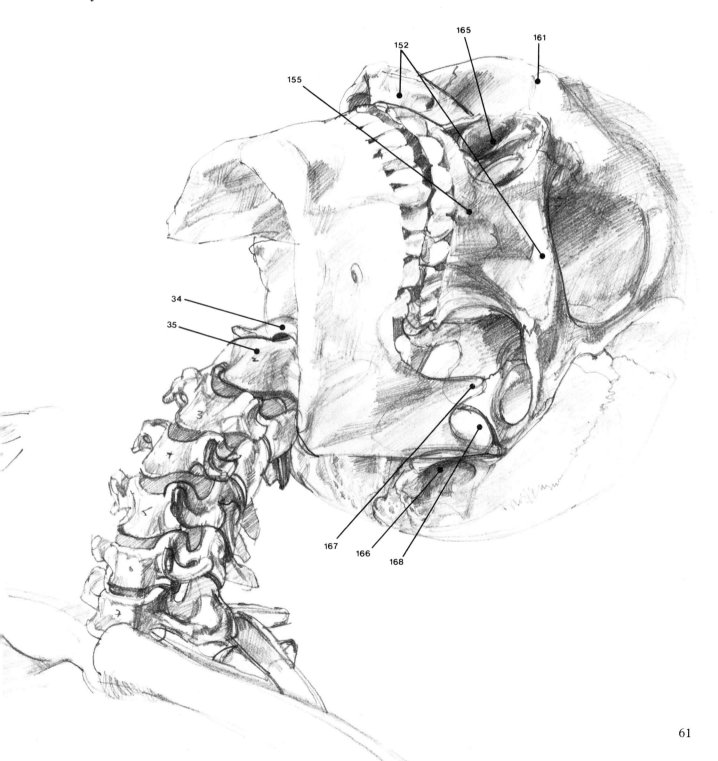

The Muscles

Just as a decision has to be made as to how detailed a knowledge of human skeletal structure is useful to the figure artist, so priorities must be allocated in the study of musculature. Surface form is finally our only interest, but it is not always the feature immediately below the surface that is principally responsible for this form. Over large areas of the body the musculature is multi-layered; in some cases all the layers are of flat sheets of muscle, while sometimes the form is defined by rounded muscles at or near the top layer, and at other times by those forming the deep layer. There is such diversity of movement, so many combinations of muscular activity, that to choose at which layer the artist should stop is very difficult.

As a result, this part of the book starts from the deep layers and works to the surface, with comment and detailed description relevant to the likely ultimate effect of each muscular group on surface form.

Probably the most significant deep muscle group in the body from the point of view of the artist is that complex of muscles known as the *erector spinae*. As the name suggests, they function as rigging for the spinal column. It is made up of many separate muscles, with complicated attachments to ribs and transverse and spinous vertebral processes, but the overall appearance of the group is of two thick ropes of muscle stretching from the coccyx to the base of the skull. It is especially prominent in the sacro-lumbar area, where it is covered by a *fascia* (a band or sheet of connective tissue), and is rather more flattened in the thoracic area and prominent again in the neck.

As can be seen in the cross-section, the erector spinae group generally lies in and overfills the grooves formed by the transverse and spinous processes of the vertebral column. It is responsible for the characteristic appearance in life of the central line of the spine lying in the hollow formed by these two powerful columns of muscle.

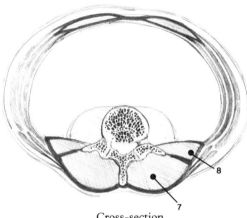

Cross-section
of thorax

The
back I

Deep layer

1 *Semispinalis capitis*
2 *Longissimus capitis*
3 *Iliocostalis cervicis*
4 *Spinalis thoracis*
5 *Longissimus thoracis*
6 *Iliocostalis lumborum*
7 *Erector spinae*
8 *Quadratus lumborum*

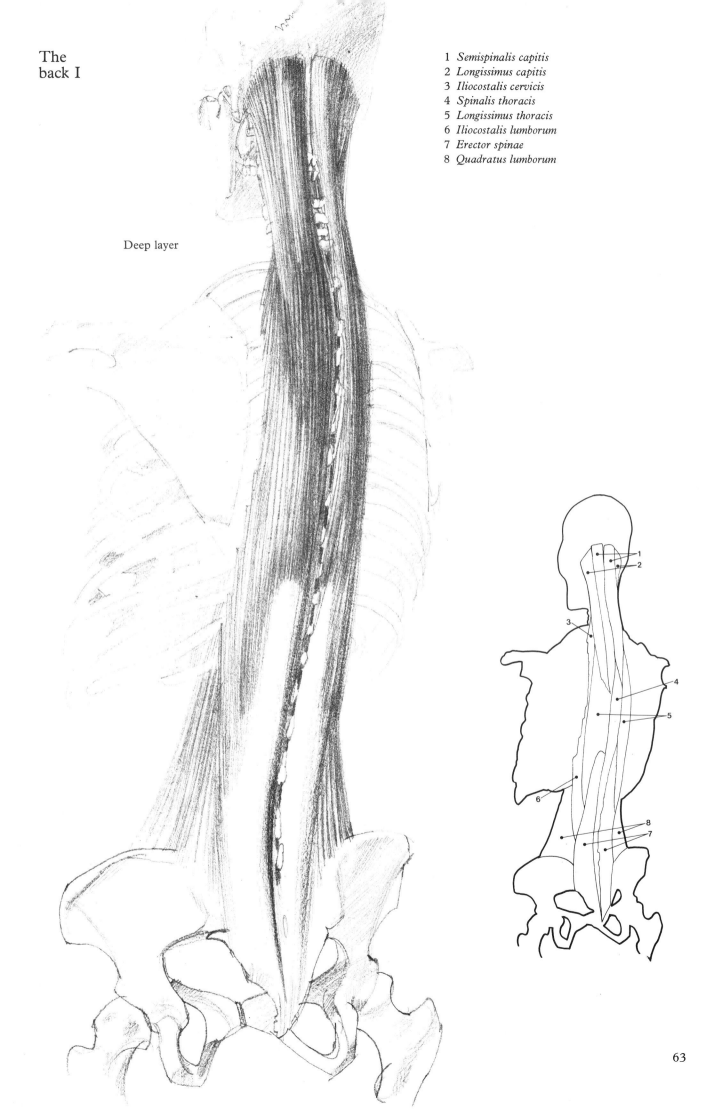

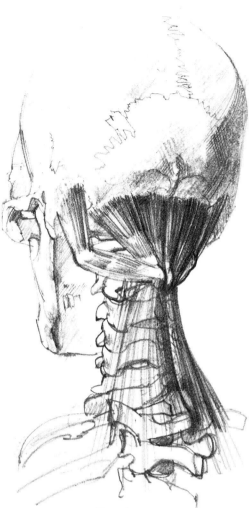

Deep layer

For the artist, the viscera can be considered as being contained in a more or less elastic sack which sits in the cup form of the pelvis and extends into the lower part of the thorax. Above is the diaphragm containing the lungs which are activated by the muscular expansion and contraction of the rib cage. The heart sits in its own sack, the *pericardium*, within the rib cage muscles. The shape of the trunk therefore depends firstly on the size of the gut that it contains and secondly on the elasticity and strength of the muscle layers that hold it in place.

There are three layers of flat muscle which perform this function, as well as more actively operating the trunk in its extension, flexion and twisting movements. The lowest layer is the *transverse abdominis*, shown in the drawing on page 68. It consists largely of an *aponeurosis* (a flat sheet of tendon-like substance, white in colour and smoother than contractile muscle fibre). Immediately above this muscle lies the layer called the *obliquus internus*. Its fibres run at an angle of about 45° to the transverse abdominis; they are shown from the back on the opposite page. The upper part of the erector spinae is overlaid by *rhomboideus major* and *minor*, together arising from the seventh cervical and the first to fifth thoracic vertebral spines, and attaching to the medial edge of the scapula.

Attaching to the same medial edge but on the inner, costal surface is another sheet-like muscle, the *serratus anterior*, which wraps around the chest to widespread insertions in (attachments to) the upper eight, nine, or even ten ribs. The *serratus posterior inferior* is a small muscle acting upon the lower ribs; it has little or no effect on surface form.

Rounding out the form of the back of the neck are several layers of muscle. Those shown as numbers 19 to 22 on this page are concerned with the fine control of head movements and cannot be discerned superficially, but the extensions of the erector spinae, the *semispinalis cervicis* and the *semispinalis capitis* partially overlayed by the *splenius capitis* all contribute to the rounded form of the back of the neck.

On the surface of the scapula are a group of muscles which are in the main superficial. They are the *infraspinatus*, the *teres minor* and *teres major*. The first two arise from the surface of the scapula and insert into the top of the humerus. The teres major threads under the long head of the *triceps* to insert into the underside of the upper humerus.

The back II

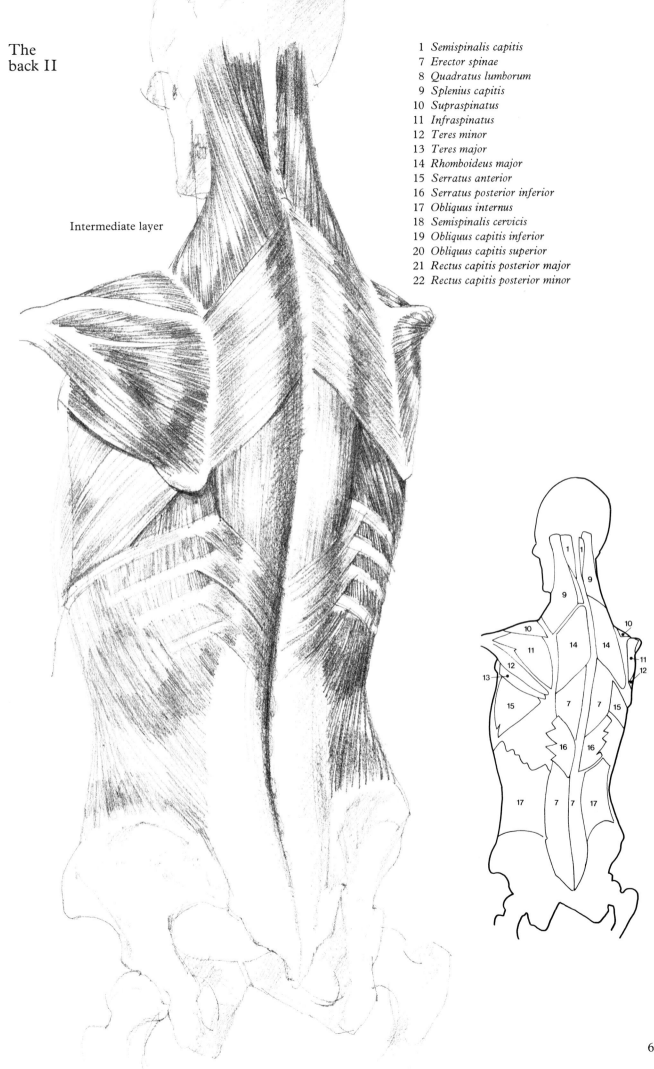

Intermediate layer

1 *Semispinalis capitis*
7 *Erector spinae*
8 *Quadratus lumborum*
9 *Splenius capitis*
10 *Supraspinatus*
11 *Infraspinatus*
12 *Teres minor*
13 *Teres major*
14 *Rhomboideus major*
15 *Serratus anterior*
16 *Serratus posterior inferior*
17 *Obliquus internus*
18 *Semispinalis cervicis*
19 *Obliquus capitis inferior*
20 *Obliquus capitis superior*
21 *Rectus capitis posterior major*
22 *Rectus capitis posterior minor*

The dominating muscles of the upper back are the *trapezius* muscles, large flat triangles which together form the trapezium shape from which the name derives. They are attached to the base of the skull at the occipital, to the *ligamentum nuchae* (which covers the first six cervical spines), the seventh cervical and all the thoracic vertebral spinous processes. The upper fibres run downwards to insert in the lateral third of the clavicle and the medial border of the acromion. The middle fibres are nearly horizontal and insert into the upper edge of the spine of the scapula and the lower fibres proceed upwards to a flat triangular tendon which attaches to the tubercle of the scapula spine. All of the spinal attachments from about the sixth cervical to the third thoracic vertebral spines are by means of short tendinous fibres and the tendon extends to form a diamond-shaped depressed area between the two trapezius muscles.

The *latissimus dorsi* wraps a large area of the lower back. Although it is extensive, it is quite thin, so that underlying forms are still discernible. It arises from the spines of the lower six thoracic vertebrae, the posterior lumbar fascia, the spines of the lumbar vertebrae, the sacrum and the iliac crest. The lateral border also arises directly from the outer lip of the iliac crest and several muscular slips (extra fibres) arise from the lower three or four ribs. The muscle converges into a narrow tendon inserting into the upper humerus with a twist by which, with the arm in the resting position, the muscle is turned over on itself. Raising the arm above the head to an extent unwraps this twist. The lower angle of the scapula lies under, and can be observed through, the upper edge of the latissimus dorsi.

The third side of the 'frame' around the scapula is completed by the *deltoid* muscle, which extends right around the shoulder. From the back, the fibres attached to the lower edge of the crest of the scapula spine can be seen to pass downward and outward to converge into a short tendon attached to the deltoid tuberosity about halfway down the shaft of the humerus.

All but a small part of the medial border of the scapula is covered by superficial muscle, but the outline of its form is normally fairly easily seen. That medial border is seen as a groove between the swellings of the infraspinatus on one side and a triangle of rhomboideus major, which appears from under the trapezius. The raised level of the scapula and the thickness of the fibres of the lower trapezius mean that the visible triangle of the rhomboideus sometimes appears as a depression. This is known as a *triangle of auscultation*.

Finally the third, top layer of the frontal and lateral trunk covering, the *obliquus externus*, is also visible.

The
back III

11 *Infraspinatus*
12 *Teres minor*
13 *Teres major*
14 *Rhomboideus major*
23 *Sternocleidomastoid*
24 *Trapezius*
25 *Deltoid*
26 *Latissimus dorsi*
27 *Obliquus externus*

Superficial layer

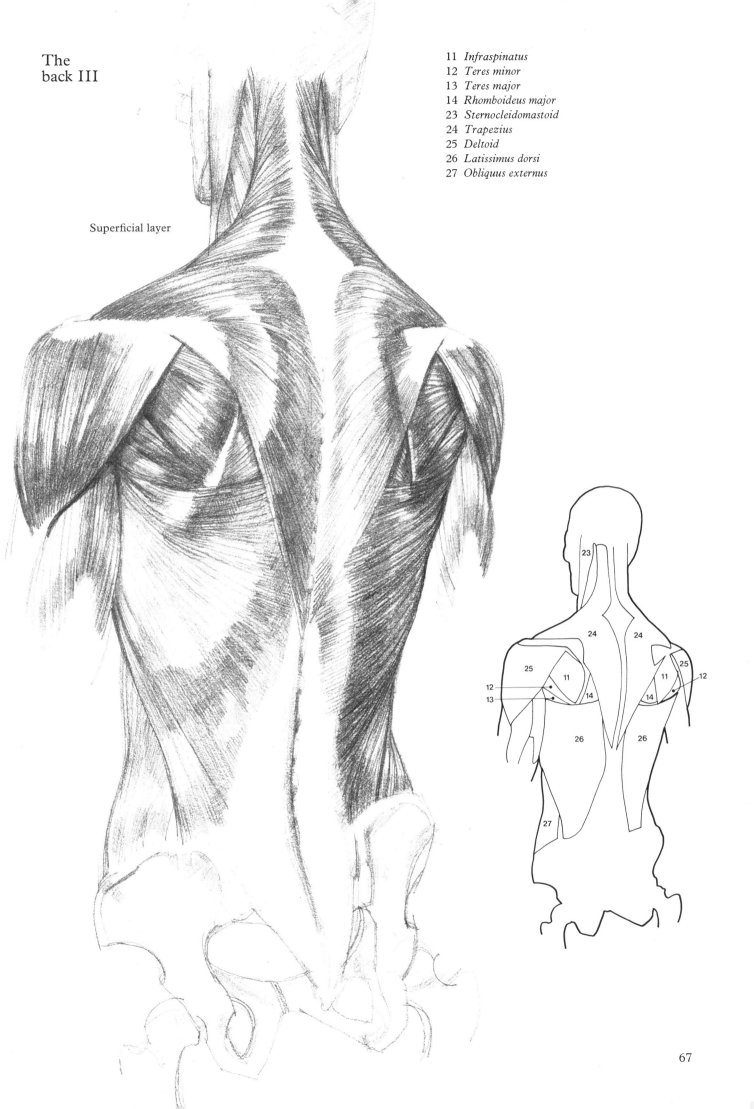

15 *Serratus anterior*
28 *Pectoralis minor*
29 *Subclavius*
30 *Transverse abdominis*
31 *Rectus abdominis*
32 *Thoracolumbar fascia*
33 *Biceps—short head (cut)*
34 *Intercostalis*

The
front I

Deep layer

Coracoid process

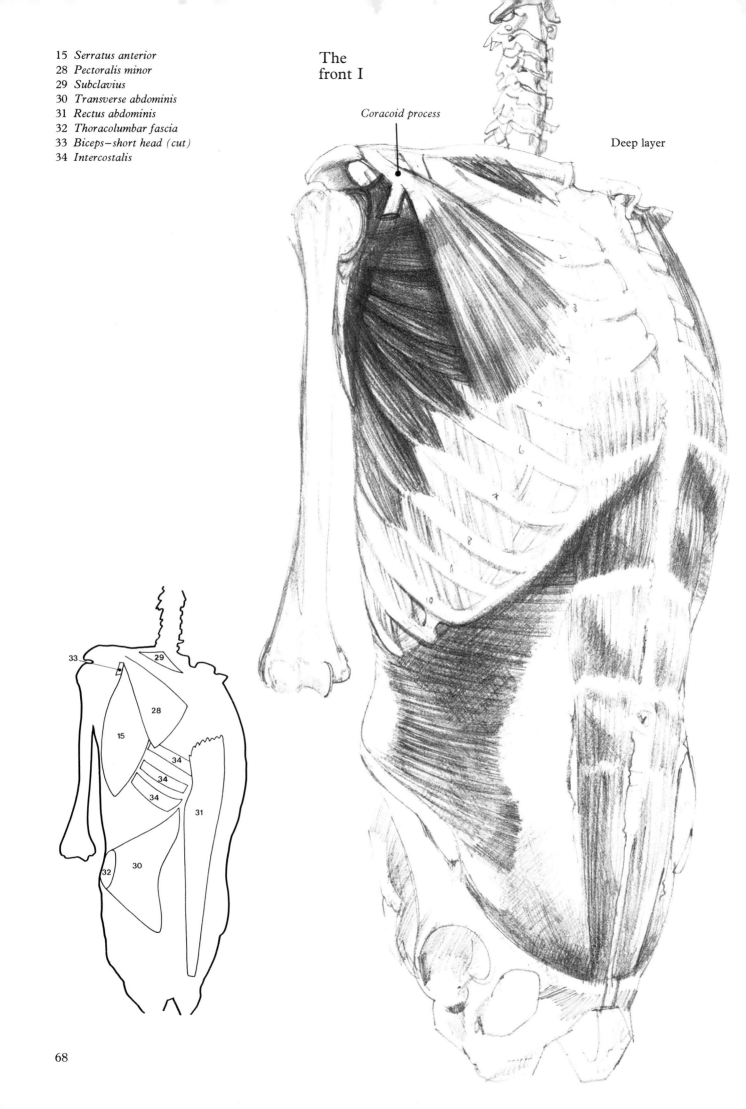

On the opposite page the illustration shows the deep muscles of the trunk viewed from three-quarter front.

The *serratus anterior* has been considered and illustrated on page 64 as a muscle of the back; here its attachments to the upper eight or nine ribs at the side of the chest can be seen. The small drawing on this page shows the full extent of the muscle. The lower four or five digitations converge on to the bottom medial border of the scapula, those from the middle attach in a sheet a little higher up the same border, and the major length of the upper medial border is occupied by fibres from the first two ribs only. Although only the medial ends of the lower four or five digitations of the serratus anterior with the ribs (costal digitations) are visible in life, and they are often mistakenly thought to be ribs rather than muscle fibres, it is in fact a strong muscle and is the prime mover in all reaching and pushing movements. It also positively anchors the scapula in rotated positions to provide a firm shoulder joint.

The *pectoralis minor*, in life, is almost entirely hidden under the large surface muscle of the chest, the *pectoralis major*. In the larger drawing it can be seen to attach by a flat tendon to the coracoid process of the scapula, and it can be continuous with the coraco-acromial ligament or can even pass through it to blend with ligaments attaching to the humerus. Occasionally a slip, called *pectoralis minimus*, joins the first rib to the coracoid process.

In this context it is worth mentioning that there is great variation between people in muscular origins and insertions throughout the body. Muscles often have non-standard additional slips and some muscles may be totally absent. The rectus abdominis, for example, which is a prominent and important muscle extending along the front of the abdomen from the pubis to attachments into the fifth, sixth and seventh costal cartilages, sometimes attaches by a slip to the fifth rib proper, and sometimes not, and it may even reach the fourth or third rib.

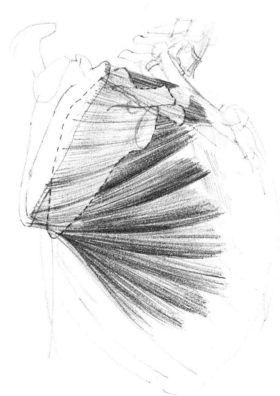

Serratus anterior

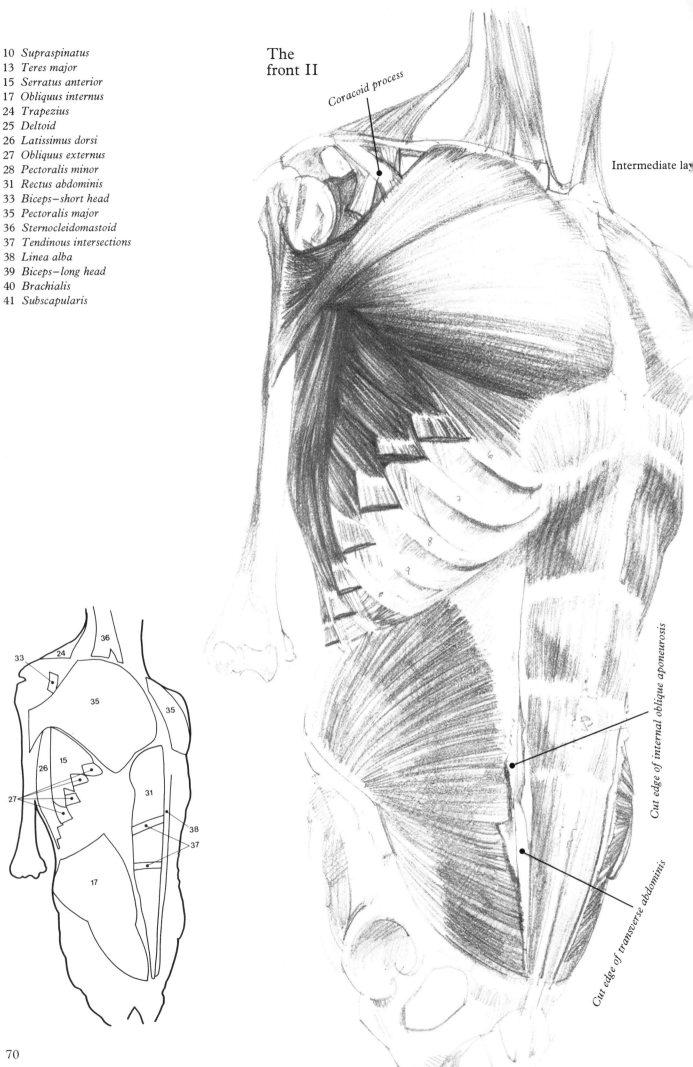

10 *Supraspinatus*
13 *Teres major*
15 *Serratus anterior*
17 *Obliquus internus*
24 *Trapezius*
25 *Deltoid*
26 *Latissimus dorsi*
27 *Obliquus externus*
28 *Pectoralis minor*
31 *Rectus abdominis*
33 *Biceps—short head*
35 *Pectoralis major*
36 *Sternocleidomastoid*
37 *Tendinous intersections*
38 *Linea alba*
39 *Biceps—long head*
40 *Brachialis*
41 *Subscapularis*

Coracoid process

Intermediate la

Cut edge of internal oblique aponeurosis

Cut edge of transverse abdominis

The most obvious addition shown on the opposite page is the large muscle of the chest, the *pectoralis major*. It is of thick triangular form, arising from the medial half of the clavicle, half the breadth of the sternum and the cartilages of the first or second to the sixth or seventh ribs and the aponeurosis of the obliquus externus abdominis. At the other end the muscle converges into a flat tendon which twists over to insert high into the humerus. The precise manner of this twisting is complicated to describe, since not all the fibres are involved; but the sternal part of the pectoralis is mainly involved in the twist and the clavicular part inserts more directly into the tendon. The small drawing clarifies the relationship of the pectoralis major to the pectoralis minor which it almost completely covers, and to the long head of the biceps around which it wraps. Slightly higher and medial to the insertion of the pectoralis major tendon on the humerus can be seen the tendon of the latissimus dorsi, described on page 66.

Returning to the larger illustration, the *rectus abdominis* is again shown, but the edges of the transverse abdominis and the internal oblique aponeurosis have been cut to show that the lower fibres of the rectus abdominis are covered by these two layers of aponeurosis, and emerge gradually as the muscle progresses upward. In fact there is a third layer, the obliquus externus, covering the complete rectus abdominis so that even the top third is not quite superficial. Nevertheless the coverings are thin and smooth, so the rectus abdominis is strongly visible at the surface, especially in fit and lean people, on whom the tendinous intersections can be clearly seen.

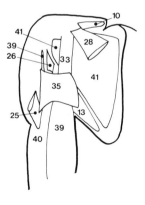

Pectoralis major
and minor

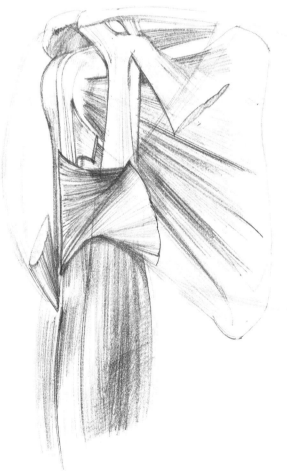

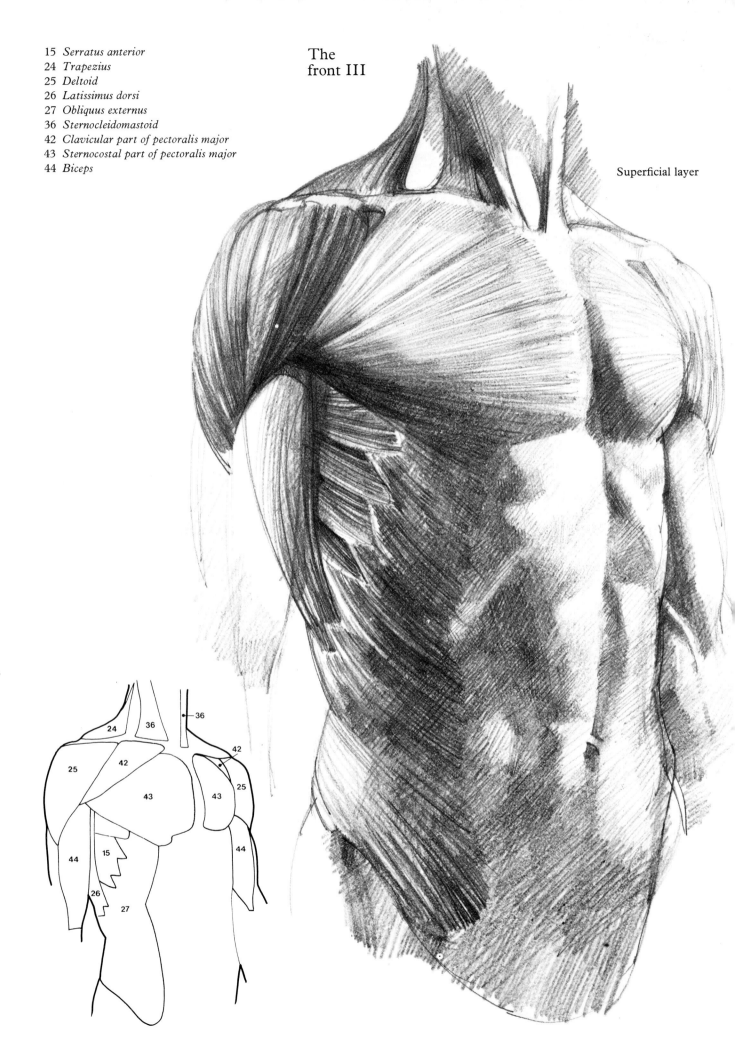

15 *Serratus anterior*
24 *Trapezius*
25 *Deltoid*
26 *Latissimus dorsi*
27 *Obliquus externus*
36 *Sternocleidomastoid*
42 *Clavicular part of pectoralis major*
43 *Sternocostal part of pectoralis major*
44 *Biceps*

The
front III

Superficial layer

We come now to the surface musculature of the front of the trunk.

The insertion of the deltoid into the humerus, and its attachments to the spine of the scapula have already been described. Here its frontal attachments to the lateral third of the clavicle are visible, and the small drawing shows the complete extent of the muscle. In life the deltoid provides the rounded form of the shoulder and in action it can appear corrugated and complex in form. This is caused by the fact that the intermediate part of the muscle is 'multi-pennate', or composed of a bundle of groups of fibres, separated by intramuscular strips of tendon converging into the main tendon. Its insertion securely wraps around the deltoid tuberosity on the humerus and also has connections with the deep *brachial fascia* (muscles underlying the biceps, described on page 78) and can thereby sometimes even reach the forearm. It is a powerful muscle and is active in almost all shoulder movements; the acromial fibres especially are capable of strong contraction when the arm is raised (see page 77).

The most superficial flat abdominal covering is the *obliquus externus abdominis*, arising by eight slips from the lower eight ribs and interdigitating as shown here (and pages 68 & 70) with the digitations of the serratus anterior and latissimus dorsi. Its fibres pass downward and forward as shown, to join a large flat aponeurosis covering the front of the trunk from around the sixth rib down to the pubic crest.

This drawing tries to suggest the appearance in life of the rectus abdominis as seen through the layers of aponeurosis. Of the linear tendinous intersections discussed on page 71, the one near the navel is normally the lowest, this and the next one up normally being the most clearly visible. The top tendinous intersection is usually nearly coincident with the lower edge of the thorax, and there are sometimes one or two extra ones below the navel (although the subject must be particularly lean for these to be visible under three layers of aponeurosis).

Deltoid muscle

On this spread and the next the musculature described on the previous pages is shown in action and from less familiar angles.

The figure on this page with the raised left arm demonstrates the rotation of the scapula associated with this action. The dotted lines indicate the resting and rotated positions of the scapulae spines. The upper medial angle of the scapulae is visible through the lower trapezius fibres, and the medial border appears superficially between the infraspinatus and the slightly more exposed rhomboideus major and is then covered at its lower angle by the latissimus dorsi.

The lateral edge of the scapula in this action projects laterally and thus changes the outline of the back from this view. Active and therefore contracted fibres of the upper trapezius bunch the form of the upper shoulder and similarly the intermediate fibres of the deltoid effectively bury the acromion at their conjunction.

The drawing on the opposite page views the

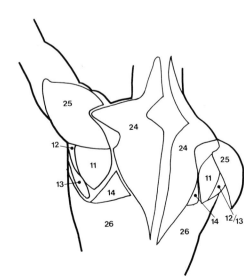

musculature of the back from above, to reveal the extension of the trapezius attachments along the scapula spine and the acromion to the outer third of the clavicle. The extent of this clavicular attachment is variable, sometimes reaching as far as halfway along; it may even blend with the edge of the sternomastoid, which is shown here connecting the inner third to half of the clavicle with the mastoid process. In the interval between these two can be seen a series of thin muscles which are variously active in swallowing, speech, and head rotation, flexion and so on. These are described in more detail on page 104.

From this view the spinous process of the seventh cervical vertebra may be prominent near the centre of the tendinous diamond of the two trapezius muscles. More noticeable is the difference in direction of the combined infraspinatus and teres minor, and the teres major, which results from their different insertions and their separation by the long head of the triceps.

11 *Infraspinatus*
12 *Teres minor*
13 *Teres major*
14 *Rhomboideus major*
23 *Sternocleidomastoid*
24 *Trapezius*
25 *Deltoid*
26 *Latissimus dorsi*
35 *Pectoralis major*

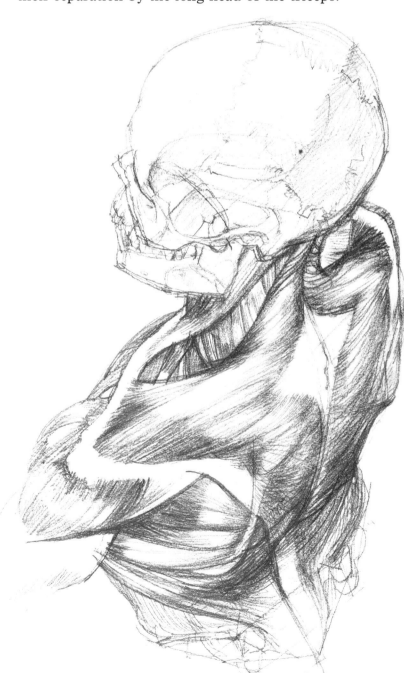

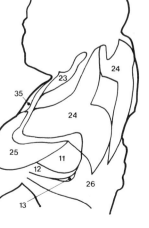

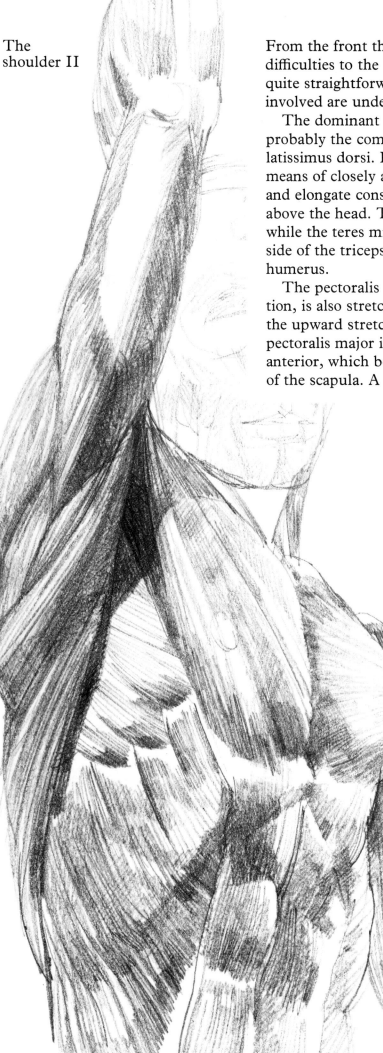

From the front the raised arm always seems to present difficulties to the anatomy student but its form is really quite straightforward if the insertions of the muscles involved are understood and taken into account.

The dominant underarm feature in this position is probably the combined form of the teres major and the latissimus dorsi. Both insert into the upper humerus by means of closely adjacent tendons and have to relax and elongate considerably to allow the arm to be raised above the head. They both pass medially to the triceps, while the teres minor and infraspinatus pass the other side of the triceps to their insertions in the head of the humerus.

The pectoralis major, with its upper humerus insertion, is also stretched by the arm raising. One result of the upward stretching of the latissimus dorsi and pectoralis major is to reveal more of the serratus anterior, which becomes prominent through the rotation of the scapula. A small section of the pectoralis minor

11 *Infraspinatus*
12 *Teres minor*
13 *Teres major*
14 *Rhomboideus major*
15 *Serratus anterior*
24 *Trapezius*
25 *Deltoid*
26 *Latissimus dorsi*
28 *Pectoralis minor*
35 *Pectoralis major*

may also be revealed in the armpit but it is rarely visible as a separate form.

The lengthened and relaxed fibres of the deltoid arising from the rotated spine of the scapula can be seen pulled upwards by the tendon shared with the active acromial fibres. The triceps itself is only active and tensed if the arm is held rigidly straight (in extension); indeed the whole arm can be quite relaxed, and all the work done by the combined action of the deltoid, trapezius and scapula muscles.

The drawing shown on this page is a rear view of exactly the same action. This drawing is based on a photograph, like several others in this book; they are intended to show clearly how the activity of the musculature fits with the actual form observed. The model in this case was well developed; most of the features are recognizable in a less pronounced form in slighter individuals, although the outline of the scapula assumes greater importance as the muscle size diminishes.

36 *Sternocleidomastoid*
37 *Tendinous intersections*
40 *Brachialis*
44 *Biceps*
45 *Obliquus externus abdominis*
46 *Linea semilunaris*
47 *Triceps—long head*
48 *Triceps—lateral head*

The arm I In considering the muscles of the limbs it is useful to distinguish between *flexor* groups and *extensor* groups. Basically, the muscles of the front of the arm in the supinated position (with the palm of the hand facing forwards) are flexors, in that they are used in flexion or bending of the arm. The muscles of the back of the arm power the extension or straightening of the arm and are therefore extensors.

The flexor muscles of the arm can be considered as two-layered on the upper arm and three-layered on the forearm. The deepest forearm layer is shown on this page. The largest muscle making up this deep layer is the *flexor digitorum profundus*, arising from the upper three-quarters of the ulna. Its attachments extend on to the *interosseus membrane* (a strong fibrous sheet between radius and ulna). Four long tendons attach the muscle to the fingers, the one for the index finger directly connected, the others interconnected by tissue and tendinous slips. Next to it is the *flexor pollicis longus*, which arises from an adjacent and similar area, including three-quarters of the radius and some of the interosseus membrane.

Just visible under the ligaments of these two muscles lies the *pronator quadratus* which extends across the front of the lower radius and ulna and is chiefly responsible for the pronation, or turning inwards, of the forearm.

Flexors – deep layer

51
52

The second layer of the right forearm and the deep layer of the upper arm are shown in the drawing below. At the front of the humerus is the *brachialis* arising from its lower half and inserting by a short but strong tendon into the coronoid process and the tuberosity of the ulna. The *coracobrachialis* arises from the tip of the coracoid process of the scapula and attaches to the medial border of the humerus about midway along its length.

Almost entirely covering the deep muscles of the forearm, the *flexor digitorum superficialis* arises by two heads, the humero-ulnar and the radial. The humero-ulnar is the main origin, springing from the medial epicondyle of the humerus and adjacent area; the radial head is a thin sheet of muscle arising from the upper two-thirds of the anterior border of the radius.

40 *Brachialis*
50 *Coracobrachialis*
51 *Flexor pollicis longus*
52 *Flexor digitorum profundus*
53 *Flexor digitorum superficialis*

Flexors – intermediate layer

79

The arm II

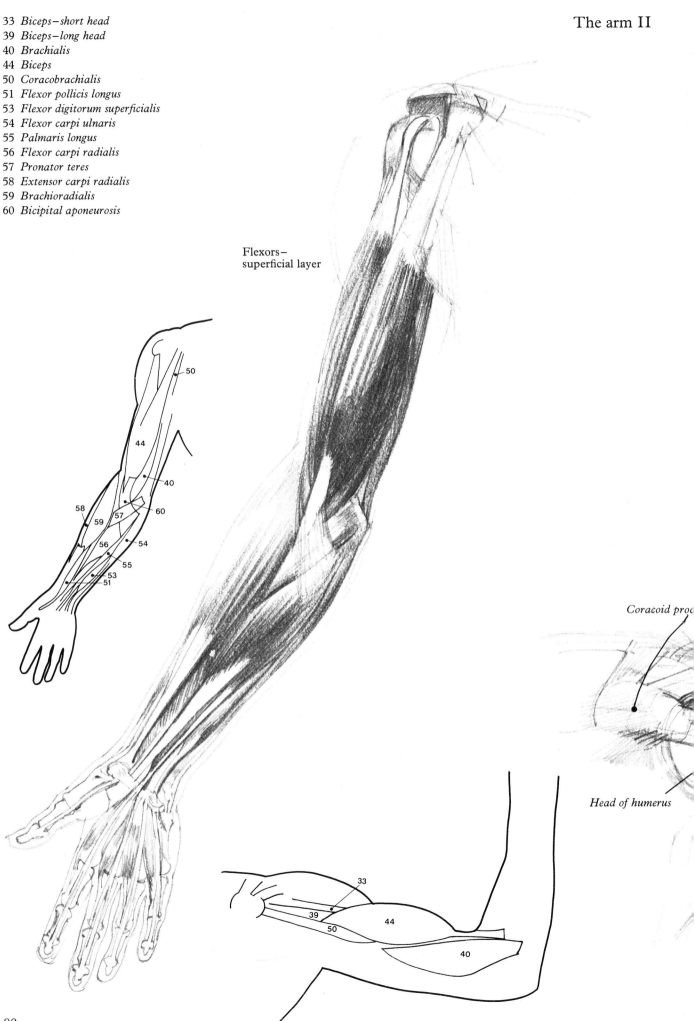

Flexors—
superficial layer

Coracoid proc

Head of humerus

Superficial muscles of the front of the arm are shown in
the drawing opposite although they are not all flexors:
two extensors have curved over from the other side.
These two, numbered 58 and 59, are described with the
extensors on page 84.

The top layer of the forearm flexors comprises the
flexor carpi ulnaris, the *palmaris longus*, the *flexor carpi
radialis*, and the *pronator teres*. All four arise wholly or
partially from the medial epicondyle of the humerus,
and the first three have long tendons which progress to
the radial, palmar and ulna areas of the hand as their
names suggest. Their insertions are shown in more
detail on page 86.

Both the flexor carpi ulnaris and the pronator teres
have ulnar as well as humeral attachments; the pronator
teres progresses not to the hand but obliquely across
the forearm to halfway down the outside of the radius,
thus helping to rotate the arm.

Lastly, the big flexor of the upper arm is the *biceps*.
It has two heads, the short head arising from the cora-
coid process, and the long head from within the shoul-
der joint just above the glenoid cavity of the scapula. The
tendon of the long head passes over the head of the
humerus and descends in the groove of the *intertuber-
cular sulcus* to the belly of the muscle, which is separate
from and lies alongside the muscle of the short head,
until they combine in a flattened tendon that inserts into
the radial tuberosity. The bicipital aponeurosis is an
additional attachment of this tendon to the deep fascia
of the flexors of the forearm.

Medial view

Medial epicondyle

Olecranon

Extensors–
deep
layer

Extensors–
superficial
layer

'Deep fascia' is a slightly misleading term in this context. It is only deep to the superficial skin layers and subcutaneous fat, and is in fact an outside wrapping to the muscles. It is called here the *antebrachial fascia* for the forearm and the *brachial fascia* for the upper arm. Muscles are able to arise from its inner face, especially in the upper forearm, and *septa* or dividing membranes are sent down from it to divide the bundles of muscles. It becomes important for the artist only in certain circumstances: its attachment to the bicipital aponeurosis is prominent in life when the biceps is flexed, and until the presence of the fascia is realized, this aponeurosis seems to have nothing to attach to.

Looking at the other, extensor, side of the upper limbs, again the multi-layers are on the forearm. The upper-arm extensors consist of only one muscle – albeit a muscle with three heads, hence its name *triceps*. The drawings here depart from the previous practice of building the drawings from the deepest layers, in that each drawing must, so to speak, be laid over the other to have the complete picture to that level. The lower drawing on this page does not include the deepest layer. Well hidden by succeeding layers of muscle is the *supinator*, which arises from an area that includes the lateral epicondyle of the humerus, the elbow area and the ulna, wraps around the four extensors shown, and inserts into the upper third of the radius.

Two of these extensors, the *extensor pollicis longus* and the *extensor indicis*, arise from the ulna, from about the middle third of the shaft. The tendon of the first of

59 *Brachioradialis*
61 *Extensor carpi radialis longus*
62 *Extensor carpi radialis brevis*
63 *Extensor digitorum*
64 *Anconeus*
65 *Supinator*
66 *Extensor pollicis brevis*
67 *Abductor pollicis longus*
68 *Extensor pollicis longus*
69 *Extensor indicis*
70 *Extensor carpi ulnaris*

these extends along the thumb to the distal phalanx, whereas that from the second goes to the index finger. The *abductor pollicis longus* and the *extensor pollicis brevis* are closely associated and arise from the middles of radius, ulna and interosseus membrane, the abductor inserts into the wrist and base of thumb and the extensor into the first joint of the thumb.

Three muscles which combine to make a single prominent form at the surface, separated from the other extensors, are drawn at the bottom of the opposite page. They are the *brachioradialis*, the *extensors carpi radialis longus* and *brevis*. All three arise from the lower lateral part of the humerus, the last from as low down as the lateral epicondyle. The brachioradialis attaches by a flat tendon to the lower end of the radius, and the other two muscles go to the second and third metacarpal bones respectively.

As can be seen more clearly in the drawing on page 85, the two deep muscles, the *abductor pollicis longus* and the *extensor pollicis brevis* become superficial near the wrist and curve over the tendons of brachioradialis and the carpi radialis extensors to their own insertions.

Also shown here is the *anconeus* muscle, which is partially overlapped by the extensor carpi ulnaris, as shown overleaf, and covered by a fascia extension from the triceps, but is still visible at the surface in some circumstances. It is a small triangular muscle, arising from the surface of the lateral epicondyle of the humerus and attaching to the upper quarter of the back of the ulna up to the olecranon.

12 *Teres minor*
13 *Teres major*
25 *Deltoid*
40 *Brachialis*
44 *Biceps*
47 *Triceps—long head*
48 *Triceps—lateral head*
54 *Flexor carpi ulnaris*

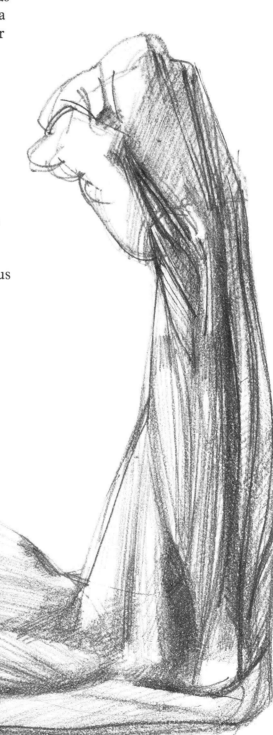

Lateral view

The arm IV

The viewpoint for the drawings opposite has been moved more to the rear. In the forearm in the left-hand drawing the muscles shown are a combination of those in the two drawings on page 82, viewed from this slightly modified position.

In contrast to the multi-layered forearm, the upper arm tensor musculature consists of only one muscle, the *triceps*. Its three heads are the long, the medial and the lateral. The long head arises by a flat tendon from just below the shoulder joint on the scapula, the lateral head from a narrow ridge high on the back of the humerus, and the medial head from a large area comprising three-quarters of the posterior surface of the humerus. Although large, the medial head is almost entirely covered by the long head from this view.

The triceps tendon begins about the middle of the muscle and is in two layers, the outer one presenting a large tendinous area in the centre of the back of the upper arm as shown. Its insertions are into the olecranon of the ulna, and, by a band of fibres, over the anconeus into the deep fascia of the forearm. The triceps muscle is very powerful – the medial head is principally active in normal lightly loaded movements, but all three act together when straightening the arm against resistance, as in weight-lifting or push-up exercises. In these circumstances the lateral head contracts into a very prominently outlined form.

In the right hand drawing the *deltoid* has been added, covering the upper tendinous attachments of the triceps, and rounding out the shoulder form.

Prominent in extension of the wrist and fingers is the *extensor digitorum*. It arises by the common extensor tendon from the lateral epicondyle of the humerus, from intermuscular septa and the antibrachial fascia, and divides below into four tendons, one for each finger.

Sharing the common extensor tendon from the lateral epicondyle and also arising from the posterior border of the ulna, the *extensor carpi ulnaris* passes downward close to the edge of the ulna to insert in the base of the little finger. It is attached to the ulna by means of an aponeurosis shared with the two flexor muscles from the other side of the arm, the *flexor carpi ulnaris* and the *flexor digitorum profundus*, but the ulna can be felt and usually seen as a depression between the flexors and the extensors.

Finally, the *extensor digiti minimi* also arises from the common extensor tendon by a thin tendinous slip and various intermuscular septa. It is small and lies mostly under the extensor digitorum; it only emerges as a tendon to the little finger, and has little effect on surface form.

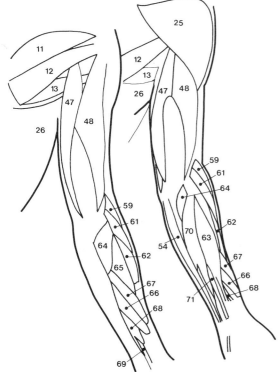

11 *Infraspinatus*
12 *Teres minor*
13 *Teres major*
25 *Deltoid*
26 *Latissimus dorsi*
47 *Triceps–long head*
48 *Triceps–lateral head*
54 *Flexor carpi ulnaris*
59 *Brachioradialis*
61 *Extensor carpi radialis longus*
62 *Extensor carpi radialis brevis*
63 *Extensor digitorum*
64 *Anconeus*
65 *Supinator*
66 *Extensor pollicis brevis*
67 *Abductor pollicis longus*
68 *Extensor pollicis longus*
69 *Extensor indicis*
70 *Extensor carpi ulnaris*
71 *Extensor digiti minimi*

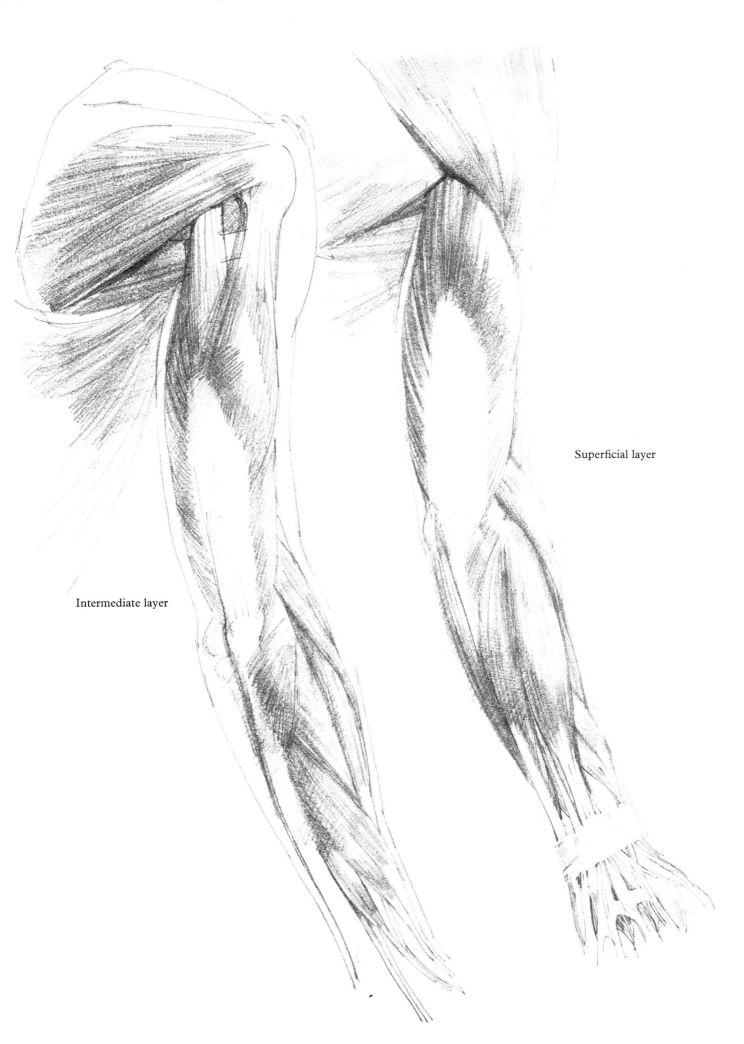

Intermediate layer

Superficial layer

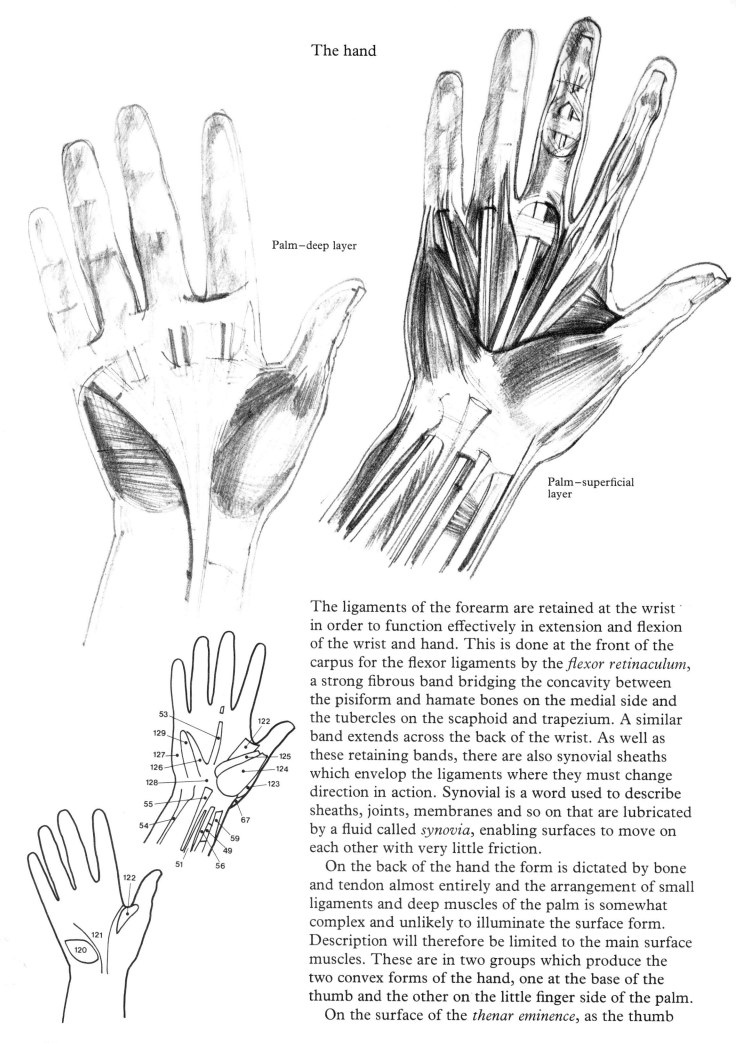

The hand

Palm—deep layer

Palm—superficial
layer

53
129
127
126
128
55
54
59
49
51 56
67
122
125
124
123

122
121
120

The ligaments of the forearm are retained at the wrist
in order to function effectively in extension and flexion
of the wrist and hand. This is done at the front of the
carpus for the flexor ligaments by the *flexor retinaculum,*
a strong fibrous band bridging the concavity between
the pisiform and hamate bones on the medial side and
the tubercles on the scaphoid and trapezium. A similar
band extends across the back of the wrist. As well as
these retaining bands, there are also synovial sheaths
which envelop the ligaments where they must change
direction in action. Synovial is a word used to describe
sheaths, joints, membranes and so on that are lubricated
by a fluid called *synovia,* enabling surfaces to move on
each other with very little friction.

On the back of the hand the form is dictated by bone
and tendon almost entirely and the arrangement of small
ligaments and deep muscles of the palm is somewhat
complex and unlikely to illuminate the surface form.
Description will therefore be limited to the main surface
muscles. These are in two groups which produce the
two convex forms of the hand, one at the base of the
thumb and the other on the little finger side of the palm.

On the surface of the *thenar eminence,* as the thumb

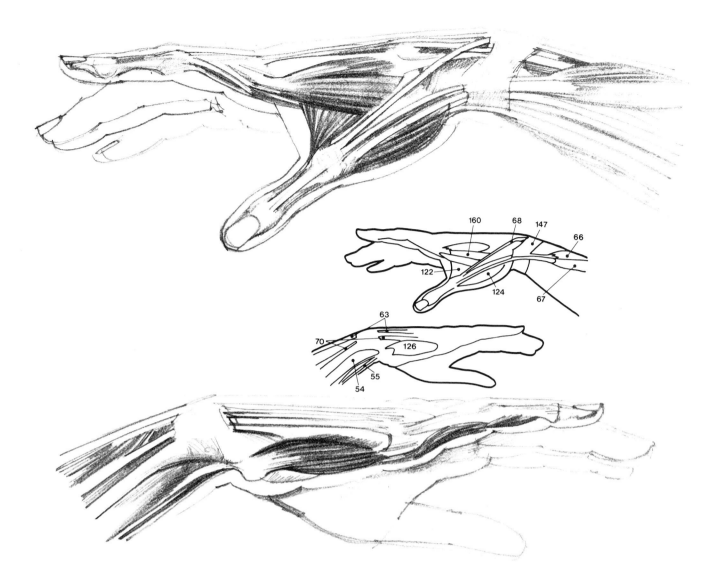

base is called, are two closely associated muscles, the *abductor pollicis brevis* and the *flexor pollicis brevis*. The abductor is thin, reflecting the shape of the fatter muscle underneath, whereas the flexor has both surface and deep parts, the surface head sharing attachments to the flexor retinaculum with the abductor. Both muscles insert at the base of the proximal phalanx of the thumb. Underneath the abductor and giving it form, is a fatter muscle called the *opponens pollicis*. This arises from the flexor retinaculum and the trapezium bone of the wrist, and inserts into the length of the outer edge of the first metacarpal or thumb bone.

On the other, little finger side, three muscles make up the *hypothenar eminence*. They are the *opponens digiti minimi*, the *abductor digiti minimi* and the *flexor digiti minimi*. The opponens is deep to the other two, arising from the hamate bone of the wrist and the flexor retinaculum, and inserting along the length of the fifth metacarpal. Side by side over the opponens, the flexor and the abductor both insert into the base of the little finger. The first arises from the hamate bone and the flexor retinaculum, the second from the pisiform bone and the ligament of the flexor carpi ulnaris.

49 *Pronator quadratus*
51 *Flexor pollicis longus*
53 *Flexor digitorum superficialis*
54 *Flexor carpi ulnaris*
55 *Palmaris longus*
56 *Flexor carpi radialis*
59 *Brachioradialis*
63 *Extensor digitorum*
66 *Extensor pollicis brevis*
67 *Abductor pollicis longus*
68 *Extensor pollicis longus*
70 *Extensor carpi ulnaris*
120 *Palmaris brevis*
121 *Palmar aponeurosis*
122 *Adductor pollicis*
123 *Opponens pollicis*
124 *Abductor pollicis brevis*
125 *Flexor pollicis brevis*
126 *Opponens digiti minimi*
127 *Abductor digiti minimi*
128 *Flexor retinaculum*
129 *Flexor digiti minimi brevis*
147 *Extensor retinaculum*
160 *1st dorsal interosseus*

The thigh I

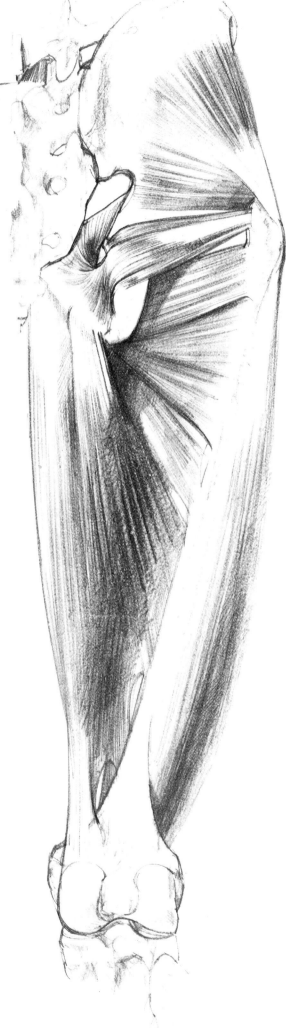

It is important for the anatomist to have a complete understanding of the musculature of the lower limb and its connections with the pelvis. Accordingly, the thigh and pelvic musculature will be examined first, followed by the lower leg. The drawing opposite shows the deep muscles of the *gluteal* (buttock) region and of the flexor aspect of the thigh.

The *adductor magnus* is a very large triangular muscle arising from the ramus of the ischium, fanning out and attaching to the femur from just below the lesser trochanter, down the whole length of the shaft to the medial condyle. Most of the muscle is flat in form, deep in the centre of the thigh and affecting surface form not at all, but the near-vertical medial fibres make a thicker mass which does remain superficial and is responsible for the typical shape of the inside of the thigh.

The *vastus lateralis* is prominent in this drawing, but it is really one of the extensor group of thigh muscles and will be described later.

The *gluteus minimus* is the deepest of three layers of gluteal muscles. Fan-shaped, it arises from the outer surface of the ilium and converges to a deep aponeurosis which ends in a tendon that inserts into the surface of the greater trochanter.

In the section below, which is taken through approximately the middle of the right thigh, the great thickness of the adductor magnus is evident. Its relationship to the superficial flexor muscles of the thigh is illuminating; it is not always easy to read the form in the round from anatomy drawings or even from life – the occasional cross-section is sometimes surprising.

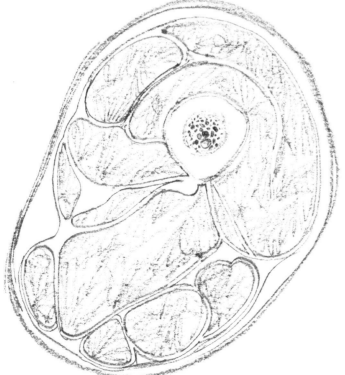

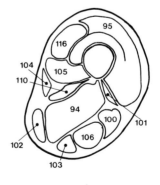

Thigh – cross-section

89 *Gluteus minimus*
90 *Gemellus superior*
91 *Obturator internus*
92 *Gemellus inferior*
93 *Quadratus femoris*
94 *Adductor magnus*
95 *Vastus lateralis*
96 *Gluteus medius*
97 *Piriformis*
98 *Obturator externus*
99 *Gluteus maximus*
 (attachment of deeper fibres)
100 *Biceps femoris—long head*
101 *Biceps femoris—short head*
102 *Gracilis*
103 *Semimembranosus*
104 *Sartorius*
105 *Vastus medialis*
106 *Semitendinosus*
107 *Obliquus abdominis externus*
108 *Obliquus abdominis internus*
109 *Gluteal fascia*

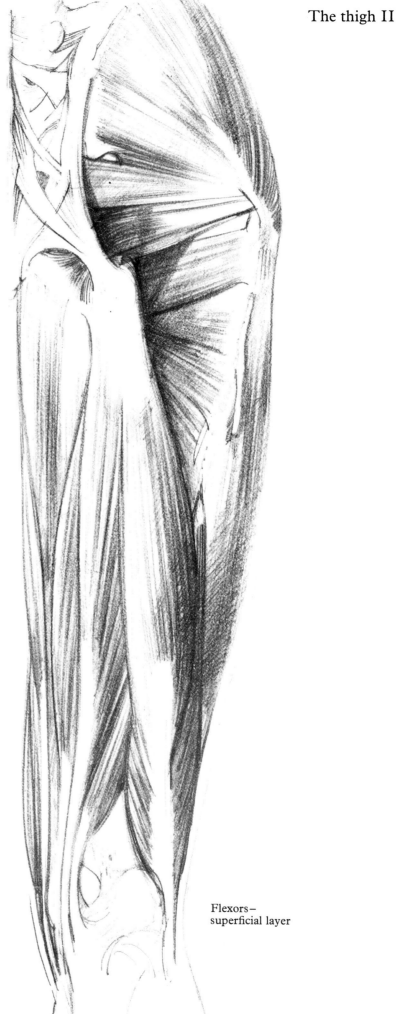

Flexors—
superficial layer

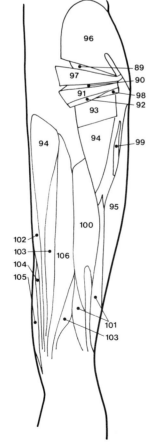

All the superficial muscles of the flexor side of the thigh are shown in the drawing opposite, with the exception of the *gluteus maximus*, which is shown wrapping over to form the familiar buttock shape in the drawing below. Partially underlying the gluteus maximus is the *gluteus medius*. The superficial part is covered by the *gluteal fascia*; this is continuous with the *iliotibial tract*, described later.

All three superficial flexor muscles of the thigh arise from the ischial tuberosity. They are the *semimembranosus*, the *semitendinosus* and the *biceps femoris*: the last of these has two heads, the short head giving the biceps an additional thin origin along a posterior ridge of the femur. Both heads combine together in a tendon that mainly attaches to the head of the fibula, although there are lesser insertions in the surrounding ligaments.

Because of its short muscle fibres and very long tendon, the semitendinosus overlies but does not obscure the semimembranosus. The upper part, close to the origin, is actually connected to the long head of the biceps femoris. About halfway down the thigh its long tendon swings medially, curves round the medial condyle of the tibia and inserts into the upper part of the bone close to the tendons of two muscles from the inside of the thigh, the *gracilis* and the *sartorius*.

The semimembranosus arises from the ischial tuberosity underneath the ligament of the semitendinosus and the biceps femoris and its fibres are partially interwoven with theirs. Its attachments in the middle of the thigh involve deep aponeuroses and are rather complex, but the main tendon emerges to insert on the back of the medial condyle of the tibia. These three muscles are important in flexing the leg and extending the hip joint in order to hold the trunk upright and maintain or regain balance.

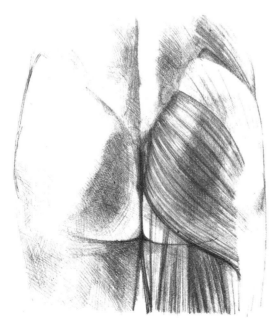

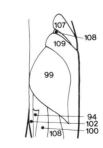

The buttocks

91

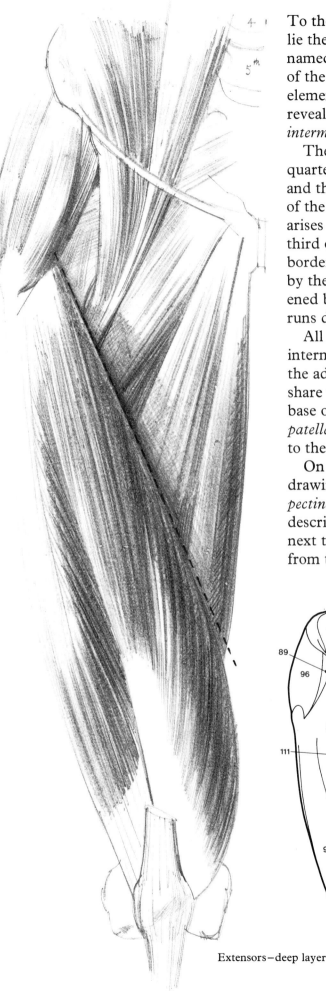

To the left of the dotted line in the drawing on this page lie the *quadriceps femoris*, comprising the four separately named muscles which together form the great extensor of the thigh. In this drawing the superficial central element, called the *rectus femoris*, has been removed to reveal the full extent of the combined *vastus lateralis, intermedius* and *medialis*.

The vastus medialis arises from the lower three-quarters of the length of the medial shaft of the femur, and the vastus intermedius from the upper two-thirds of the front and lateral surfaces. The vastus lateralis arises by a broad aponeurosis attached to the upper third of the back of the femur and including the anterior borders of the greater trochanter. It is largely covered by the *iliotibial tract*, which is a thickened and strengthened band of the fascia that covers all of the area, and runs down the lateral surface of the thigh.

All three vastus muscles also arise from the principal intermuscular septum which divides the extensors from the adductors and flexors, and all three converge to share the quadriceps femoris tendon inserting into the base of patella (some fibres blend with the *ligamentum patellae* in its top surface), and continuing from there to the tubercle of the tibia.

On the right side of the dotted line in the same drawing lie the medial femoral muscles. They are the *pectineus*, the *adductors brevis* and *longus*, and the already described *adductor magnus*. The adductor longus, lying next to the adductor magnus, arises by a thin tendon from the pubis and spreads to insertion by a very thin,

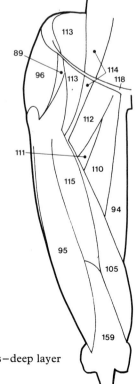

Extensors—deep layer

92

wide tendon into the middle third of the back of the femur. There is only a little space remaining on the middle of the femur shaft for insertions, as the vastus muscles are wrapped around about five-sixths of its circumference. Into this space the adductor longus, the adductors brevis and magnus all manage to insert by thin tendons. Next there is the pectineus, arising from farther out on the pubic ridge of the pelvis and inserting in the femur higher up, near to the lesser trochanter.

The thigh muscles added to complete the superficial musculature in the drawing on this page are the *sartorius* and the *rectus femoris*.

The rectus femoris covers the vastus intermedius, lying to some extent in a trough between the vastus lateralis and medialis. Its fibres are arranged in a bi-pennate form, as shown. It originates from the anterior inferior iliac spine and a rough groove above the hip joint, and gives rise to a single tendon which emerges between the *tensor fasciae latae* and the sartorius and extends over the front of the muscle, sometimes as far as the middle of the thigh. A narrow tendon inserts into the base of the patella with the common quadriceps tendon.

An unusual muscle, very long and strap-like, the sartorius arises from the anterior inferior iliac spine, sweeps across to the inside of the thigh, neatly separating the extensor group from the medial group, and accentuating the angled form of the frontal thigh. It inserts into the medial surface of the tibia shaft and the surrounding fascia and ligament.

27 *Obliquus externus*
89 *Gluteus minimus*
94 *Adductor magnus*
95 *Vastus lateralis*
96 *Gluteus medius*
102 *Gracilis*
104 *Sartorius*
105 *Vastus medialis*
110 *Adductor longus*
111 *Adductor brevis*
112 *Pectineus*
113 *Iliacus*
114 *Psoas major*
115 *Vastus intermedius*
116 *Rectus femoris*
117 *Tensor fasciae latae*
118 *Inguinal ligament*
158 *Ligamentum patellae*
159 *Quadriceps tendon*

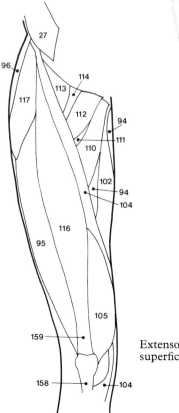

Extensors – superficial layer

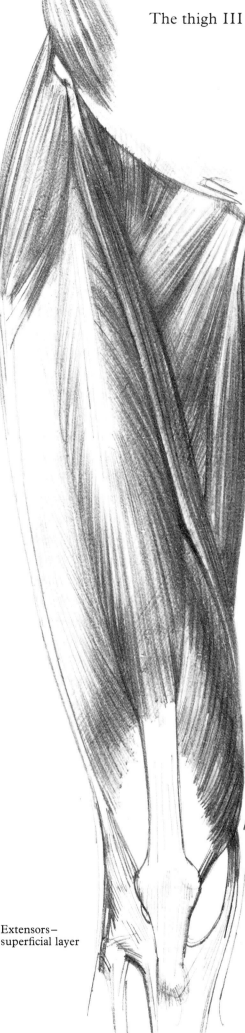

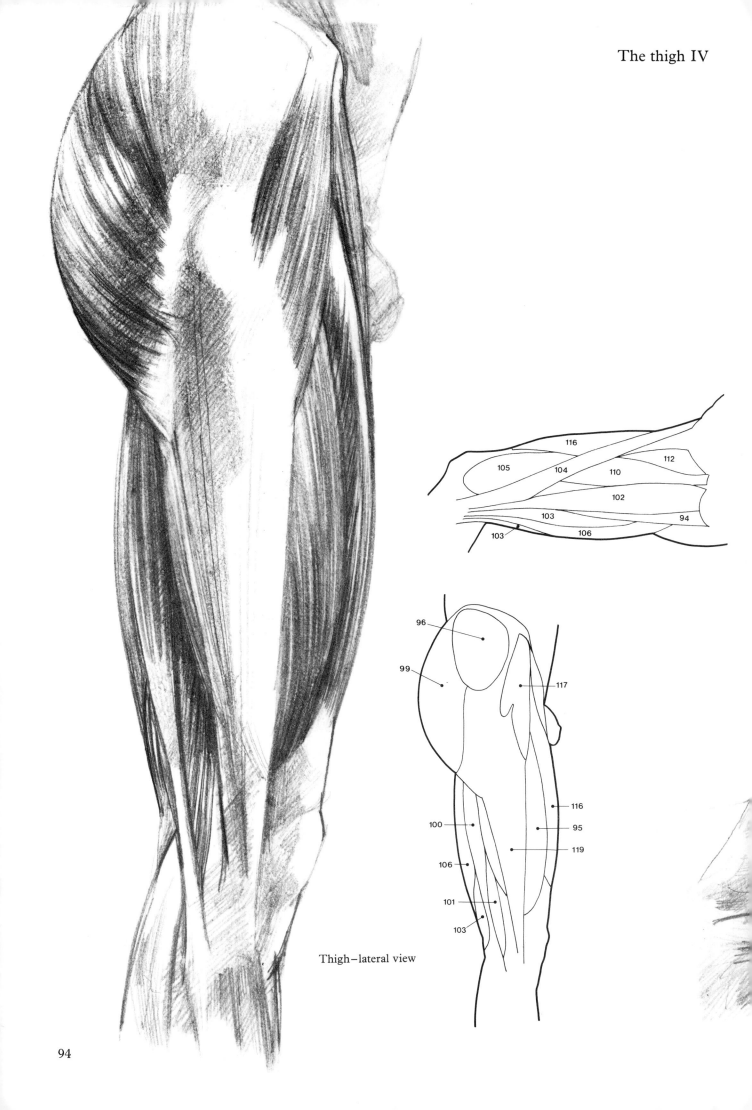

116
105 104 110 112
102
103 94
103 106

96
99 117
116
100 95
119
106
101
103

Thigh—lateral view

There is such a radical difference in the aspects of the outer and inner sides of the thigh that it is necessary to draw them separately although no new undescribed muscles are brought to light by so doing, but the relationship between the extensor, medial and flexor groups is, I hope, further clarified. The drawing below is based on a leg which is being flexed, rotated and slightly adducted at the same time. As a result the sartorius is prominent and takes a straighter than usual line from origin to insertion, rising from the surface at its pelvis origin to leave a pronounced hollow on its medial side.

The mass of the adductors, which includes the adductor longus, gracilis and adductor magnus, can be seen as one large form emerging from the groin. By contrast the rectus femoris and vastus extensors are lying flat and inactive.

On the opposite page the lateral view of the thigh is represented, and the reader's attention is directed especially to the extent and direction of the iliotibial tract. This and other strengthened fascia around the knee, are in fact localized thickenings of the general fascia that covers the whole leg, called in this area the *fascia lata*. In order to clarify the musculature, it is not normally represented in the areas where it is thin and functions mainly as an envelope, but shown only where it becomes akin to a ligament and provides attachments for muscles.

The iliotibial tract is a particularly strong and well-defined example of this local thickening, and it has a flattening effect on the form of the outside of the thigh. Its edges, especially from halfway down the thigh to the knee, are frequently visible under the skin in life. The front edge can appear as a thin groove in the convexity of the thigh, and the lower end of the back edge may appear sufficiently sharply to resemble a muscle's tendon of insertion.

94 *Adductor magnus*
95 *Vastus lateralis*
96 *Gluteus medius*
99 *Gluteus maximus*
100 *Biceps femoris—long head*
101 *Biceps femoris—short head*
102 *Gracilis*
103 *Semimembranosus*
104 *Sartorius*
105 *Vastus medialis*
106 *Semitendinosus*
110 *Adductor longus*
112 *Pectineus*
116 *Rectus femoris*
117 *Tensor fasciae latae*
119 *Iliotibial tract*

Thigh—medial view

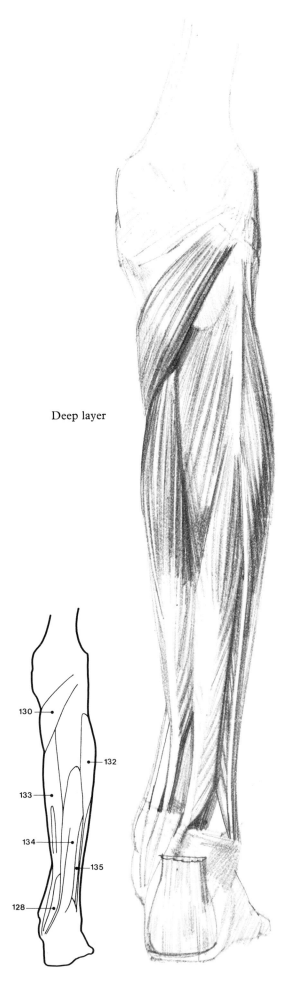

Deep layer

At the back of the lower leg there are effectively three layers of muscles, the deepest of which is drawn on the left, the two intermediate and superficial layers being shown in the drawings opposite.

The deepest of the deep group is the *tibialis posterior*, which has extensive origins, including the shafts of tibia and fibula, the interosseus membrane and surrounding fascia and septa. Its tendon has a synovial sheath which facilitates it to change direction around the medial malleolus to multiple insertions in the navicular, cuneiform and calcaneus bones and the bases of the second, third and fourth metatarsals.

The *popliteus* arises by a tendon from the lateral condyle of the femur, and sweeps across the back of the knee joint to insert into the back of the upper shaft of the tibia. Its tendon of origin emerges from beneath the fibrous capsule of the knee joint.

Two deep flexors, the *flexor digitorum longus* and the *flexor hallucis longus*, also have tendons in synovial sheaths which are led around the underside of the medial malleolus to insertions under the foot; the tendon of the hallucis inserts only into the base of the distal phalanx of the big toe, but the digitorum inserts into the lateral four toes. Their origins are from the shafts of fibula and tibia respectively.

Entirely covering the bodies of these two flexors, the *soleus* muscle is the biggest muscle of the lower leg and is largely responsible for its characteristic outline. Its triple origin is from the upper fibula, a fibrous arch high up between tibia and fibula and a large part of the middle of the tibia shaft. The deeper fibres of this muscle are longer than the superficial ones, and reach down almost to the ankles on each side before joining the main tendon of the heel, the *tendo calcaneus*, known popularly as the Achilles tendon. Shorter superficial fibres join the under-surface of a broad membranous tendon which eventually becomes fused with the tendo calcaneus. A small fleshy muscular slip, called the *plantaris*, arises from above the lateral condyle of the femur and becomes a long, thin tendon which descends over the soleus to insert close to the medial side of the tendo calcaneus.

Overlying the soleus, and often thought to comprise the bulk of the calf muscle, is the *gastrocnemius*. It is in fact relatively thin and mainly tendinous, but the ability of its two heads, especially the medial one, to contract and shorten severely makes it a conspicuous feature of the back of the leg. The medial head arises from above the medial epicondyle of the femur, and the lateral head from slightly lower on the lateral condyle. Both arise by strong tendons and the bellies of the two remain separate from each other. They insert together into the tendo calcaneus.

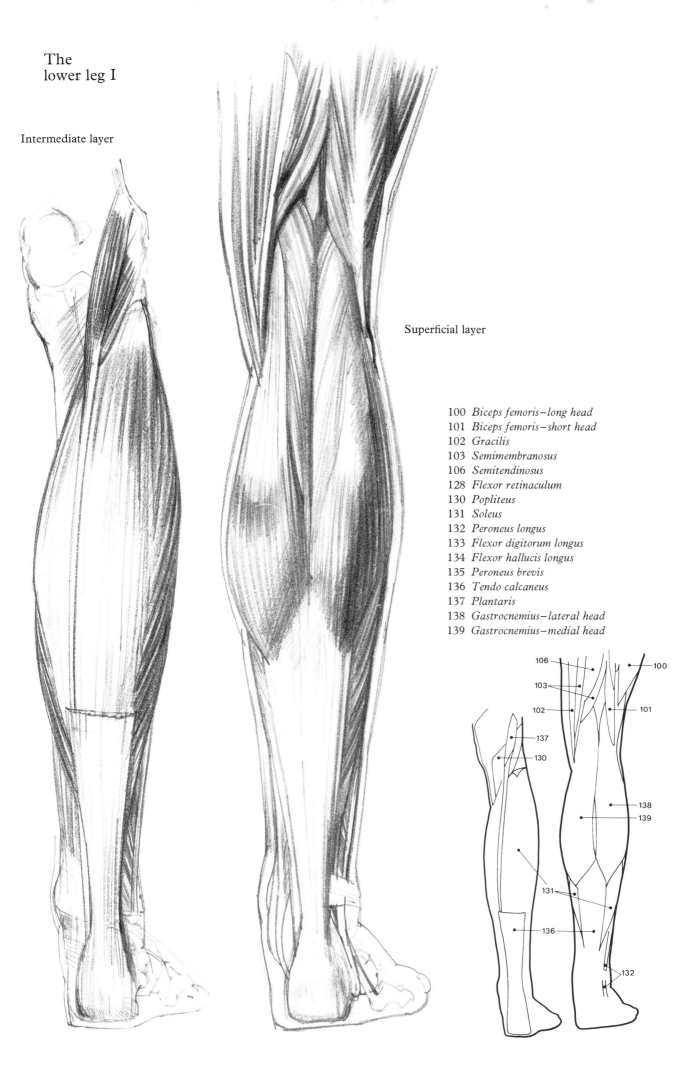

The
lower leg I

Intermediate layer

Superficial layer

100 *Biceps femoris—long head*
101 *Biceps femoris—short head*
102 *Gracilis*
103 *Semimembranosus*
106 *Semitendinosus*
128 *Flexor retinaculum*
130 *Popliteus*
131 *Soleus*
132 *Peroneus longus*
133 *Flexor digitorum longus*
134 *Flexor hallucis longus*
135 *Peroneus brevis*
136 *Tendo calcaneus*
137 *Plantaris*
138 *Gastrocnemius—lateral head*
139 *Gastrocnemius—medial head*

Front view

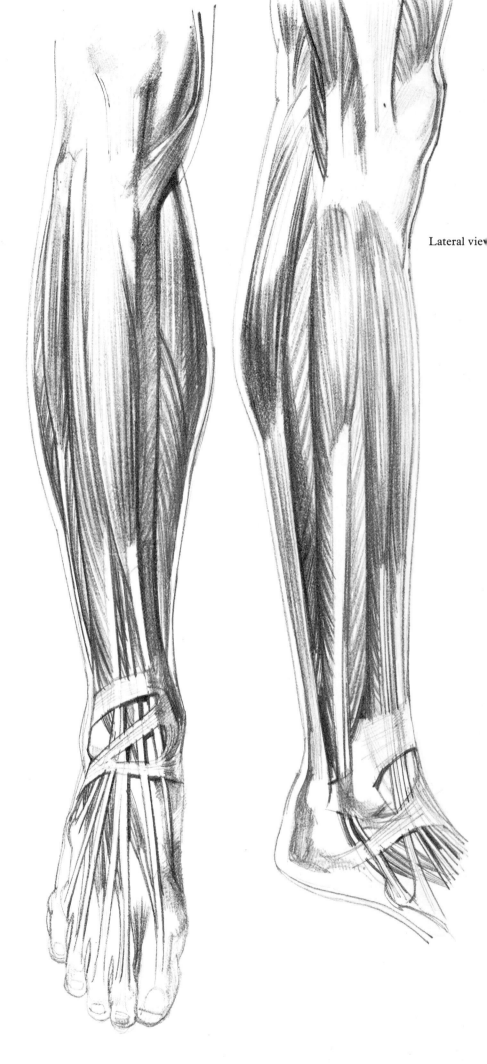

Lateral view

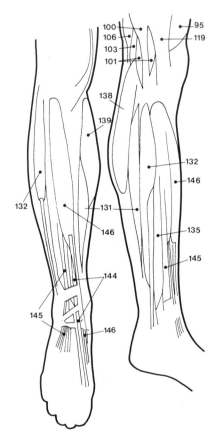

The main extensor muscle at the front of the lower leg is the *tibialis anterior*. It lies alongside the tibia, lateral to it and for its whole length, although its tendon crosses medially to insert into the medial cuneiform bone and the adjoining part of the base of the first metatarsal bone. It arises from the lateral condyle and from almost half the length of the lateral surface of the tibia, the interosseus membrane and adjoining fascia and septa. The tendon can be clearly seen when the muscle is flexed, as in dorsiflexion, and when the foot is turned inward at the ankle joint (inversion). Both movements are combined in walking when the heel is presented to the ground at the beginning of each step.

The *extensor digitorum longus* is the main extensor of the toes, arising from the lateral condyle of the tibia and the upper three-quarters of the fibula, the interosseus membrane and other associated fascia and septa. Its tendon divides into four on the top or dorsal surface of the foot, fanning out to insertions in the distal phalanges of the second to fifth toes. From between this muscle and the tibialis anterior, emerges the lower part of the *extensor hallucis longus* and its tendon, which extends to the distal phalanx of the big toe. It arises from the middle three-fifths of the fibula next to the origin of the extensor digitorum longus.

Last in this group of extensors come the *peroneus longus* and *brevis*. They are properly described as the lateral group operating as evertors, or turning muscles of the foot, but they are certainly also active in dorsiflexion, and if keeping to the simple division into flexors and extensors, they must stay with the latter.

The peroneus longus arises from the head and upper two-thirds of the fibula, alongside the other extensors, and other fascia and septa. It ends in a long tendon which is led by a groove around the lateral malleolus in a synovial sheath shared by the peroneus brevis. Its tendon then dives under the foot, crossing the sole obliquely to insert into the lateral side of the medial cuneiform bone and the base of the first metatarsal.

The peroneus brevis arises lower on the shaft of the fibula, and descends behind the peroneus longus. Its tendon shares the path round the lateral malleolus with the peroneus longus but attaches to the lateral side of the foot at the base of the fifth metatarsal bone.

As at the wrist, all the tendons, except the big tendo calcaneus, are retained at the ankle by retinacula. At the front of the ankle there are two, the upper and lower *extensor retinacula* and on the medial side, the single *flexor retinaculum*. Some tendons are led under one and through a loop in the other; some tendons even go through one retinaculum, or beneath two or more. All are positioned and lubricated by synovial sheaths as they pass the retinacula.

The leg

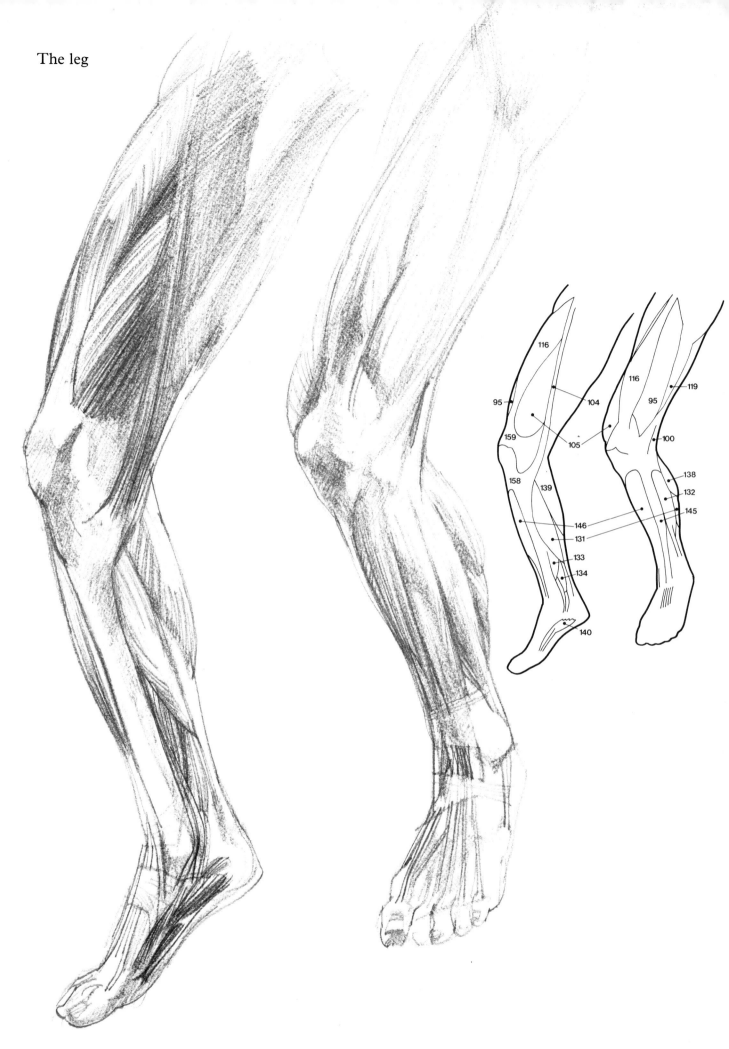

95 *Vastus lateralis*
100 *Biceps femoris – long head*
104 *Sartorius*
105 *Vastus medialis*
116 *Rectus femoris*
119 *Iliotibial tract*
131 *Soleus*
132 *Peroneus longus*
133 *Flexor digitorum longus*
134 *Flexor hallucis longus*
135 *Peroneus brevis*
138 *Gastrocnemius – lateral head*
139 *Gastrocnemius – medial head*
140 *Abductor hallucis*
145 *Extensor digitorum longus*
158 *Ligamentum patellae*
159 *Quadriceps tendon*

The intention of these drawings is to clarify the links between the thigh and lower leg musculature and also to show their relationship to the knee joint.

A large area of the tibia is not actually covered by muscle or tendon; almost the entire length of the medial front surface of the bone is covered only by skin and fascia. Around the knee joint are two retinacula not yet mentioned – the medial and lateral retinacula of the patella. These are virtually extensions of the tendon of the quadriceps femoris spreading each side of the patella, and merging into the fibrous capsule of the joint before they eventually insert into the upper extremity of the tibia.

The *ligamentum patellae* is also a continuation of the quadriceps femoris tendon, and joins the under-surface of the patella to the tuberosity of the tibia. Superficial fibres continue the quadriceps tendon right over the upper surface of the patella.

101

The foot

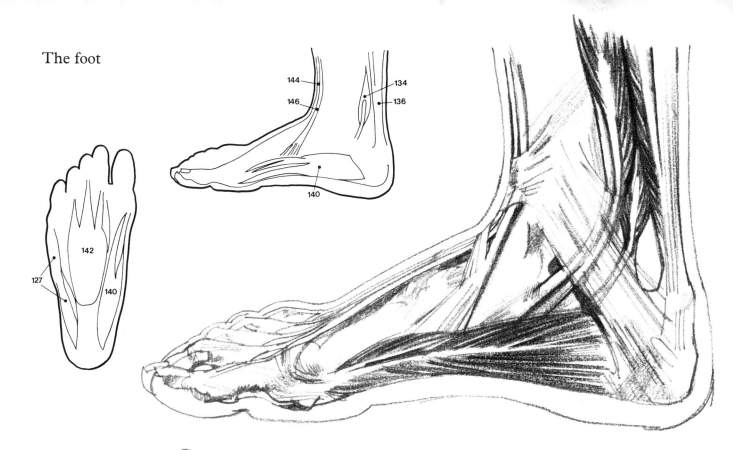

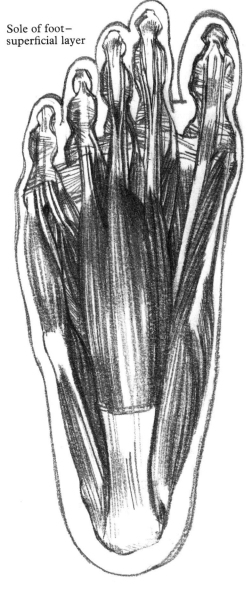

Sole of foot—
superficial layer

Most of the musculature of the foot is extrinsic; in other words it consists of tendon extensions of muscles of the leg. The intrinsic muscles are almost all on the sole or plantar surface; on the top or dorsal surface there is only one: the *extensor digitorum brevis* which arises from the upper lateral surface of the calcaneus bone and ligaments and fascia in that area. It divides into four fleshy parts from which narrow tendons extend to join the tendons of the extensor digitorum longus to insert into the upper surface of the second, third and fourth toes. Another tendon slants across the foot to join the tendon of the extensor hallucis longus to the big toe. Although the muscle is small and is deep to the long extensor, its main belly can often be seen at the surface, just above the tendon of peroneus brevis.

In the sole of the foot there are four layers of muscles. Overlaying them all is the *plantar aponeurosis*, the central part of which is quite thick. Superficial to that there are the layers of fat and the skin; on the parts of

127 *Abductor digiti minimi*
132 *Peroneus longus*
134 *Flexor hallucis longus*
135 *Peroneus brevis*
136 *Tendo calcaneus*
140 *Abductor hallucis*
141 *Plantar aponeurosis*
142 *Flexor digitorum brevis*
143 *Peroneus tertius*
144 *Extensor hallucis longus*
145 *Extensor digitorum longus*
146 *Tibialis anterior*
147 *Extensor retinaculum*
160 *Extensor digitorum brevis*

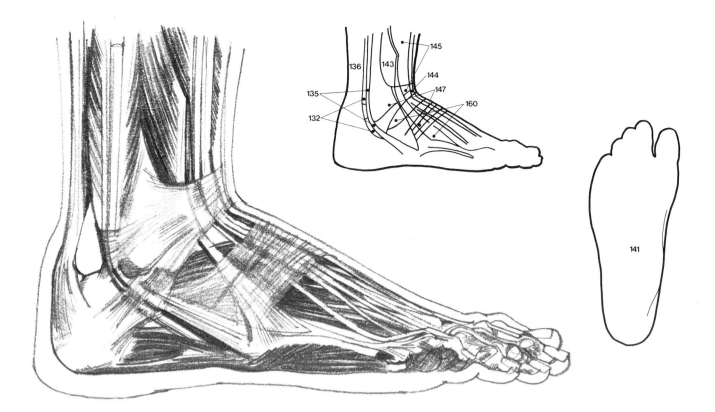

the sole that make contact with the ground these are especially thick. In view of the relative unimportance of the deep muscle layers of the palmar foot in affecting outer form, only the superficial layer is described here.

The *abductor hallucis* arises by a short tendon from the medial side of the calcaneus and from the plantar retinaculum, and runs along the medial side of the foot to insert, together with a deeper muscle, the *flexor hallucis brevis*, into the base of the big toe. The *flexor digitorum brevis* lies centrally in the foot, immediately deep to the central plantar aponeurosis. It arises by a narrow tendon from the calcaneus, from the centre plantar aponeurosis and adjacent fascia and septa, and inserts by four tendons into the lateral four toes. The superficial muscle of the outer edge of the foot is the *abductor digiti minimi*. It arises from tuberosities of the calcaneus and surrounding tissue, and passes over the base of the fifth metatarsal by a smooth groove and inserts into the base of the little toe.

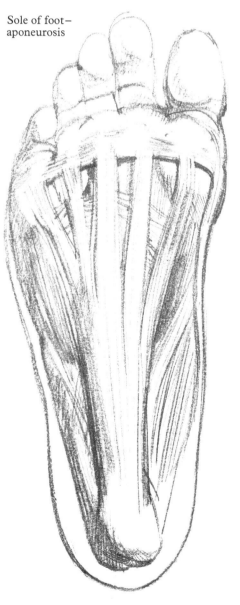

Sole of foot—
aponeurosis

Hyoid

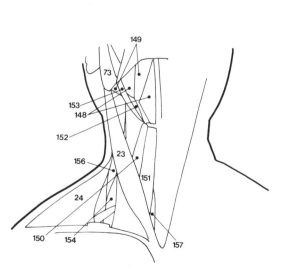

The muscles of the back of the neck have been illustrated and described with the superficial muscles of the back on page 64.

Here the front and side of the neck are illustrated. Involved in nearly all the muscular arrangements at the front of the neck is a bone not previously mentioned. It is the *hyoid*, a small U-shaped bone which is suspended by the styloid processes of the temporal bones of the skull by the *stylohyoid ligaments*. Virtually its whole surface is occupied by muscular insertions. In life it takes up a position at the junction of the underside of the jaw with the neck, just above the thyroid cartilage or Adam's apple.

The *digastric, mylohyoid* and *stylohyoid* muscles are all above the hyoid bone and occupy the space under the mandible in a manner that can be understood better by reference to the illustration than by description. The digastric perforates the stylohyoid, its posterior belly attaching to the temporal bone.

Attaching to the lower surface of the hyoid bone and pulling downwards are two more paired muscles, the *omohyoid* and the *sternohyoid*. The latter arises from the medial end of the clavicle, behind the *sternocleidomastoid* and proceeds directly upwards to the body of

the hyoid. The omohyoid makes a sudden change in direction about two-thirds of the way down its length, the lower part inclining outwards to its origin on the upper border of the scapula. To maintain this turning angle, a band of fascia attached to the first rib and the clavicle ensheaths the intermediate tendon at the point of the turn, holding it down.

The *scalenus muscles*, anterior, medius and posterior, join the first and second ribs to the transverse processes of the axis and third, fourth and fifth cervical vertebrae.

The most prominent surface form in the front and side of the neck is the *sternocleidomastoid*. At its lower end it has two heads, the medial head attaching to the *manubrium* of the sternum, the lateral to the medial third of the clavicle. They unite almost immediately and assume together a more rounded form, ascending obliquely to insert by a strong flat tendon into the lateral surface of the mastoid process. The form of the sternocleidomastoid is especially noticeable in life when the head is turned strongly to one side.

Overlaying the whole of the front and side of the neck is a broad sheet of fascia called the *platysma*, which is only evident in extreme facial expressions of horror or anguish, or when great effort is being exerted.

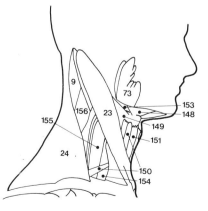

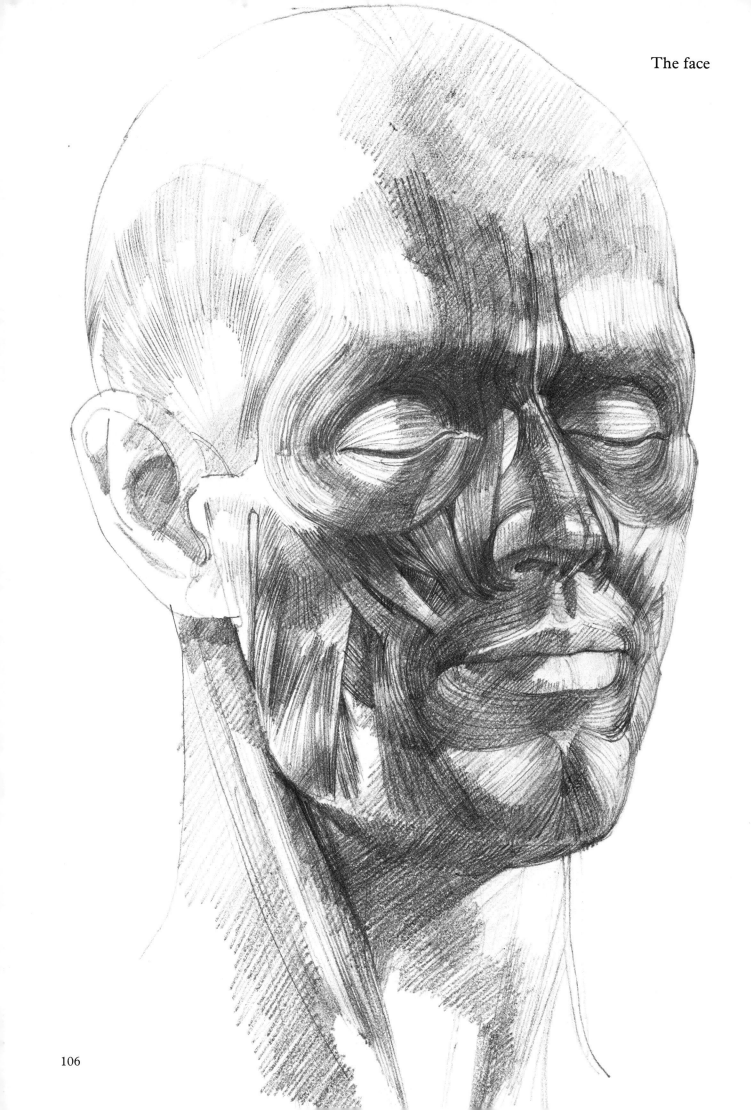

The muscles of the head and face modify the form established by the bony structure comparatively little. When the face is relaxed, the musculature fills the hollows and smooths the angular transitions, but otherwise allows the basic form of the skull to show through. Most of the muscles are concerned with movement of the features where little force is required.

The muscles acting on the mandible are exceptions to this. Known as the muscles of mastication, they are capable of exerting considerable force – the circus performer, for instance, can suspend the whole body from the clenched teeth. The *masseter* is the most prominent of this group, and can be seen at the angle of the jaw when it is clenched. Its three layers all arise from the zygomatic arch and insert into the mandible.

The *temporalis* is a large fan-shaped muscle, and its origin fills the whole depression of the temporal area. It converges to a tendon passing behind the zygomatic arch to its insertion; this virtually covers the coronoid process and extends down the front border of the ramus of the mandible.

Returning to what might be called the muscles of expression, one that produces its own form to some degree, rather than following what underlies it, is the *depressor anguli oris*. It arises from the mandible just lateral to the chin and blends into the corner of the mouth and the *orbicularis oris*.
The *depressor labii inferioris* covers the chin and when inactive its form is responsible for the rounded shape of the chin in life. Intermingled fat in the superficial fibres also contributes to this, and possibly also to the frequently dimpled surface when the muscle is active.

The orbicularis oris, usually depicted as a band simply surrounding the mouth, is rather more complicated than this, comprising fibres from most of the surrounding muscles enmeshed together.

Muscles numbered 81–84 on the drawing opposite are all considered to be muscles of the mouth. The first, the *levator labii superioris alaeque nasi* arises from the upper part of the frontal maxilla, between eye and nose, running downwards to insertions by two slips into the cartilage of the nose and into the upper lip. The *levator labii superioris*, the *zygomaticus major* and *minor* arise from just below the zygomatic arch.

The *orbicularis oculi*, on the other hand, is a fairly simple sphincter-like muscle, although the *palpebral* or eyelid parts can act independently of the orbital parts.

Covering the whole of the dome of the skull from the eyebrows to the base of the skull is a broad fibro-muscular layer called the *occipito-frontalis*. The frontal muscular layers are thus joined to the occipital parts by an aponeurosis called the *galea aponeurotica*.

23 *Sternocleidomastoid*
72 *Temporalis*
73 *Masseter*
74 *Buccinator*
75 *Occipito-frontalis*
76 *Corrugator supercilii*
77 *Oculi–orbital part*
78 *Oculi–palebral part*
79 *Procerus*
80 *Compressor naris, dilatator naris*
81 *Levator labii superioris alaeque nasi*
82 *Levator labii superioris*
83 *Levator anguli oris*
84 *Zygomaticus major*
85 *Zygomaticus minor*
86 *Depressor anguli oris*
87 *Depressor labii inferioris*
88 *Orbicularis oris*

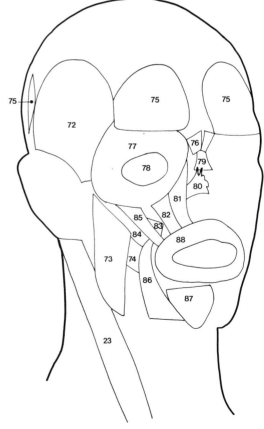

Surface Form

When drawing the live standing figure much of one's time and energy is taken up by the search for the precise relationship between head, backbone, pelvis and feet.

If, in a relaxed standing position, the weight of the body is not distributed exactly equally and one leg takes more of the weight than the other, then the leg taking the weight locks at the knee and the pelvis tips to allow the other leg to unlock and relax. To compensate for this imbalance of the figure, the spine curves, setting the shoulders at a compensating angle and placing the head exactly above the altered centre of gravity.

From the back view, lateral flexion of the spine is clearly visible and the tilt of the pelvis can be deduced from the posterior superior iliac spines; these are clearly visible in the photographs on this page as two dimples forming an inverted triangle. From the front, too, the iliac crest can usually be detected and the tilt of the pubic triangle helps to corroborate the attitude of the pelvis.

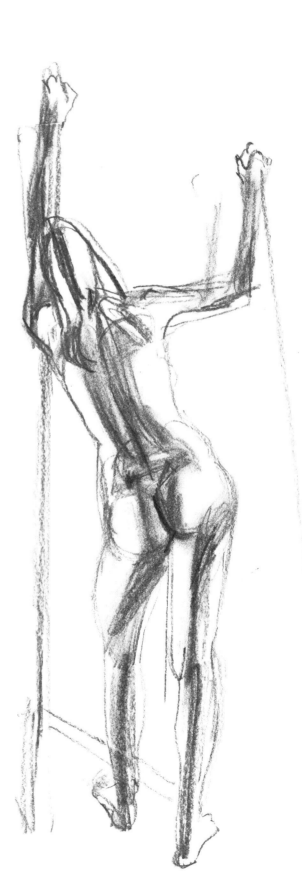

Muscular structure is almost always less easily seen and identified in the female subject than in the male. Apart from the generally lighter musculature of the female, there is also often a thick layer of subcutaneous fat which blurs and softens the outlines of individual muscles and contributes to the smooth roundness of the female contours.

Nevertheless, clues can be found to the internal structure. The photograph and drawn analysis on this page shows how dominant the twin rope-like forms of the deep erector spinae group can be. Although the outlines of the trapezius are not as sharp as, for example, that of the male subject on the previous page, it is possible to see the bunching of the middle fibres, creating the tell-tale dimple at the medial end of the scapula spine. A depression extends downwards and indicates the medial edge of the scapula. This is usually a strong

form of the upper back, but when the arm and shoulder are relaxed, it shows instead as a prominence, a ridge where the plane of the shoulder turns inwards towards the backbone.

A useful landmark here for the artist is the triangle at the base of the spine, bounded by lines joining the depressions over the posterior superior iliac spines and the beginning of the division of the buttocks where lies the coccyx. This triangle loosely outlines the sacrum, and is often covered by a pad of fat in the female. It is a sure indication of the disposition of the pelvis. In the pose of the larger drawing there is little other evidence of the pelvic position, since the iliac crests do not show very clearly.

The narrowing of the shoulders in this pose results from the greater relaxation of the weight-taking scapulae, compared with the pose in the photograph.

7 *Erector spinae*
24 *Trapezius*
30 *Posterior superior iliac spine*

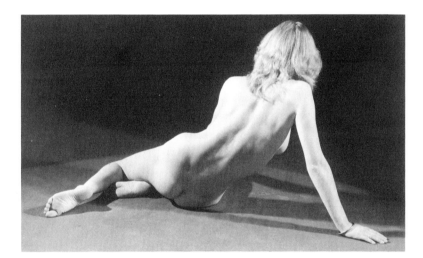

When the figure reclines, gravity exerts its pull across the body at right-angles to the more normal downward pull on the erect figure. As a result, those parts of the structure which are rigid and resistant to the gravitational pull, maintain their position, while the softer tissues are pulled into hollows, or spread over underlying solid structures.

This effect is evident in the sunken abdomen of the girl in the drawing; the iliac crests figure as twin prominences, with a hammock-like form strung between them and the similarly upstanding lower outlet of the thorax. This effect, incidentally, is accentuated by the position of the arms; their extension raises the thorax.

Contrast this with the thorax of the model in the photograph. Although the iliac crests are very evident, the thorax is much less convex in form, so that the 'hammock' in a sense is extended right to the shoulder supports. Note also how the soft tissue of the breasts is flattened against the resilient thorax and pulled outward and downward to an extent, to follow the curvature of the rib cage.

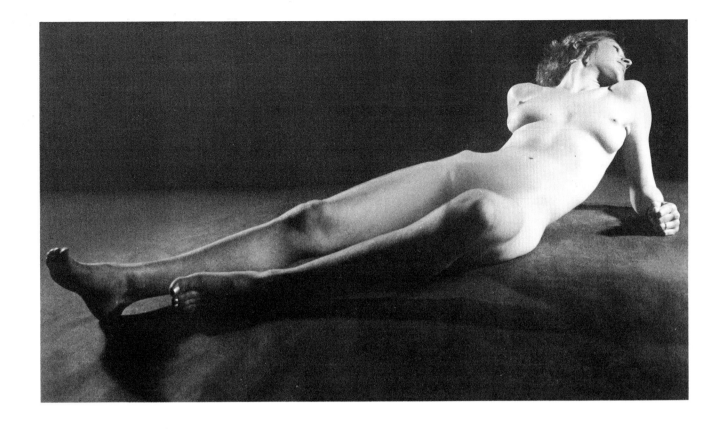

These drawings continue the theme of the previous pages from a different view point. In the smaller drawing, the abdominal hollow between thorax and iliac crests has been exaggerated by positioning the arms above the head, and can be compared with the large drawing, in which the arms are by the side.

Better muscle tone in the model for the large drawing has contributed to the clear twin forms of the rectus abdominis divided by the groove of the linea alba, undulating over the xiphoid process to the line of the sternum.

The small photograph is a slight variation on the theme, with the pelvis now turned so that gravity pulls the relaxed abdominal tissues downward away from the left pelvic girdle. Again the tautness of this young model makes the effect of gravity less striking than usual. Slacker musculature on a bonier form would leave the upper iliac crest more prominent above an initial hollow, with the viscera pulled across the body and appearing as a convex form lying on the lower side of the abdomen.

There is a tendency to see anatomy in terms of architectural elevations from various set views. But the figure may be often seen from high or low eye levels, from the head or feet end when reclined, or even occasionally in plan view. All the poses on this spread are viewed from high eye levels; the resultant foreshortening can produce surprising juxtapositions. In the left-hand figure on the opposite page, the model's far knee is almost on a level with the pubis, and the heel of that leg appears well above the knee of the near one.

Many large changes of plane are also more obvious when viewed from nearer one end of the figure than the other. The upper plane of the shoulders down to the spine of the scapula is very strongly seen in the right-hand figure, after which the narrowing form of the back is angled down and away from the eye to 'insert' into the haunch form as the lumbar curve swings back, presenting the plane of the sacrum at a similar angle to that of the upper back.

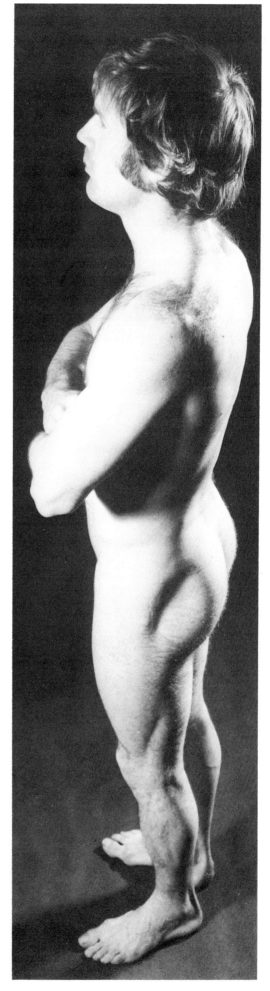

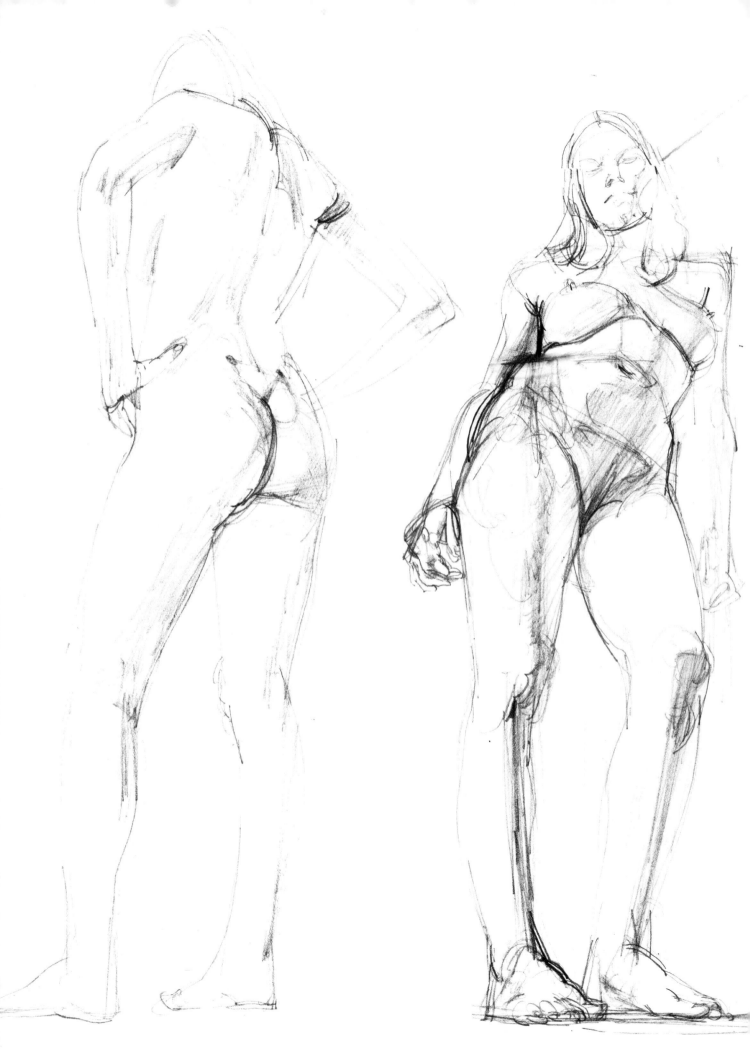

A low viewing angle provides a slightly unfamiliar perspective, as does a high one; both can clarify forms and their inter-relationship in a way that a straight view does not. The shape of cross-sections, particularly, becomes much easier to estimate. Fairly subtle shifts of weight to achieve balance are also accentuated.

Looking up at the figure, as in the right-hand drawing opposite, the contours of the frontal and near-side planes of the body can be clearly interpreted. The flat plane across the shoulders, the more rounded rib cage defined by the breasts resting upon it, the flat-topped convexity of the abdomen just above the navel, the rather flatter plane across the lower abdomen and the gradual twist as one plane succeeds the next, are all more obvious when the perspective is foreshortened.

The model's right shoulder appears close to her right hip, whereas her left shoulder and hip are much more distant from one another, thereby making the already considerable pelvis swing even more evident.

A low-level view of the back of the standing figure (far left) is revealing about the angles of scapulae spines. From this view the form of the back turns away out of sight at their ridges, and the shoulder and neck are well hidden.

The pelvis tilt in this case is towards the viewer and is thus to an extent cancelled out by the low eye level, but the straight supporting leg, clenched right gluteus and relaxed left leg combine to tell the story of weight transference in equilibrium.

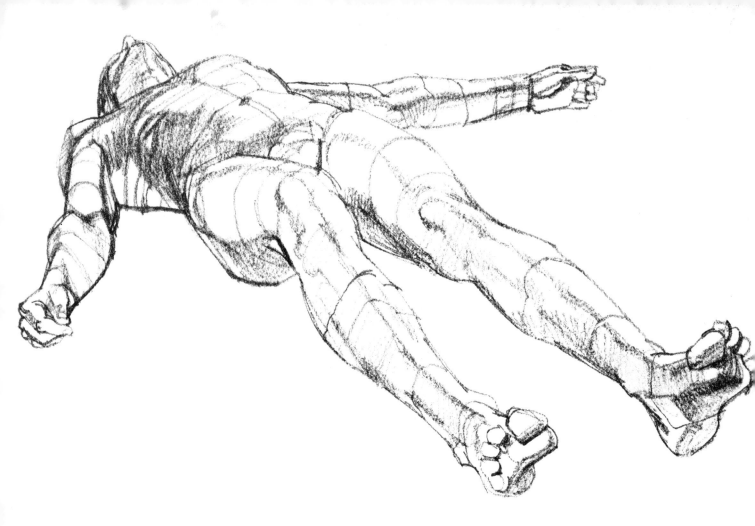

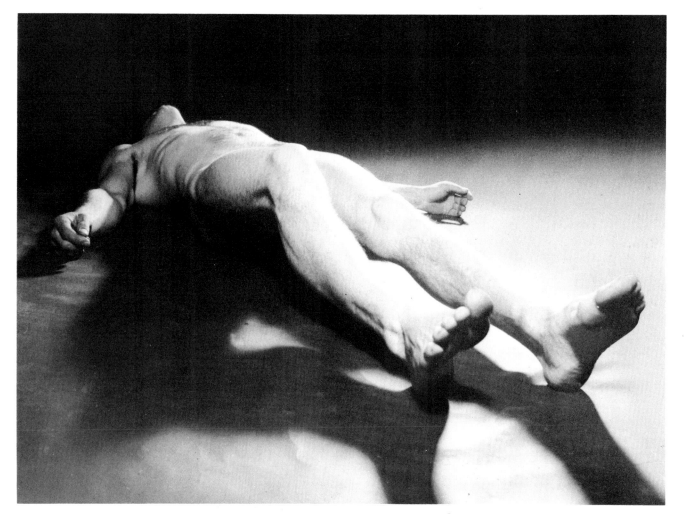

A rather different kind of foreshortening occurs when observing the prone figure from a position near the head or feet. Since the legs, pelvis and vertebral column are relieved of their support activity, the whole body adopts a completely different equilibrium. Although the lack of tension in a supporting leg and the resultant tilts of the pelvis indicate this different equilibrium, the pulling of the softer tissue towards the floor is not very evident in this taut-muscled subject. However, it is the revelation of limb sections by foreshortening that I consider of primary interest here.

Consider the foreshortened right arm of the model in the photograph opposite below. Biceps can be seen to occupy the top of the wall-like form, which inclines away at the forearm with the brachioradialis and extensor carpi radialis uppermost. At the wrist the wall is upright again. Similar cross-sectional changes occur in the thigh.

In the drawing I have tried to stress and clarify these changes by lines running around the foreshortened forms. In such relaxed poses, heavy musculature tends not only to be undefined and unrevealing of its inner structure, but also to hide by its bulk much of the skeletal structure.

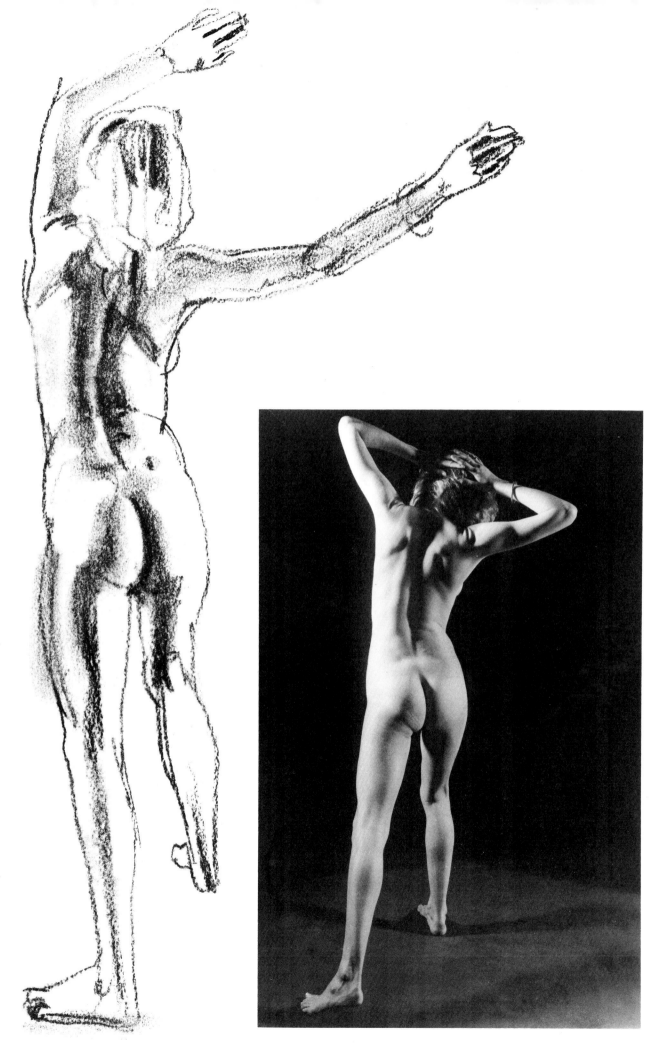

Raised arms necessitate the rotation of the scapulae, and the medial border usually becomes much more prominent than in the relaxed arms position. In a lighter muscled female back, the spine of the scapula is likely to be seen as a prominence whereas the heavier musculature of the male leaves it as a division between the trapezius above and the infraspinatus below.

As the arm is raised higher above the head the scapula is forced to rotate more, and the lateral border and even the lower angle eventually pushes out the form of the latissimus dorsi to break the smooth line.

The action of raising one or both arms also has the effect of unbalancing the body forward, necessitating activity in the erector spinae group. This can be seen with great clarity in the photographs on this page. Note also the disappearance of the acromion between the bunched deltoid and the upper fibres of trapezius.

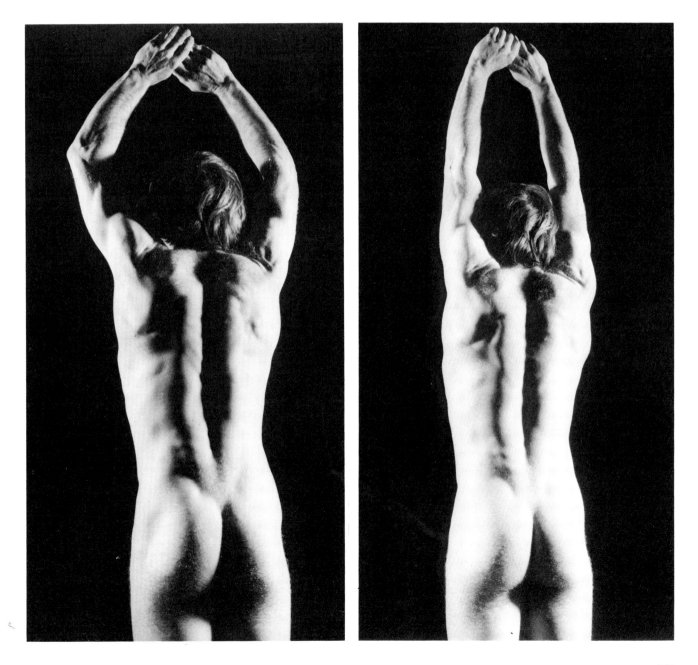

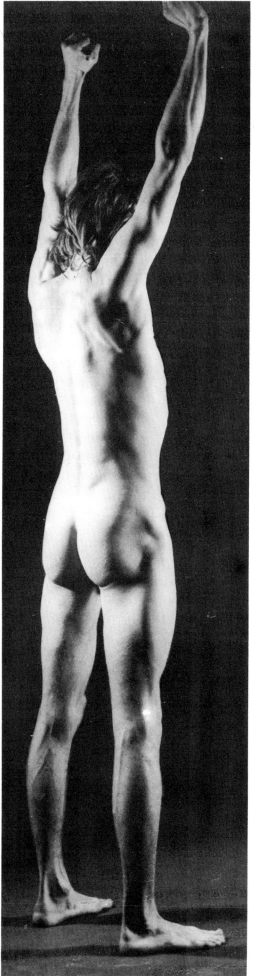

These drawings and photograph show the arms and shoulders extended, demonstrating rotation of the scapula and stretching of the latissimus dorsi.

On the back of the standing figure, the trapezius is strongly active and is bunched into an unfamiliar knotted form, but the upper border of the latissimus dorsi can be clearly seen sweeping round over the lower part of the scapula and upwards to its insertion in the humerus. Except in heavily muscled males, the vertebral edge of the scapula is almost always one of the most dominating forms of the upper back, visible through and sometimes appearing to cut across the lower border of the trapezius.

This apparent division of the trapezius is especially clear when, as often occurs, the edge of the scapula coincides with the junction between the thoracic fibres of the trapezius and the triangular tendon by which they insert into the tubercle of the crest of the scapula. The flat, tendinous triangle appears discontinuous with the rest of the trapezius and merges with the infraspinatus which it overlays.

It is worth noting that in well-defined musculature the infraspinatus can often bunch into two discernibly

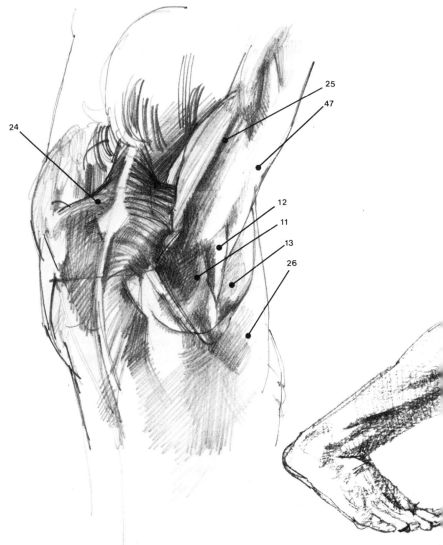

separate forms, combining with the teres minor to produce quite a bumpy surface on the scapula. The teres major can also be seen clearly in the photograph, separated from the teres minor by the active long head of the triceps.

The drawing shows a similar extension of the arm and shoulder, but here the arms are supporting the weight of the body, the trapezius being less active. Holding the scapula in its rotated position is the serratus anterior, its costal insertions very sharply defined.

On the left arm, the *cubital vein* curves over the tendon of the biceps. Although it is beyond the scope of this book to consider the venous system in detail, occasionally a vein shows as a prominent superficial feature. When this occurs, the vein is identified.

11 *Infraspinatus*
12 *Teres minor*
13 *Teres major*
15 *Serratus anterior*
24 *Trapezius*
25 *Deltoid*
26 *Latissimus dorsi*
47 *Triceps−long head*
96 *Gluteus medius*
100 *Biceps femoris−tendon*
117 *Tensor fasciae latae*
119 *Iliotibial tract*

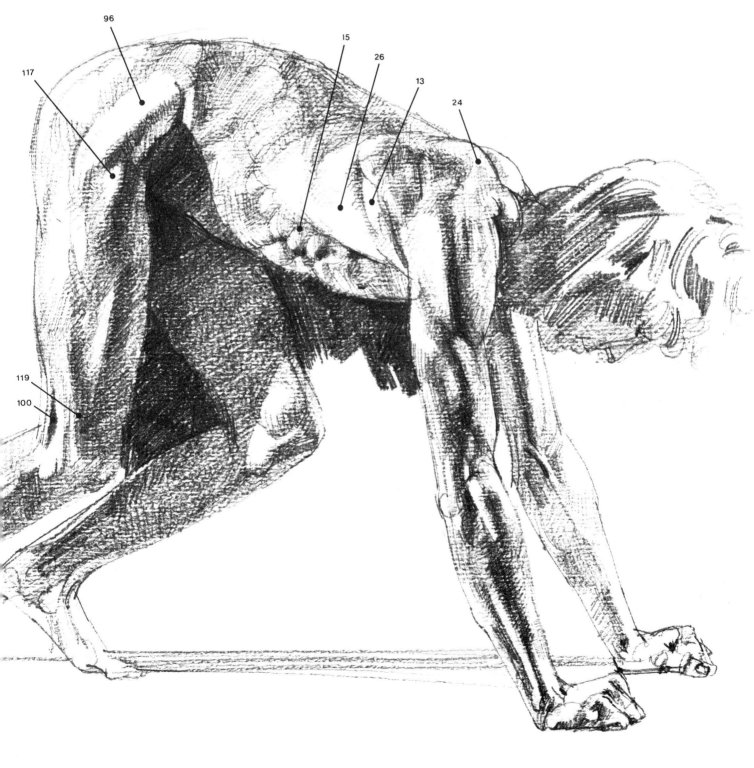

From the front view, the arms raised pose seems to present further difficulties for the student, even though the structure of the underarm is quite simple. The latissimus dorsi and teres major muscles insert close together high up on the medial surface of the shaft of the humerus on the medial side of the triceps, and the teres minor passes the other side of the long head of the triceps to its insertion in the head of the humerus. It therefore follows logically that the lateral side of the armpit, from the front view, will be composed of the triceps stretched upwards, with the combined forms of teres major and latissimus dorsi swinging up and round to disappear medially to their insertions in the humerus. An annotated drawing on this can be found on page 76.

The inner, medial border of the underarm is formed principally by the pectoralis major and to a small extent the coracobrachialis and biceps. In the hollow formed by these two stretched forms, hair, tissue and lymph glands obscure the serratus anterior, which begins to show through a little lower down.

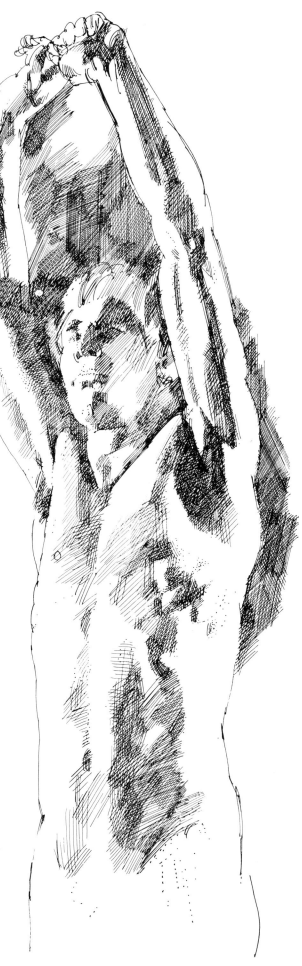

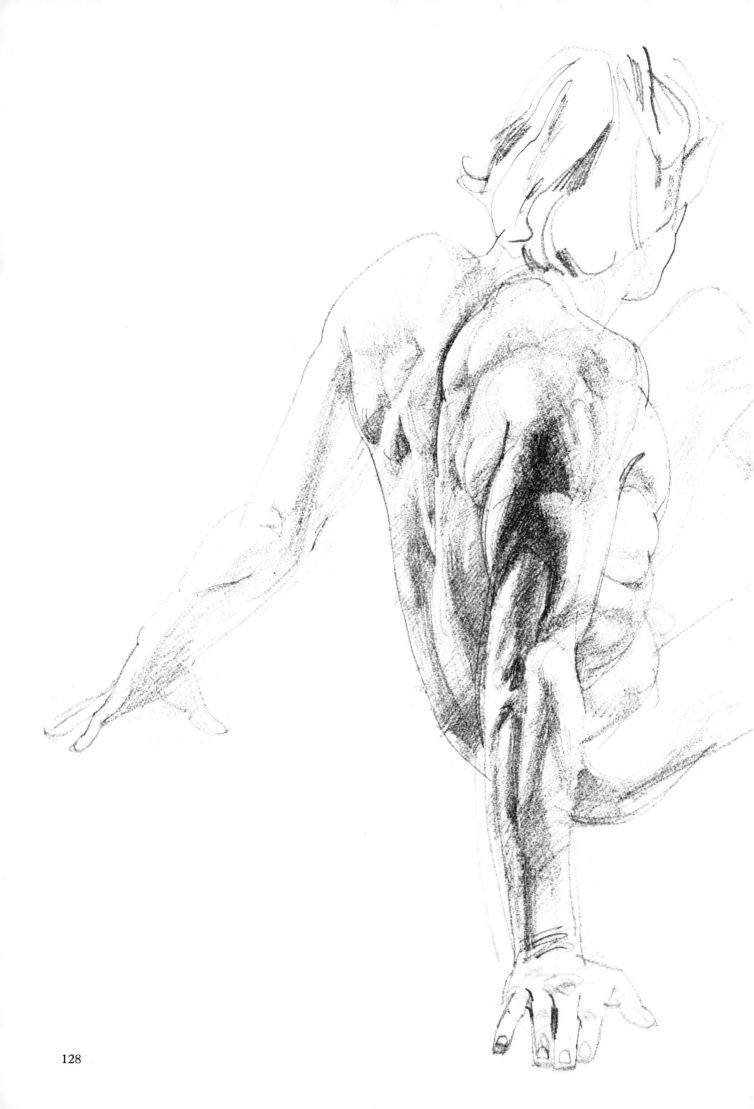

The drawings on these pages examine principally the relationship between the upper trapezius, the deltoid and the triceps.

In an arm fully extended support position, both long and lateral heads of the triceps seem, in the main drawing, to be shortening equally. This is something of an illusion; the lateral head is bunched quite short, but the lower part of the long head is out of sight on the inside of the arm, the upper part is pushed into extra prominence by contact with the body.

The upper fibres of all three heads of the triceps are all bunched where they underlie the deltoid; this has swelled out that muscle, giving the appearance of activity there, although in fact the deltoid is relatively inactive in this pose. In these circumstances the scapular fibres of the deltoid and upper triceps can appear as one convoluted form.

The photograph shows how activity in the triceps ceases when the body is supported from the elbow.

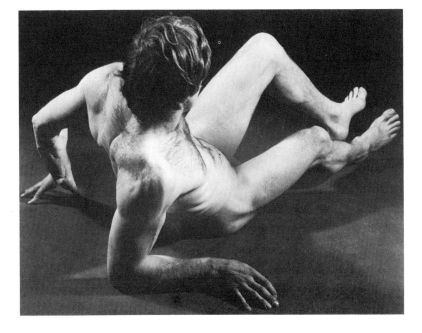

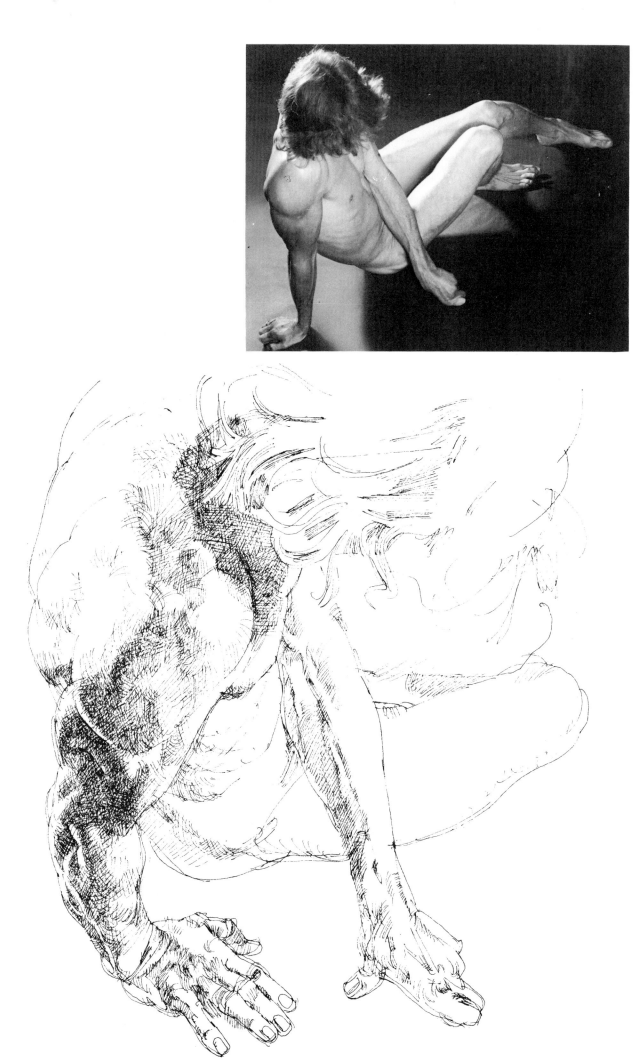

The lighter musculature of this male subject, and the viewpoint chosen, combine to throw the lateral head of the triceps into even greater prominence, and the generally relaxed pose allows the encapsulated head of the humerus to be pushed upwards and forwards appearing as a domed form in the upper deltoid. In the photograph the shoulder girdle has been pushed so high that it almost reaches the subject's ear and indeed it is not uncomfortable in this arm support position to rest the head on the supporting shoulder.

Activity of the triceps is rarely so clearly visible in the female. The upper extensor area of the arm is one of several areas of the body where female fat deposits occur, which, together with the generally lighter musculature, give the upper arm a much more rounded appearance, while the prominence of the humerus head is if anything even more obvious.

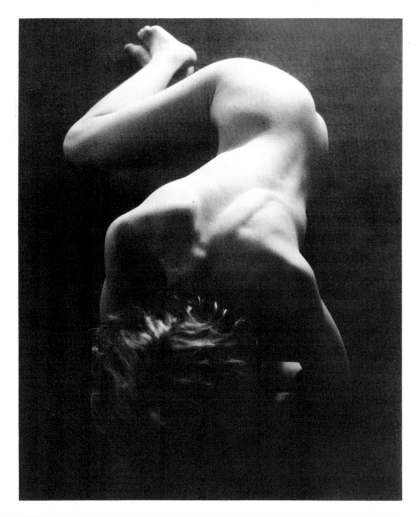

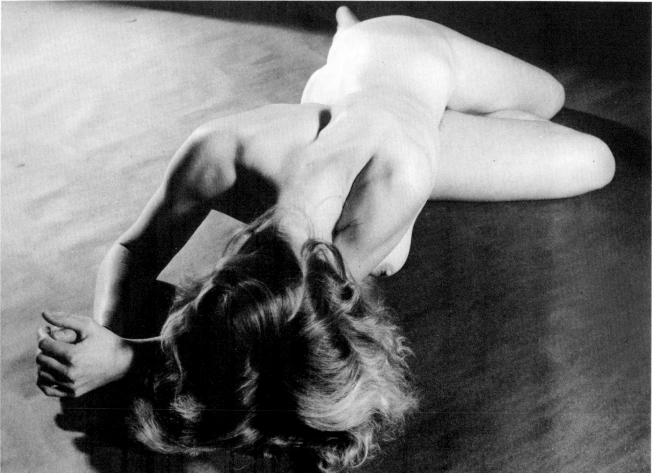

When the torso of the reclined figure is supported on elbows as here, the humerus works as a strut, with no sign of muscular tension at the surface. The lateral edges of the scapulae are somewhat raised from the costal surface by the push on the shoulder joint, and their medial borders are pushed together by the action, thus deepening and narrowing the trough over the upper thoracic vertebrae.

The lighting of the model in the top photograph accents the line of the scapula spines. The upper and medial borders of the left scapula have clearly lifted from the costal surface, but the other scapula is held down by muscular activity, revealed by the sharp ridges of the lateral borders of the lower trapezius meeting the curving upper border of latissimus dorsi. Note also the light catching on the protuberance of the first thoracic and seventh cervical spinous processes.

Both photographs prove that the vertebral column can twist throughout its length enough to allow pelvis and shoulders to rest quite easily at an angle of 90° to one another, even though each single vertebra can rotate on the next only slightly.

133

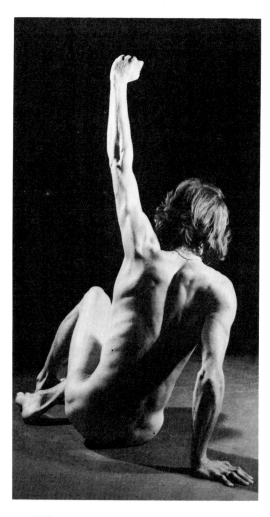

The appearance in life of the upper back is probably the most difficult for the student to reconcile with theoretical drawings.

The confusion mostly results from the fact that the superficial muscle arrangement has to accommodate to the varying positions of the scapula, the medial edge of which 'shows' through and cuts across other forms, as described on page 124. In the photograph below, the dotted line indicates the upper border of latissimus dorsi as it enfolds the lower angle of the scapula. The convexity of the active infraspinatus combines with the medial edge of the scapula to form an edge which dominates other forms in the area, and appears to cut across the continuous border of the latissimus dorsi.

In the upper photograph, the outline of the trapezius can be seen fairly well and it is interesting to note the difference in height of its tendinous attachments to the medial ends of the scapula spines on each side. These can be identified here as two small nodule-like forms in the angle between the lower and middle fibres of the trapezius. The right-hand one is conspicuously higher than the left, which is lowered by rotation of the scapula.

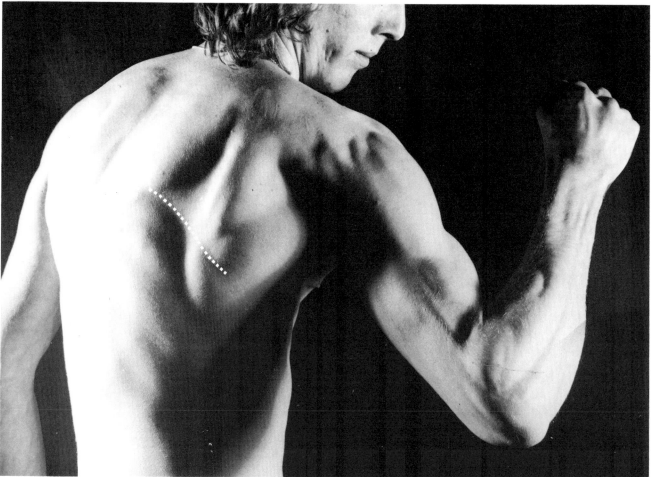

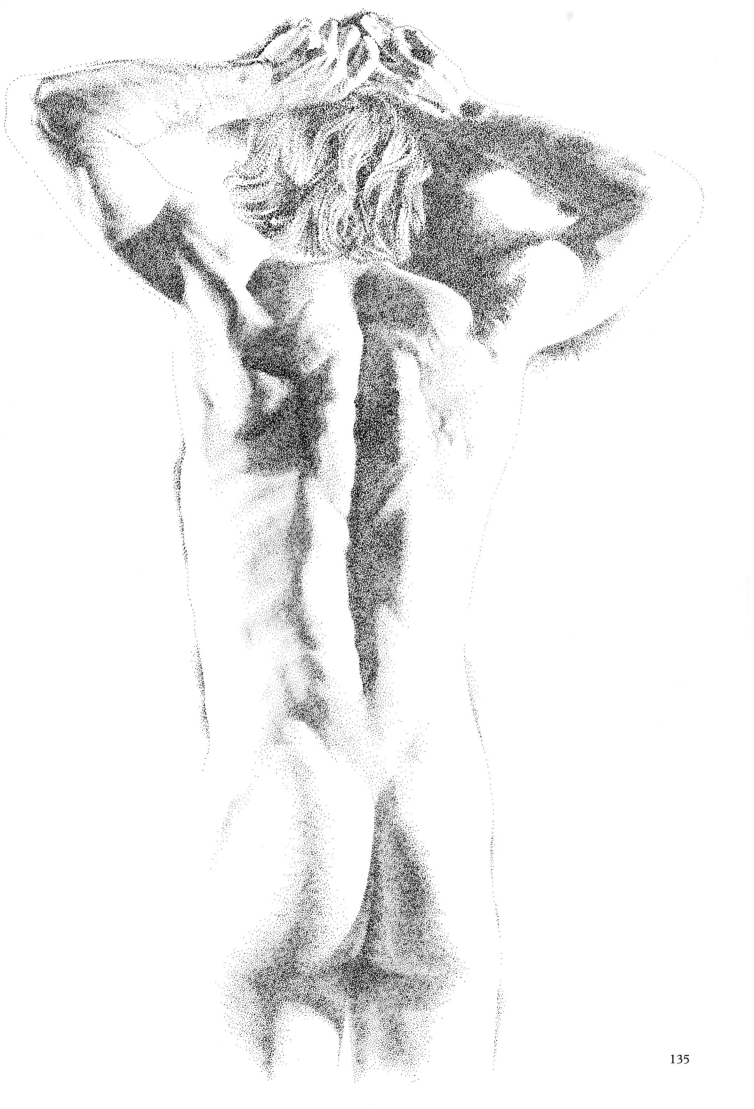

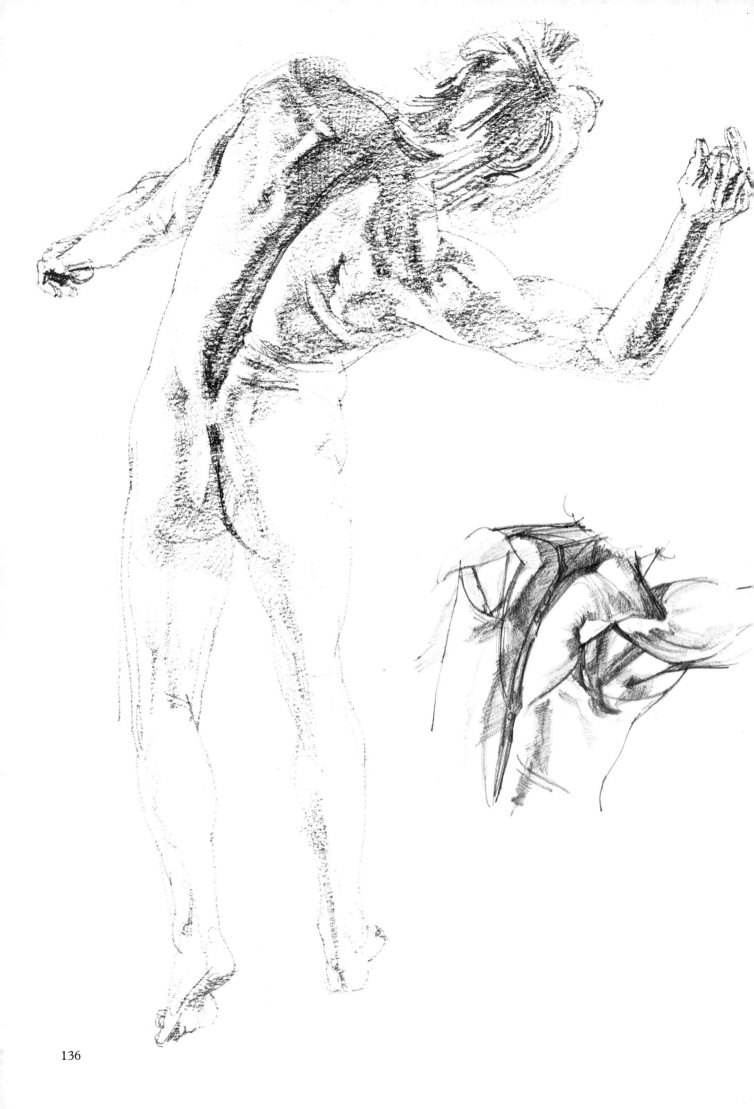

Here is another well muscled back. The right shoulder area of the figure in the photograph on the right below, may present a formidably complex appearance at first sight, but it can be sorted out fairly easily. The diagram should separate out the groups sufficiently for the individual muscles to be recognized.

It is interesting to compare the activity over and including the right scapula with the relaxed musculature of the left upper back. Reference to the muscle drawing on page 77 may also help understanding. The erector spinae group is strongly active in this pose, and the rope of muscles at each side of the lumbar spine are almost equally prominent. In the drawing on the left the weight is shifted laterally and backwards and the left-hand column of erector spinae takes over the bulk of the work, the other side relaxing somewhat. In the photograph below, almost all the extension is powered by the left-hand group and the right-hand side is quite flat.

Incidentally, the attachments of the erector spinae tendon to the sacrum are clearly visible, especially in the right-hand photograph, as are the depressions over the posterior superior iliac spines.

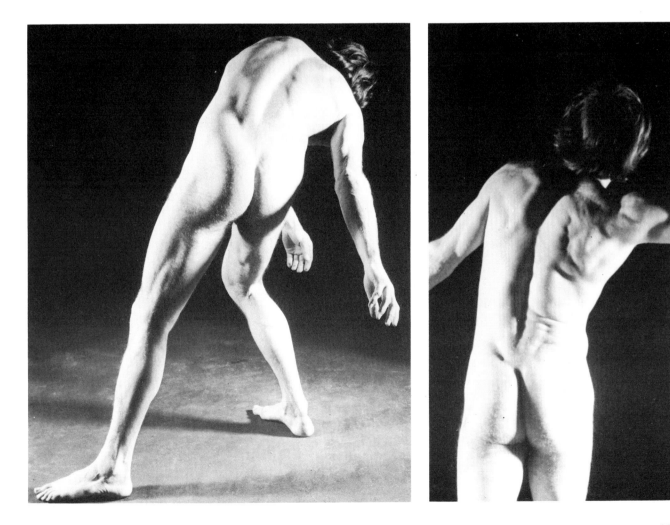

Activity in the various sections of the trapezius muscle is demonstrated in these photographs.

In the left-hand photograph on this page the model is trying to raise his arms against resistance. The middle and lower fibres of the trapezius are taut and straight, pulling on the medial spine of the scapula to anchor the deltoid for raising the arms. Associated with this arm-raising is the need to maintain the body balance, and the erector spinae group has tensed strongly against the leverage of the arms.

The right-hand photograph shows the situation when the straight arms are lowered against resistance. Only the upper fibres of the trapezius are active, causing tensioning of the scapula against the downward pull of the long head of the triceps (which arises from just

Direction of arms

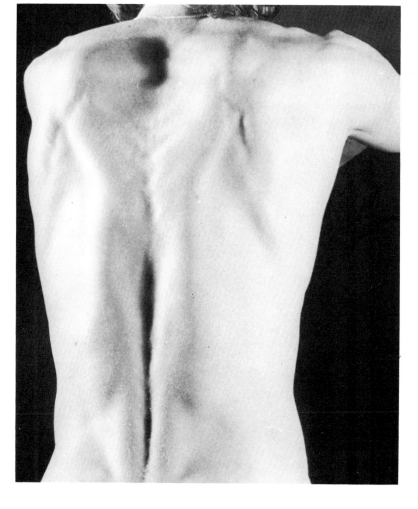

below the glenoid cavity on the scapula) and, to a lesser extent, the lower fibres of the deltoid. The erector spinae is less active, but the fibres of latissimus dorsi can be seen pulling on the spinous processes of the lumbar vertebrae.

If the front of the trunk could be seen, the upper insertion of the latissimus dorsi could be seen pulling the humerus downwards, as would the pectoralis major. The rectus abdominis will have taken over the duties of the erector spinae in maintaining body posture, against the upward leverage exerted by the downward pressure of arms on an immovable support.

The two diagrams should clarify the activity and outlines of the muscles in each case. They could be compared with the drawings on pages 66 and 74.

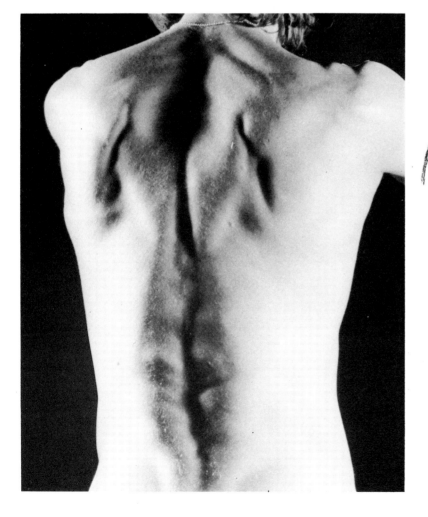

Direction of arms

139

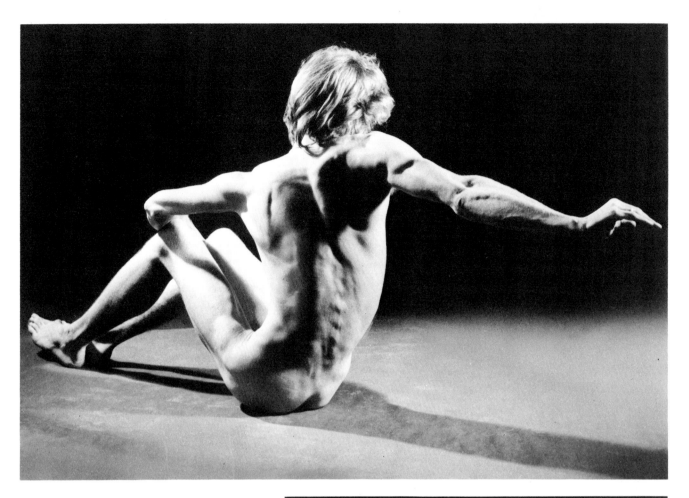

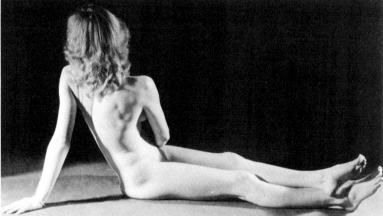

When shoulder movement is combined with twist of the upper body, different forms result in the upper back. Most notable is the extreme shortening of the middle trapezius fibres pulling the scapula back and producing an abrupt change of plane from the depression along the line of the spinal column. The photograph of the male subject also shows the strong pull exerted by the lower fibres of the deltoid which virtually separate themselves from the rest of the muscle. Note that the small form on the right upper arm (strongly defined by a small dark shadow nearly continuous with that under the lower edge of the active deltoid fibres) is not the continuation of the deltoid border; it is the lateral head of the triceps in contraction.

As before, the same forms are detectable in the back of the female subject but are rather more generalized and less well defined.

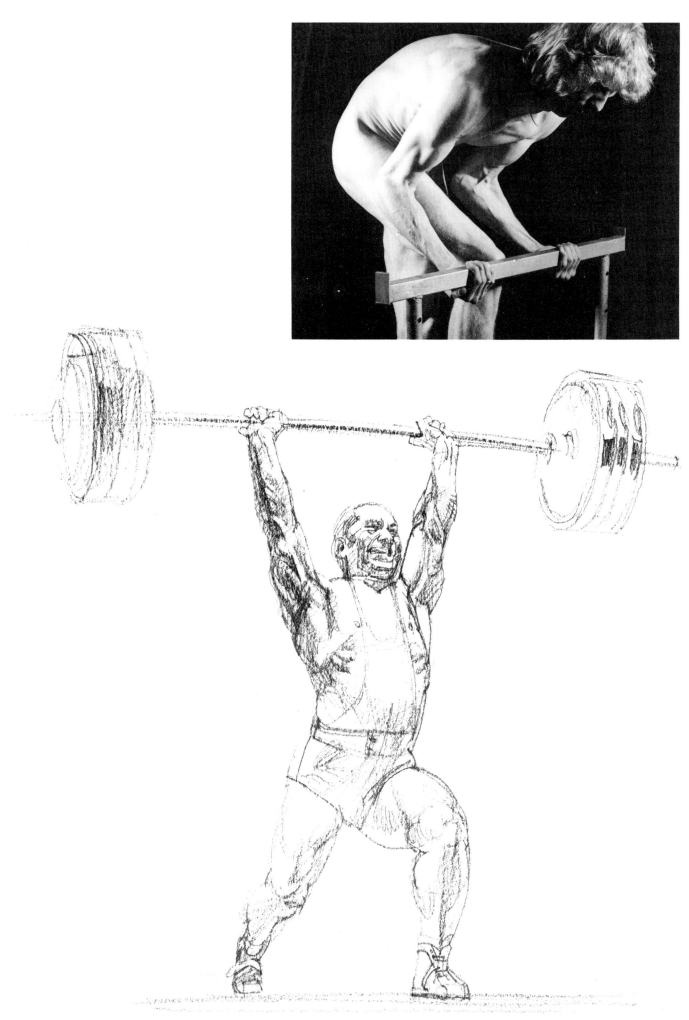

The action of the biceps in flexion of the arm has been drawn and described on page 81. Here the photographs show the surface form when the action is used in lifting or holding a weight. Obviously the primary and most visually striking muscle in use is the biceps, but many others are also involved.

As can be seen in the large photograph, the clavicular and acromial fibres of the deltoid are active in holding the upper arm in place, and the brachioradialis assists in flexing the elbow. Less obviously, but very importantly, the brachialis, which contributes to the power of the movement, puts tension into the intermuscular septa, both lateral and medial, from which it partly arises. These septa, plus the countering flexions of the adjacent triceps fibres, then produce a discernible ridge on the surface which defines the division between triceps and brachialis.

When musculature has heavy demands put upon it, all groups are active. The weight-lifter here is primarily pushing the bar upwards, but such a large weight must be kept exactly above the centre of gravity, and virtually every muscle is involved in holding the body and the weight in this position.

The intention in these pictures has been to show the lean, well-defined muscular development of the runner contrasted with the heavy build of weight-lifters, shot-putters and the like, and at the same time to examine some of the surface clues to leg structure.

Emil Zatopek, in the lead below, has typical distance runner's build. Upper arm development is sparse, but the leg making contact with the ground shows where the power is. Rather unusually, the vastus lateralis seems to be combining with the rectus femoris in a single form separated from the vastus medius, but this may be mainly an effect of the lighting. Incidentally, the pronounced flap behind the knee of the leading leg of the second runner is made by the tendon of the biceps femoris.

The divisions between vastus medius, rectus femoris and vastus medius are exceptionally clear in the tensed thighs of the subject on the far right. Tensor fasciae latae and gluteus medius can also be seen inserting into the iliotibial tract on the lateral surface of the model's right thigh.

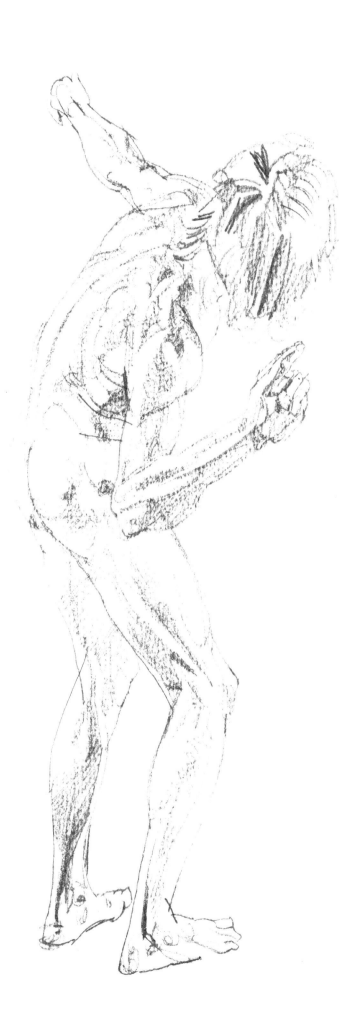

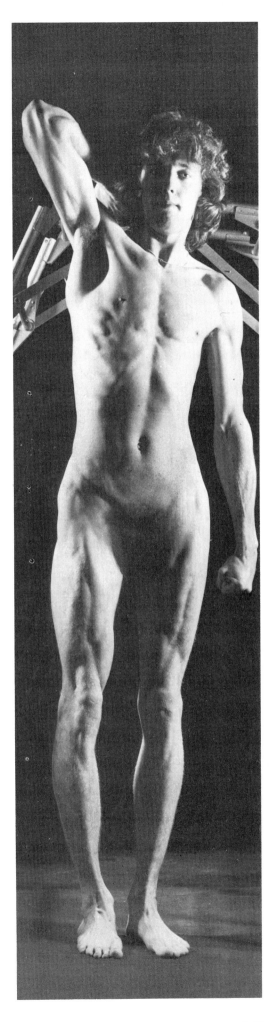

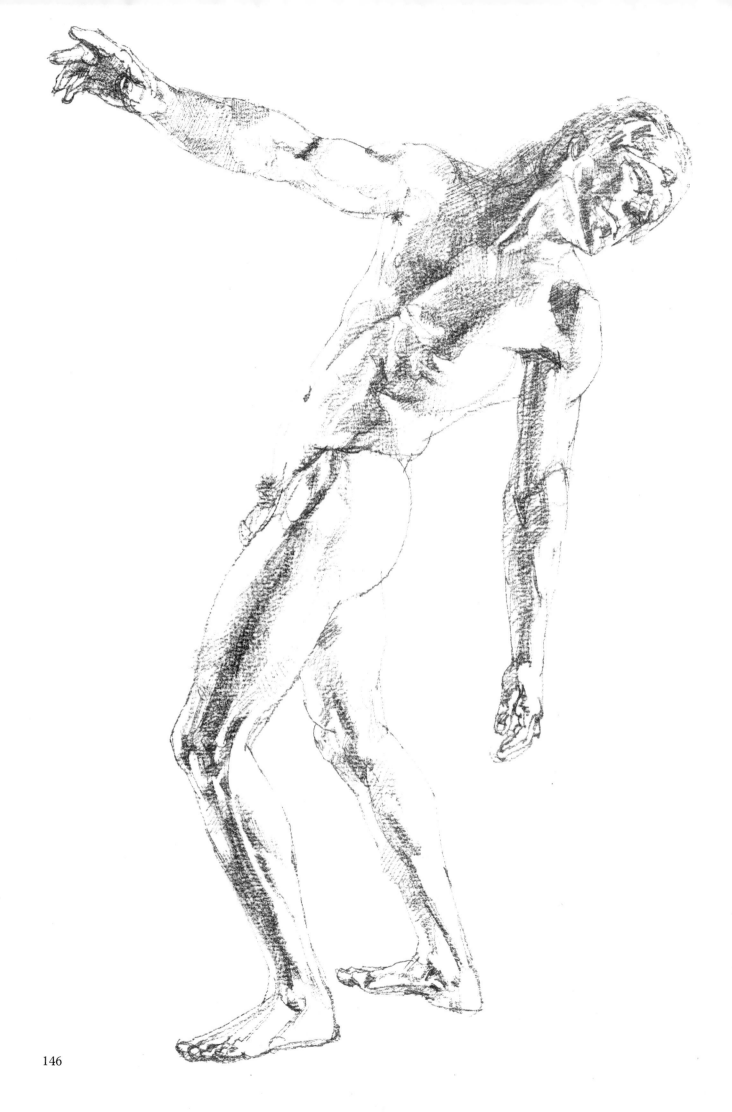

Feet and ankles are superbly strong structures capable of absorbing heavy loads and exerting considerable force, yet appearing quite delicate.

Bones and tendons are visible over almost the whole dorsal surface of the foot, most of the tendons descending from calf extensors having passed under or through retaining bands or retinacula at the ankle. The prominent ligament on the model's right foot in the photograph below is that of the extensor digitorum longus. It is emerging from the upper retinaculum to be further retained by the clearly visible Y-shape of the lower extensor retinaculum.

In any reasonably active upright pose, the ligament of the tibialis anterior is likely to be visible angling over the lower end of the tibia and the inside of the foot to its insertion at the base of the first metatarsal bone. Also likely to be prominent if the weight is on the toes, are the ligaments of the peroneus longus and brevis in their synovial sheaths around the external malleolus.

The rather grooved appearance of the lateral side of the lower leg, where all the long extensors lie, is in marked contrast to the medial side, where the rounded forms of the gastrocnemius and soleus predominate. At its lower end the ligament of these muscles, the tendo calcaneus, inserts directly into the calcaneus without the restraint of a retinaculum, leaving pronounced hollows between it and the malleolus on each side of the ankle.

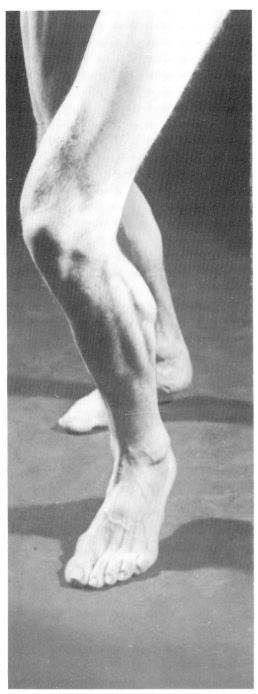

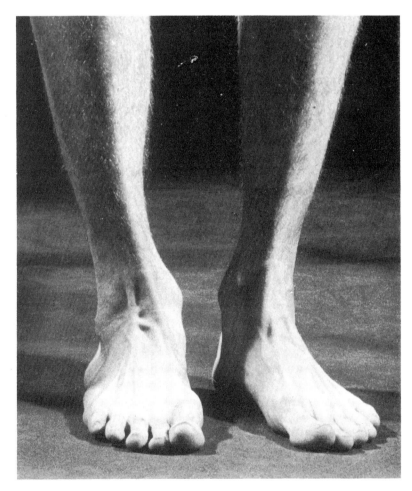

The form of the knee in full flexion sometimes causes a certain amount of difficulty in interpretation. The key to the situation is to realize that the patella maintains a more or less constant distance from the tuberosity of the tibia, to which it is attached by the ligamentum patellae. In full extension the patella is situated high up on the articular surface of the femur. However, at the limit of flexion, as here in the squatting position, relaxation of the quadriceps tendon allows the femur's articular surface to slide on that of the tibia, rotating from behind the patella and presenting its lower surface as the dominant form of the knee joint. The flattened surface of the lateral condyle and the rounded contour of the medial condyle of the femur can be seen clearly in the photograph below. The patella is the protuberant form below and between them, and beneath it the frontal face of the knee narrows to the triangular shape bounded by the tibial condyles at each side and the prominent tuberosity at the base. The nodule on the lateral side of the knee, visible in the drawing but shadowed in the photograph, is the head of the fibula, and the drawing also shows the edges of soleus and peroneus longus. Note also the ligament of peroneus brevis stretched around the pulley of the lateral malleolus, which shows very clearly in the photograph.

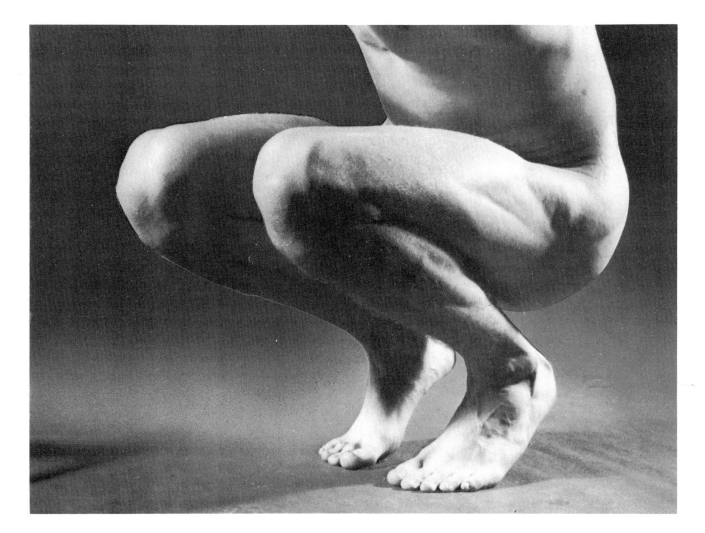

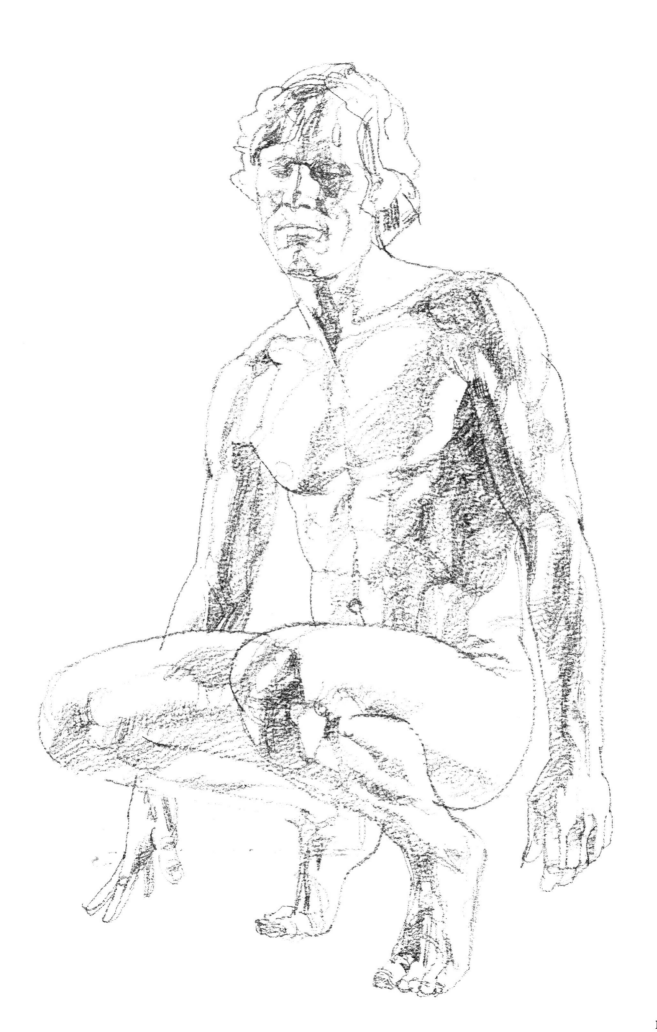

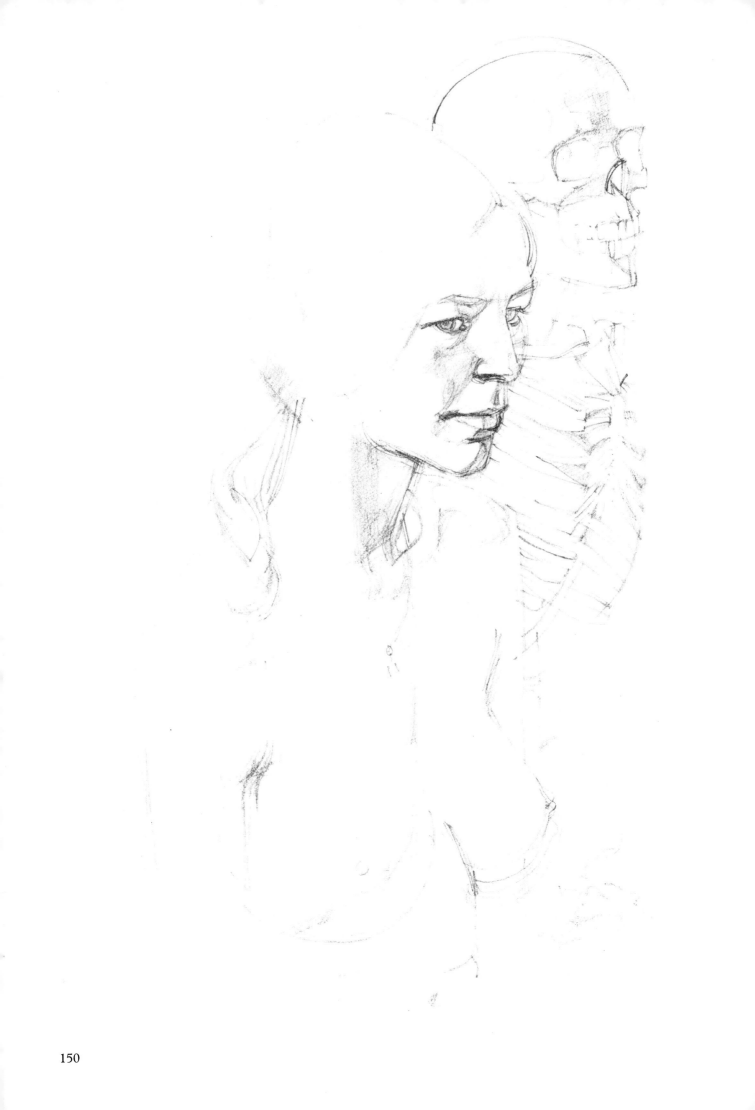

The musculature of the head and face is illustrated and described on page 106, but, as stated there, the important structures of the head in terms of effect on surface form, are more bony than muscular.

To draw the head successfully, it is important that the frontal planes across forehead, cheek bones, chin and so on relate properly to each other and to the side planes of the head and face, and that the ridge of the nose should appear to rise from the frontal plane at right angles to it.

The orbicularis oculi is thin and owes its form to the eyeball, the eyebrow ridges above and the lower borders and zygomatic beneath. The bulk of the nose is formed by cartilage. Twin lateral cartilages continue the nasal bone on each side, a septal cartilage along the top, and minor and major alar cartilages form most of the lower parts of the dorsum nasi, the sides of the nose. The lowest fleshy flaps enclosing the nostrils are made of fibres and fatty tissue covered with skin.

Surrounding the mouth the orbicularis oris receives attachments from numerous small muscles, the outward effect of which is to produce a downward-slanting form from the dorsum nasi, filling in the hollow between the zygomatic and the frontal maxilla bone. The lower border of this form follows the line of the junction of the cheek muscles with the orbicularis oris making the well-known expression line to the corner of the mouth. This groove, and with it the sides of the mouth, can be pulled in a great many different directions and degrees by a complex system of interlaced muscles of expression.

The really powerful muscles of the face are the masseters, one at each angle of the jaw or mandible. They fill the hollow between that angle and the zygomatic bone, and can be seen when the jaw is clenched.

151

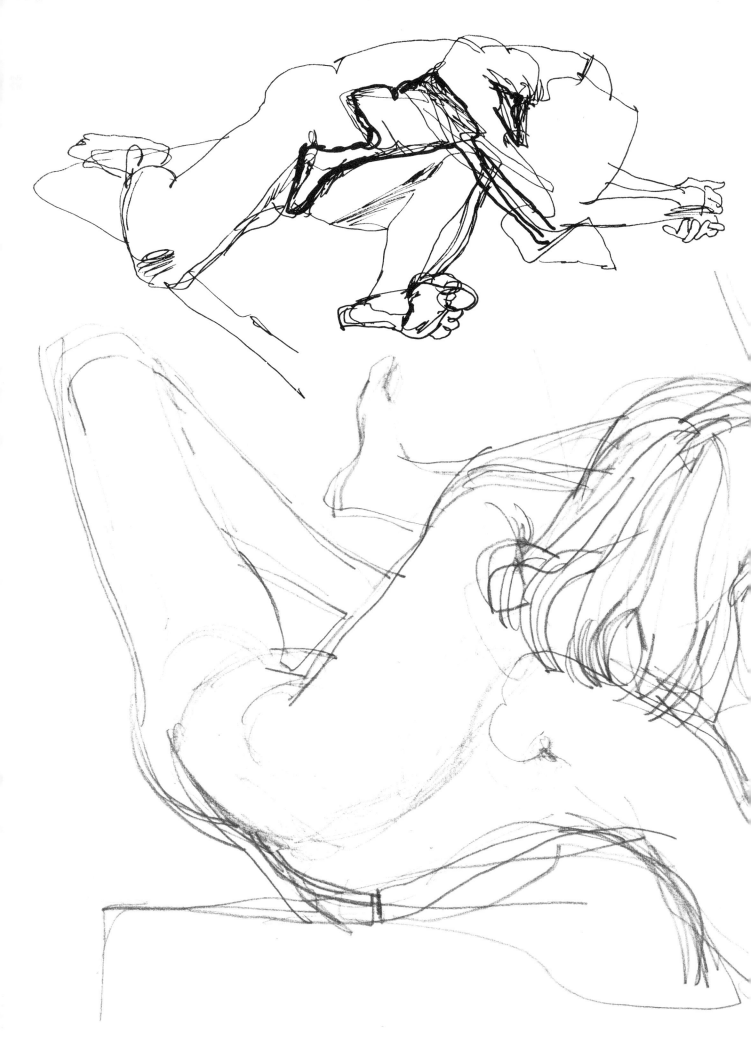

The point to be made here is perhaps the most funda-
mental for an artist attempting to comprehend surface
form. A perfect understanding of all the parts of the
body does not necessarily add up to knowledge of the
body as a complete entity. It is such an incredibly
diverse and complex organism, capable of such in-
finitely subtle variations of movement and juxtaposition,
that the total shape observed in any instant need never
be repeated exactly.

All the drawings reproduced here are quick records
of poses which were held for only a few minutes. The
intention was to try to put down, not the detail of any
part, but the totality of each human shape as rapidly as
possible before it changed.

Photography is of course useful for recording these
fleeting glimpses, and is pretty well essential where
rapid activity is involved, but the photograph cannot
really convey three dimensions; the eyes cannot measure
depth from a photograph.

It is necessary to observe and draw living breathing
people if the theory of anatomy is to mean anything.

153

Anatomy in Art

This last section looks at some examples of art through the ages by artists who have shown interest in and knowledge of human anatomy, and who perhaps have thereby reflected changing ideals of and attitudes towards the human figure.

The art of ancient Greece was discussed in the Introduction. Further examples shown here include the fragmentary *Belvedere* torso, the back of which certainly inspired Michelangelo in his sculpture of the figure of *Day* in the tomb of Giuliano de'Medici. Why is it that fragments of sculpture sometimes have such power? Perhaps because of the concentration of attention on the fundamental essence of the pose of a figure, without any inessential details. This, of course, presupposes that it is the essential part that has accidentally survived; presumably there must be many more sculptures that were not so happily mutilated.

The famous sculpture *Laocoön and Sea Serpents*, of the 1st century BC, is an extraordinary demonstration of anatomical knowledge. It is not my intention to judge this or any of the other works reproduced here as art, only to comment on the anatomical forms, and there is no doubt that the sculptor of the *Laocoön* had a complete knowledge of the male form. The cephalic vein, which runs along the edge of the biceps and over into the groove between the deltoid and the pectoralis major, had been obviously admired and prominently featured by earlier sculptors, but the entire surface of the struggling centre figure here, knotted with nerves and veins, represents a pinnacle of anatomical virtuosity.

Pollaiuolo's drawing of *Fighting warriors*, dating from the last part of the 15th century AD, is rather less accurate anatomically but is none the less dramatic for that. The sinuous patterns of muscularity suggest vitality and movement more than convincing form. Much more coherent in solid form are the figures of *Adam and Eve* (1504) in the Dürer engraving, although there are one or two curious anatomical features. For example, Adam's thigh seems to have no connection between the rectus femoris and the quadriceps tendon, and the deltoid of his right arm appears to insert into the biceps rather than through the brachialis into the lateral surface of the humerus. The figure of Eve looks rather strange to our eyes too, but all the anatomy looks possible even if unusual, and the strangeness is probably just a question of changing preferences in the female form.

Leonardo and Michelangelo brought to the study of anatomy a new human 'fleshiness', a feeling for tension and flaccidity, hardness and softness. Michelangelo's study for the *Libyan Sibyl*, a figure from the Sistine Chapel, is incredibly subtle and beautifully observed. The knotted trapezius, the combined form of teres minor and infraspinatus above and teres major below

opposite The Belvedere torso, a Hellenistic work of the 1st century BC, is shown here in rear view. Its bold, powerful musculature was greatly admired by late Renaissance and Baroque artists. *Vatican Museum, Rome.*

straddling the long head of the triceps, the medial edge of the scapula with its lower angle held by the latissimus dorsi, through which the lower ribs subtly show: all these features and many more can be seen, but they do not impose themselves. Everything contributes to a coherent and curiously vital action.

The same forms are featured in the massive brooding figure of *Day*, and here Michelangelo is successfully orchestrating them. It is difficult to believe that the teres major could be quite so huge and separated from the latissimus dorsi, but what a magnificent form the combined scapula and deltoid is. Michelangelo knew anatomy so well that he could ease the forms into groupings that were larger than life in order to express the life force through his figures. Observation of real human anatomy gave him the means of constructing new heroic figures, idealized but with minds and feelings, impossible but remarkably convincing.

By contrast Caravaggio (1573–1610) painted people as they are, so far as that can ever be said of a translation of observation into an image. At any rate, he wanted to show their imperfections and the subtle variations in form, skin texture and coloration, attitude and expression which changes each figure into a person. The subtlety and restraint in the painting of the figure of Christ in the *Deposition* is very impressive. Note the biceps of Christ's right arm slightly flattened against

opposite Laocoön and sea serpents was sculpted in Rhodes in the 1st century BC. It was considered the finest sculpture of antiquity by Pliny the Elder; and after the discovery of this Roman copy in 1506, it served as inspiration for many Baroque artists as well. *Vatican Museum, Rome.*

below The study of ten nude fighting warriors, drawn by Antonio Pollaiuolo in the late 15th century and later copied in this engraving, is a typical Renaissance fantasy in which an implausible subject is chosen as an excuse for studies of the nude figure in a variety of vital poses. *Uffizi Gallery, Florence.*

This engraving of Adam and Eve (1504), by
Dürer, epitomizes the achievements of the
northern Renaissance, applying a clear sharp
line to the scientific study of the body. *British
Museum, London.*

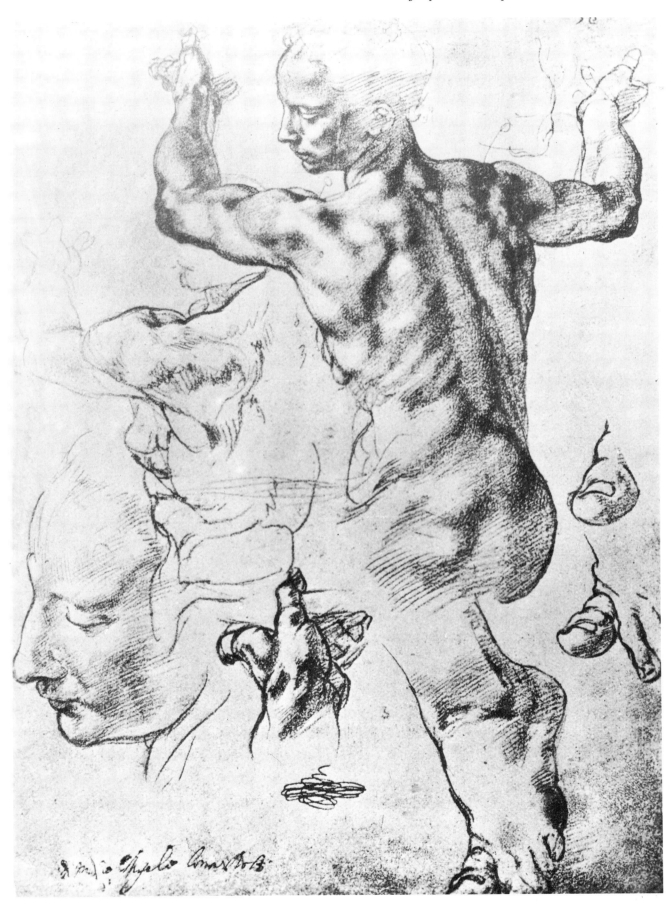

This sketch was made by Michelangelo as a study for the Lybian Sybil, a figure in the Sistine Chapel. Like many such sketches, its anatomy is perhaps more sensitively depicted than in the finished painting. *Metropolitan Museum of Art, New York. Purchase (1924) Joseph Pulitzer Bequest.*

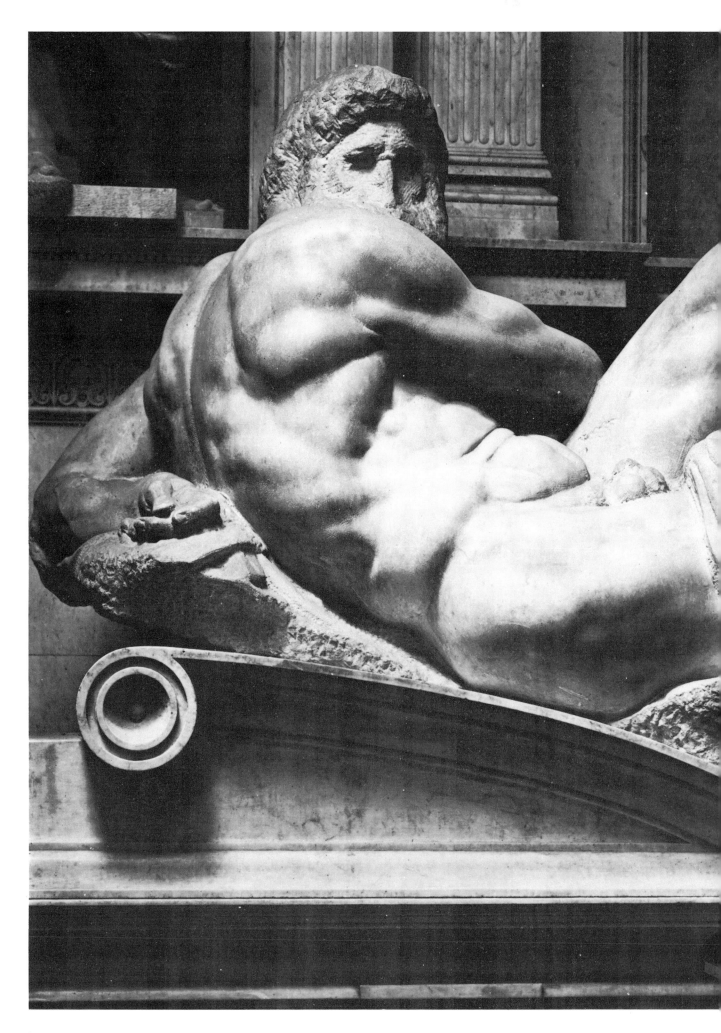

The figure of Day, from the tomb of Giuliano
de' Medici, sculpted by Michelangelo, is a
stunning evocation of the gradual stirring of an
enormous power. His roughly-carved face peers
over a massive shoulder and imbues a somewhat
improbable anatomy with a strange inner life.
Medici Chapel, Florence.

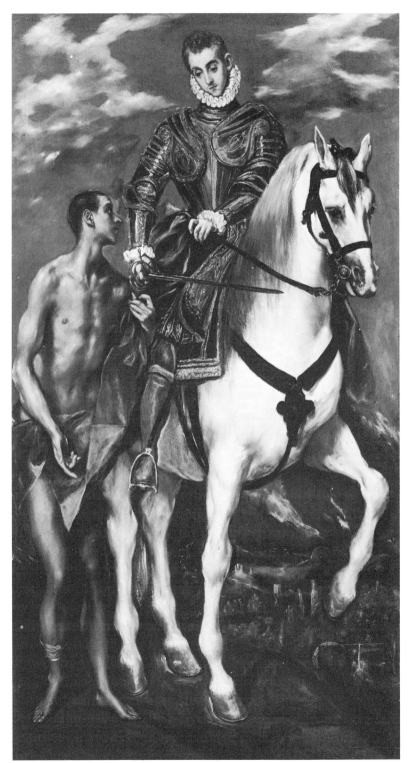

opposite The Deposition, or The Burial of Christ, was painted by Caravaggio shortly before 1606. Despite its theatrical composition, the realism in the depiction of Christ, as an entirely undramatic corpse, was revolutionary in its time. *Vatican Museum, Rome.*

left St Martin and the Beggar (1597), by El Greco, conveys an unworldly spirituality through a combination of its flickering light and shade with the tall, attenuated bodies and bony joints. *National Gallery of Art, Washington, D.C.*

The allegorical painting of peace and war was completed by Rubens in 1629 in England. Its swirling power is based on a scrupulous anatomy, but unlike earlier Renaissance paintings all the figures are subservient to the overall composition. *National Gallery, London.*

the supporting hand, and the thinness of the pectoralis insertion, entirely consistent with the negligible amount of that muscle visible on the chest. To paint Christ with such a real, unidealized, almost scraggy chest must have required great courage and conviction at that time.

At about the same time that Caravaggio was painting in Italy, El Greco, the Spanish painter, was using anatomy in a completely new way. As Michelangelo pushed anatomical structure into new forms to express his own ideas, so did El Greco, but by transmuting the figures into more ethereal, sinuously elongated shapes. A device constantly used by El Greco was the narrowing of the joint structures of the limbs. Thighs and calves almost billow in form, but always become slender at knees and ankles. The musculature is scrupulously correct, but its plasticity almost belies the bony structure beneath.

A little later in Flanders, another totally different interpretation of human form emerged. For Peter Paul Rubens (1577–1640) big was beautiful! With enormous gusto he composed great flowing patterns of drapery, animals, fruit and vegetation intermingled with expansive, exuberant male and female nudes. The figures were anatomically impeccable but always of massive build, the ladies especially hiding their bony structure under generous rolls of fat.

Rembrandt van Rijn (1606–69), although not primarily a painter of the nude, drew many studies of the figure in which his unerringly honest vision is evident. The drawing of a seated female nude reproduced here is uncompromising in its search for the un-idealized reality of this sturdy peasant body, rather overweight by today's standards. The simple form of the right leg manages to suggest the subtler shapes of the knee joint underneath, with the sartorius sweeping obliquely to divide the quadriceps from the abductors. Even deltoid and triceps are suggested by subtle tone changes, and the abdomen is manifestly solid.

In portraiture, Rembrandt showed the same intensity of objective vision, especially in his long series of self-portraits. Their structural solidity coupled with a subtle sensitivity to the texture and colour of the skin, the resilience and slacknesses of tissue as revealed by a single source of light, has probably never been equalled.

Skipping over the European Baroque era, for no other reason than that nothing really new was added to anatomical knowledge and usage during that time, we come to the flowering of early 19th-century Romanticism in Géricault's *The Raft of the Medusa* (1819). Géricault took immense trouble in the preparation for this picture to ensure anatomical realism. Many drawings and even oil studies survive of flayed cadavers, dismembered arms, legs, even heads. Figures which finally

opposite This study of a seated female by Rembrandt is typical of his humane but firmly realistic depiction of the body. Naked rather than nude, this woman is far removed from the theatrical, classically-inspired works on the previous pages of this book. *Musée du Louvre, Paris.*

166

167

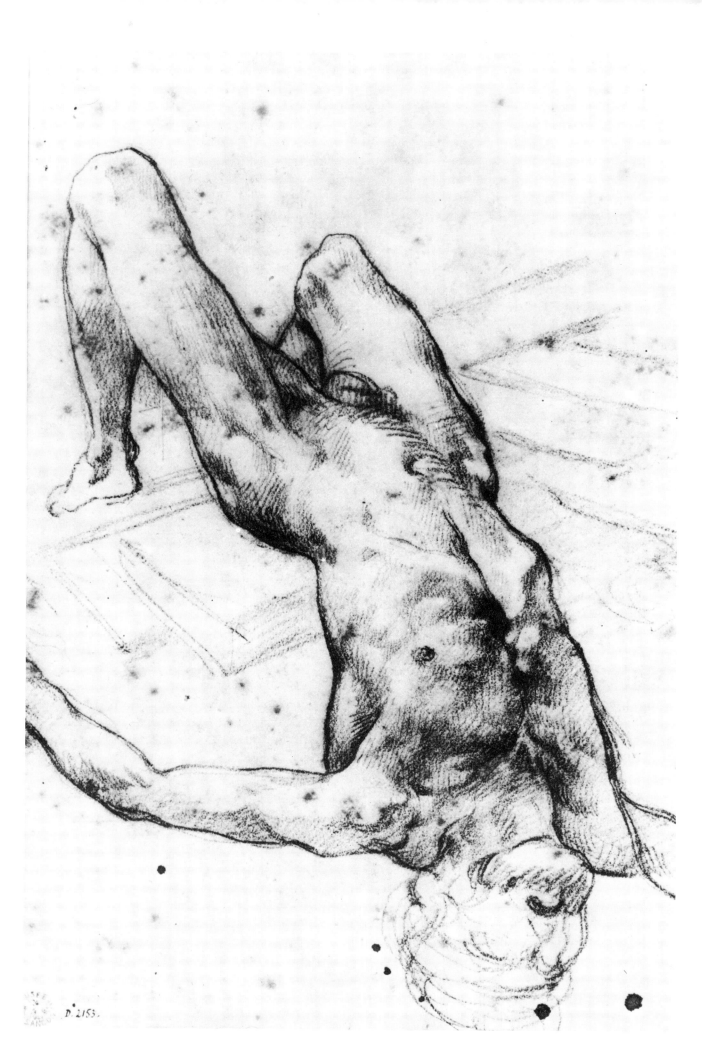

D. 2153.

opposite Study for the figure in the right foreground of The Raft of the Medusa, by Géricault. *Musée des Beaux Arts, Besancon.*

below and bottom Studies of severed heads and flayed torsos for The Raft of the Medusa, by Géricault. *Private collection.*

overleaf The Raft of the Medusa (1819), by Géricault. *Musée du Louvre, Paris.*

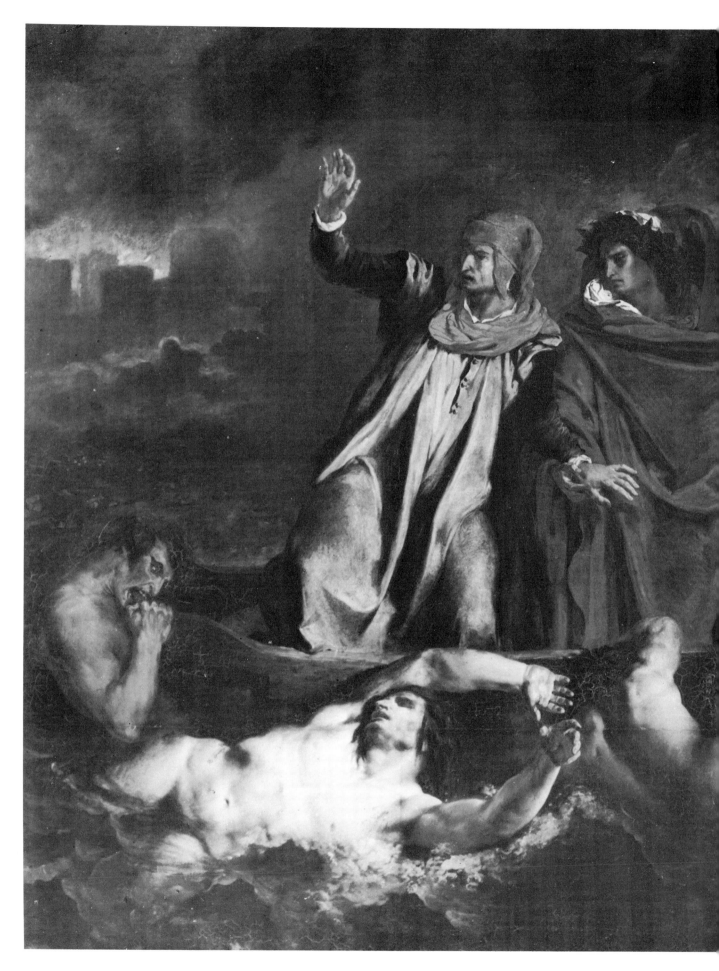

Dante and Virgil crossing the River Styx (1822) was one of the earliest paintings by Delacroix. Although it represents an attempt to escape from the neo-classical style of the period, the naked figure of the boatman on the right was based on the Belvedere torso. *Musée du Louvre, Paris.*

appear draped were drawn with infinite care as nude studies. Many areas of this painting give evidence of the thoroughness of his research, but I will discuss only the prone figure at the bottom right, for which a sketch is also shown. The vastus medialis of the right leg can be seen to be flaccid, so that the medial condyle of the femur shows at its distal end and the rectus femoris too is slack enough for its weight to produce a slight roundness at its normally upper proximal end; the quadriceps tendon insertion and the similarly slack vastus lateralis leave a hollowing of the form from the projecting patella.

The arms and shoulders trailing over the edge of the raft have produced the characteristic hammock-like form stretching from the iliac crests to the enlarged lower outlet of the thorax. Even the pectoralis major is visible under the loose and presumably wet cloth. In fact the shape of this muscle is one which I might dare to dispute. I would have expected the pectoralis to be stretched downwards (upwards in normal orientation) by its attachments in the humerus of each stretched arm. However, the whole composition is a theatrical,

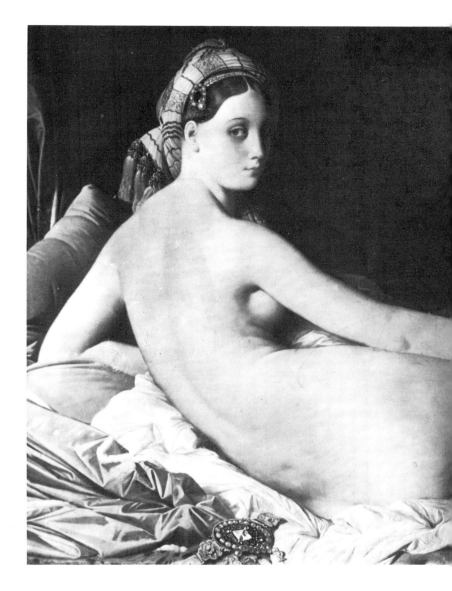

carefully contrived arrangement of a situation which in reality would no doubt be utterly chaotic, and a little rearrangement of anatomy for dramatic effect is entirely reasonable.

Eugène Delacroix (c.1798–1863) was drawing and painting in a similar genre a little later. His figures were perhaps even more extravagantly romantic, the forms a little more plastic, facial types more exotic. Comparison of *The Raft of the Medusa* with Delacroix's *Dante and Virgil crossing the Styx* (1822) is an interesting exercise. The figure in the bottom left of *Dante and Virgil* is worthy of Michelangelo—the extravagant pose, heavy musculature and feminine features all bring to mind figures from the Sistine Chapel.

Bitterly hostile to Delacroix and Romanticism, Jean Auguste Dominique Ingres (1780–1867) brought to figure painting a cool, carefully organized idealism. His painting of a reclining female nude entitled *La Grande Odalisque* is a typical example of his obsession with detail and precision. Ironically, although his proclaimed intention was, to quote John Ruskin, to go 'to nature in all singleness of heart, selecting nothing, rejecting

La Grande Odalisque (1819) is one of a number of nudes by Ingres in which the skeleton is barely evident, in an attempt to convey an idealized sensuality. The distorted, unexplained figure baffled most of Ingres' contemporaries. *Musée du Louvre, Paris*.

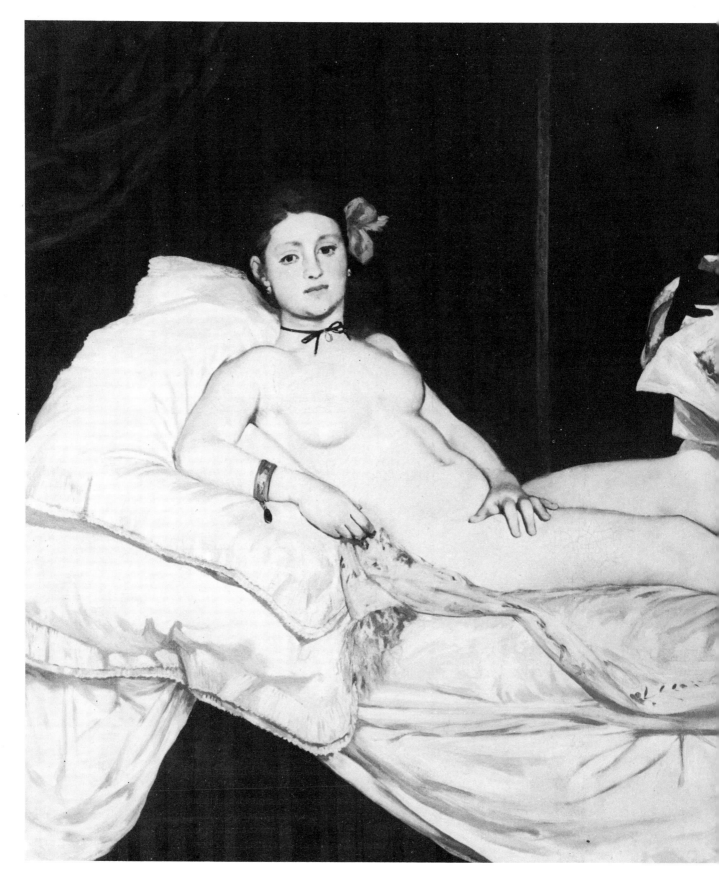

176

Olympia (1863), by Manet, outraged the Parisian public for the defiance of its stare, and the pertness of the pose. Sculptural beauty or languidity were more acceptable than this cold, tough muscularity. *Musée du Louvre, Paris.*

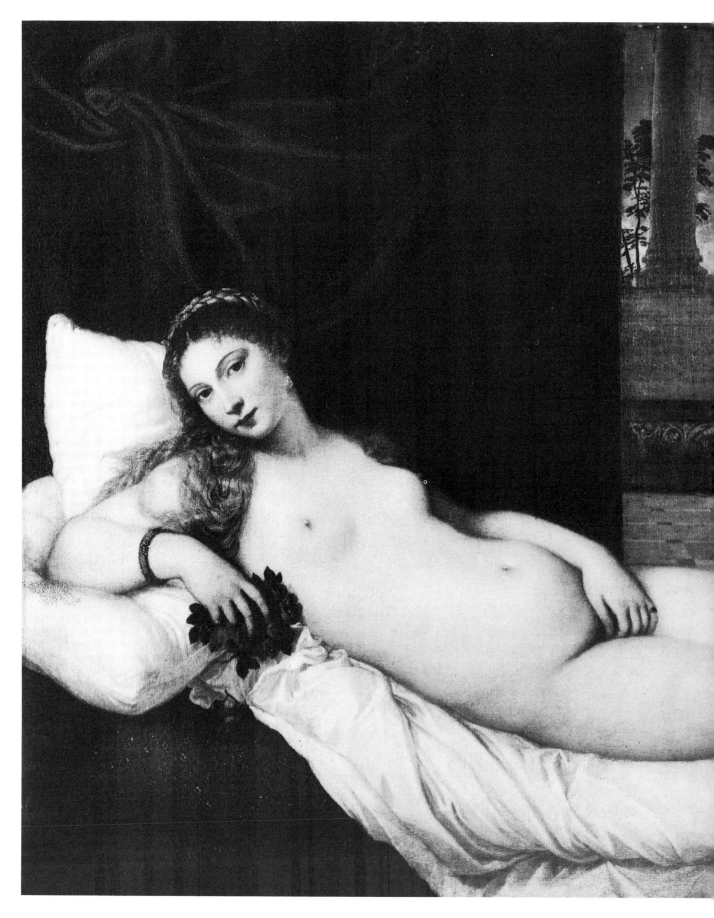

The Venus of Urbino (1538), by Titian, provided the inspiration for the pose of Olympia, and also the yardstick by which that painting was judged. This earlier goddess of love had a submissiveness and a golden glow from her body which were considered more appealing. *Uffizi Gallery, Florence.*

nothing' this painting is anything but naturalistic. This exotic lady's spine curves too ideally and is extraordinarily long. If one tries to fit a pelvis into that form bounded by her upper hip (which should be the iliac crest) and the line of the buttocks, the pelvis clearly appears impossibly deep. The droop of the shoulders too, with their extreme slope of the upper trapezius is rather difficult to believe and the bulge of the breast from underneath her right arm gives the upper body the look of a bas-relief. The hands and feet, and to an extent the head are fairly convincing, albeit rather smoothed out. All this is not, I repeat, a condemnation of the painting as a work of art. To achieve his vision of the ideal, almost mythical appearance of the symbol of 'femaleness' in a formally structured painting, it was necessary for Ingres to bend the rules of anatomy, as others had done before him.

Edouard Manet's *Olympia* (1863) invites comparison with the Ingres painting. In fact the composition was based on Titian's *Venus of Urbino*, but whereas both the Ingres and the Titian are languid, urbane idealizations, '*Olympia*', actually a prostitute named Victorine Meurend, is disturbingly real. There may be many reasons for this; although Manet's craft is not based on anatomy alone, his careful observation and informed selection of the forms of this young lady's body has much to do with it. The drawing of her figure is deceptively simple – for so much to be omitted what remains must be just right. Look at the subtle rise of her right shoulder to allow the upper arm to rest on the pillow, and the way her left hand reflects the shape of the thigh on which it rests. The pressure of her right leg on the calf crossing it is described by a gentle bulging of the form of the left gastrocnemius and soleus. Even the edge of the pelvis can be sensed from the slight change of tone along a line pointed by her left thumb.

In 19th- and early 20th-century France there were a number of other artists and sculptors interested in exploring the human form in their own ways. Principal among them were Degas, Renoir, Modigliani, Maillol and Rodin. Others such as Toulouse-Lautrec, Cézanne and Matisse may be added to the list although they were less obsessed by the figure than the first named.

Edgar Degas (1834–1917) had an amazing ability to see the totality of the figure, with all superfluous detail ruthlessly sacrificed for the vital primary shape. He was interested in the fleeting moment of a pose, and made use of the newly available science of photography to capture these moments.

The sculptor Auguste Rodin (1840–1917) was also moved by the expressiveness of the body in its entirety and when only momentarily at rest. He instructed his

models to move about the studio constantly while he made very rapid drawings in search of the expressive line, the form that transcends its human limitations. The *Prodigal Son* and the *Juggler* are examples of the forms evolved from observation of the human body and imbued with this 'different' life.

Anatomically, the bronze figure of *John the Baptist* is very interesting. At first sight it is a straight representation of a fairly sinewy old man. But it is more than that. The legs are massive, strongly set and immensely vigorous, the toes clenching the ground. From a wide pelvis the trunk rises powerfully erect; only at the neck and shoulders does the muscular stringiness intrude. The chest is narrow by comparison with the lower body, and the bearded head completes the impression of an old man invested with a subtle strength.

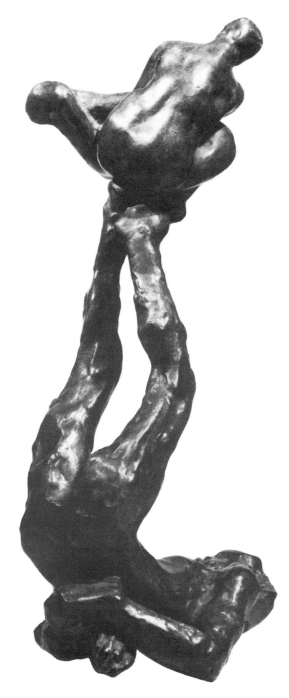

The Juggler, a bronze model 29cm (11·4in) high, was produced by Rodin. Themes from the circus were popular in the late 19th century, combining figures in extreme motion with symbolic and political overtones. *Musée Rodin, Paris.*

below The Prodigal Son, by Rodin, was originally planned as a figure for the complex Gates of Hell. Its extreme movement and the elongation of the body convey the abandon of the youth. *Musée Rodin, Paris.*

opposite St John the Baptist preaching is one of Rodin's most important works. Its pose manages to convey both the emaciation and the authority of the figure. *Rodin Museum, Philadelphia Museum of Art.*

Henri Matisse (1869–1954) is not a painter who would normally be considered a devotee of human anatomical study, but the painting in the Tate Gallery, London, called *Nude study in blue* is just about the ultimate in simplification of the human figure in order to capture its essential structure logic. The painting loses a lot in black and white, as the colour does more than approximate the tones to depict form; it seems to indicate the resilience of tissue and the strength of its supporting structures.

As far as I am concerned, the king of figure draughtsmen was Egon Schiele (1890–1918). In his short life he produced a large number of drawings and rather fewer paintings of extraordinary intensity, almost all of them nude or semi-nude figures. Bone never seems far from the surface in Schiele's drawings and yet there are plenty of exuberantly fleshy forms too. Whether or not he ever studied anatomy formally, there is no question that he understood it intimately.

I will make special comment on just one drawing, the one entitled, rather lengthily, *Sitting nude, with her arm leaning on her right knee* (1914). It is drawn in pencil and watercolour as are most of his drawings. First of all, as a total shape it is strong, self-contained and entirely convincing. Her left thigh, defined by a simple line, suggests the bulk of the abductor muscle group, shows the origin of the sartorius from the ilium, and even indicates, by a sort of strap, the tensor fasciae latae.

The flank extending from the painfully sharp edge of the iliac crest to slide behind the lower rib cage, the latissimus dorsi just showing thinly behind an equally sparse deltoid, all convinces with stringency and economy. But overall, it is much more than an anatomy lesson; there is a human being there, feeling, knowing, looking out.

Lastly, a painting rather more like an anatomy lesson, and yet full of social human implications and suggestion; it is entitled *Standing male and seated female models* (1969) by Philip Pearlstein. There are some marvellously explicit forms in this painting; the woman's knee and bent leg tell more about the anatomy of the leg than most dissections, and the man's arm is worthy of investigation by anyone interested in surface anatomy.

There are many other artists who are worthy of study and for whom there has been no room. The works of Botticelli, Titian, Watteau, Boucher, David, Blake, Henry Moore and Matthew Smith are all consistently interesting anatomically, and *The Forge of Vulcan* by Velasquez, the *Disasters of War* by Goya and the many etchings of Picasso are equally important. There are many lesser known names as well; armed with a basic knowledge derived from this book, it should be possible to seek themselves out in the art galleries yourself.

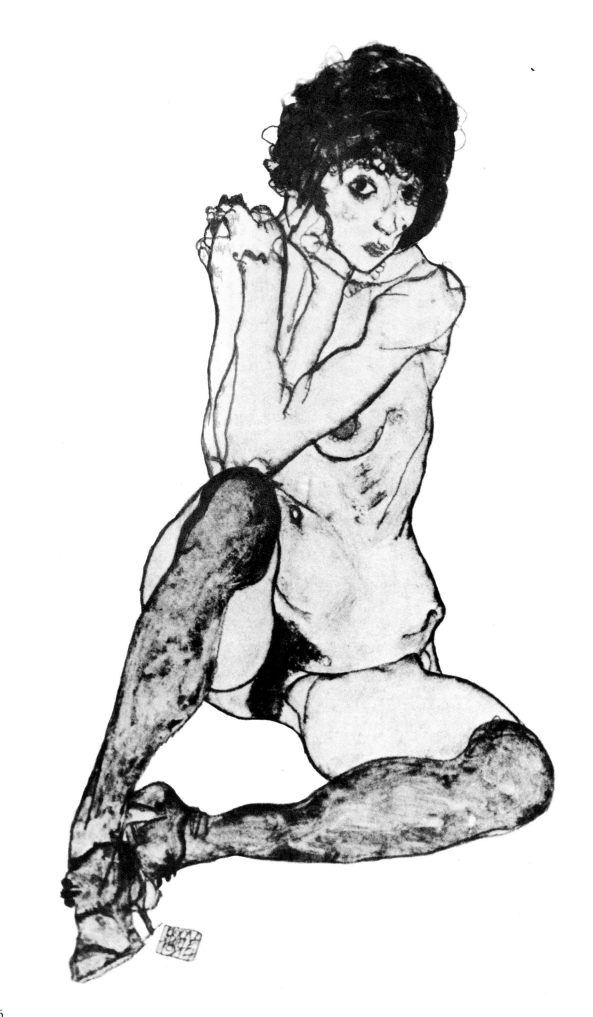

186

opposite Sitting nude, with her arm leaning on her right knee (1914); pencil and water-colour sketch by Schiele. *Albertina, Vienna.*

below Standing male and seated female models (1969) by Pearlstein. *Collection of Professor and Mrs Gilbert Carpenter, Greensboro, North Carolina.*

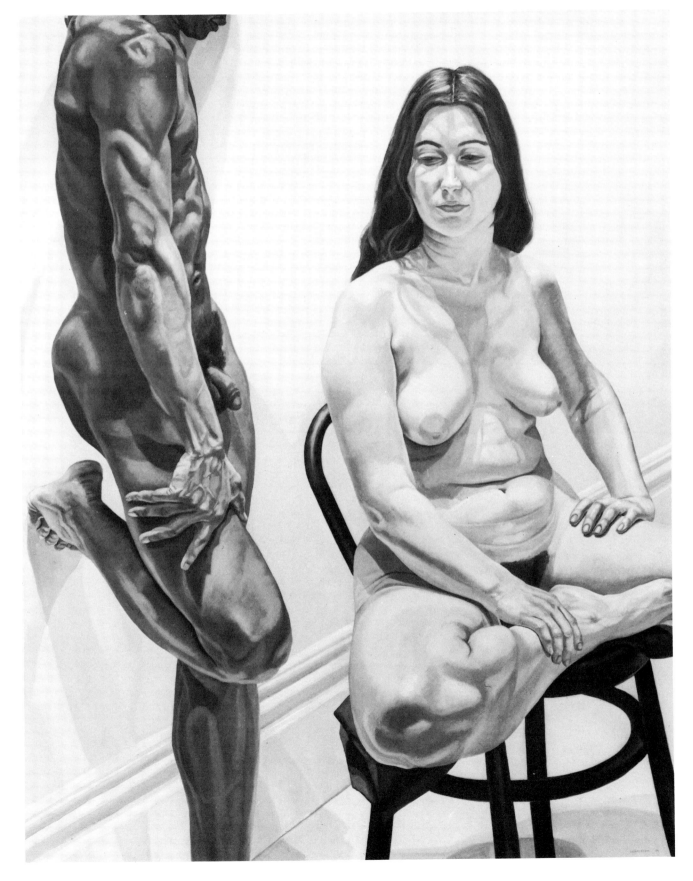

Glossary

Abduction Movement of a limb outwards (laterally).

Adduction Movement of a limb inwards (medially).

Anterior Pertaining to the front side of the body.

Aponeurosis A sheet-like expanse of dense connective tissue, associated with muscle attachments.

Articulation Movement of two bones together at a joint.

Belly The main contractile part of a muscle.

Condyle A smooth knuckle-shaped eminence on a bone, for articulation with another bone.

Costal Pertaining to the ribs.

Crest A marked ridge on a bone.

Digitation A finger-like strap of muscle.

Distal The part of a limb, muscle or bone furthest from the limb root.

Dorsal Pertaining to the back, or to the back of the hand or foot.

Dorsiflexion Flexion or movement of the foot upwards.

Eversion Movement of turning the foot such that the sole faces outwards (laterally).

Extension The movement of straightening a joint or bending the vertebral column backwards.

Facet A small articular surface of a bone.

Fascia A sheet or band of fibrous connective tissue.

Fossa A depression or groove in a bone.

Head (bone) The expanded proximal end of many elongated bones.

Heads (muscle) The origins of a divided muscle.

Insertion Attachment of a muscle to a bone or cartilage, usually at the movable or distal end.

Lateral Pertaining to the side of the body.

Line (linea) A low, narrow ridge on a bone.

Medial Pertaining to the centre of the body.

Origin Attachment of a muscle to a bone or cartilage, usually at the secure or medial end.

Plantarflexion Extension or movement of the foot downwards.

Posterior The rear side of the body, a muscle or a bone.

Process A sizeable projection from a bone.

Pronation Movement of turning the hand downwards such that the bones of the forearm are crossed.

Proximal The part of a limb, muscle or bone nearest to the limb root.

Ramus A branch or arm of a bone.

Retinaculum A fibrous band of strengthened fascia, retaining tendons at a joint.

Septum An extension of the deep fascia, dividing muscles and providing attachments for them.

Slip An attachment for a muscle additional to the main one.

Spine A long sharp projection from a bone.

Supination Movement of turning the palm of the hand upwards such that the bones of the forearm are not crossed.

Synovial A sheath or joint lubricated by the fluid synovia.

Tuber, tubercle, tuberosity A roughly rounded projection on a bone.

Index

Acknowledgements

The illustrations on pages 12 and 13 are reproduced by gracious permission of Her Majesty the Queen.

Photographs
Aerofilms, Boreham Wood 7 bottom; Graphische Sammlung Albertina, Vienna 186; Alinari, Florence 157, 178-179; Archives Photographiques, Paris 175, 182; British Museum, London 7 top, 8, 158; Allan Frumkin Gallery, New York 187; Photographie Giraudon, Paris 170-171; Graphische Sammlung, Eidgenössischen Technischen Hochschule, Zurich 184; Hamlyn Group Picture Library 159, 172-173; Hans Hinz, Allschwilz 6; Hirmer Bildarchiv, Munich 10 bottom, 11 top, 156; Librairie Larousse, Paris 176-177; Mansell-Alinari 15; Mansell-Anderson 160-161, 162; Musées Nationaux, Paris 167; Museum of Fine Arts, Boston, Massachusetts 10 top; National Gallery, London 164-165; National Gallery of Art, Washington D.C. 163; Phaidon Press, Oxford 168, 169 top, 169 bottom; Paul Popper Ltd., London 144; Rodin Museum, Philadelphia Museum of Art, Pennsylvania 183; Roland Browse and Delbanco, London 181, Soprintendente alle Antichità di Napoli e Caserta, Naples 11 bottom; Tate Gallery, London 185; Leonard von Matt, Buochs 155; Roger Wood, London 9.

All remaining photographs are by the author.

The illustration on page 185 © SPADEM (1978)

The skeleton depicted in the drawings was loaned with the kind co-operation of Educational and Scientific Plastics Limited, Redhill, Surrey.

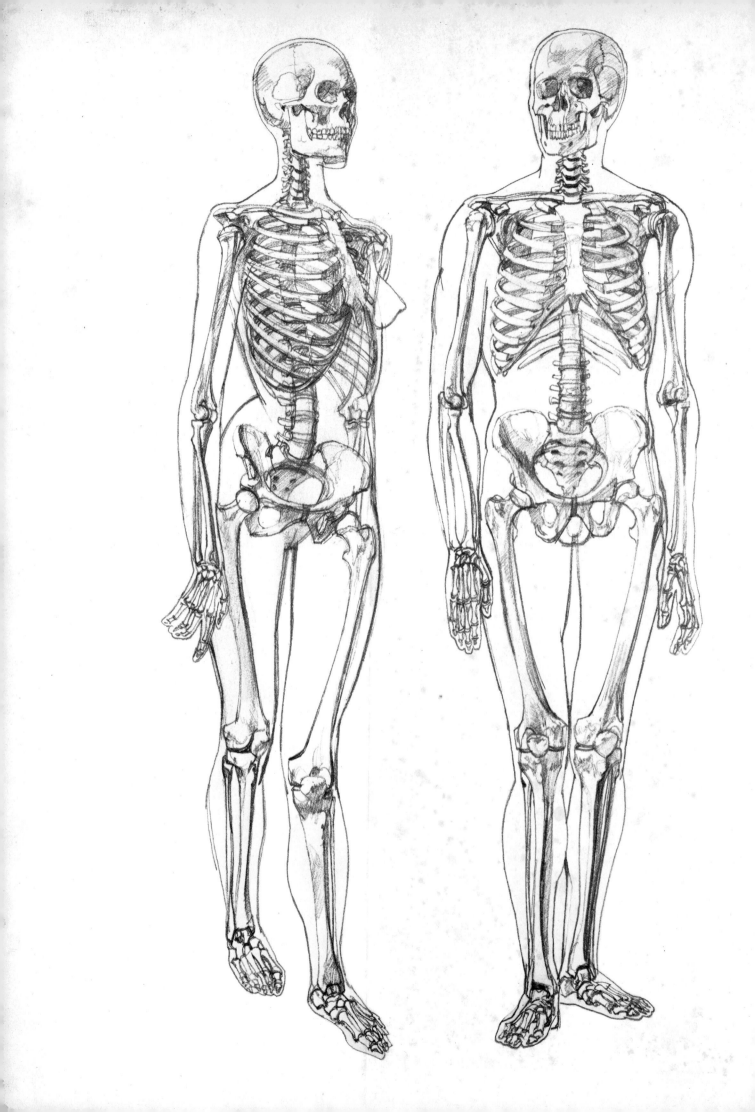